MW01050209

OF BIRDS AND TEXAS

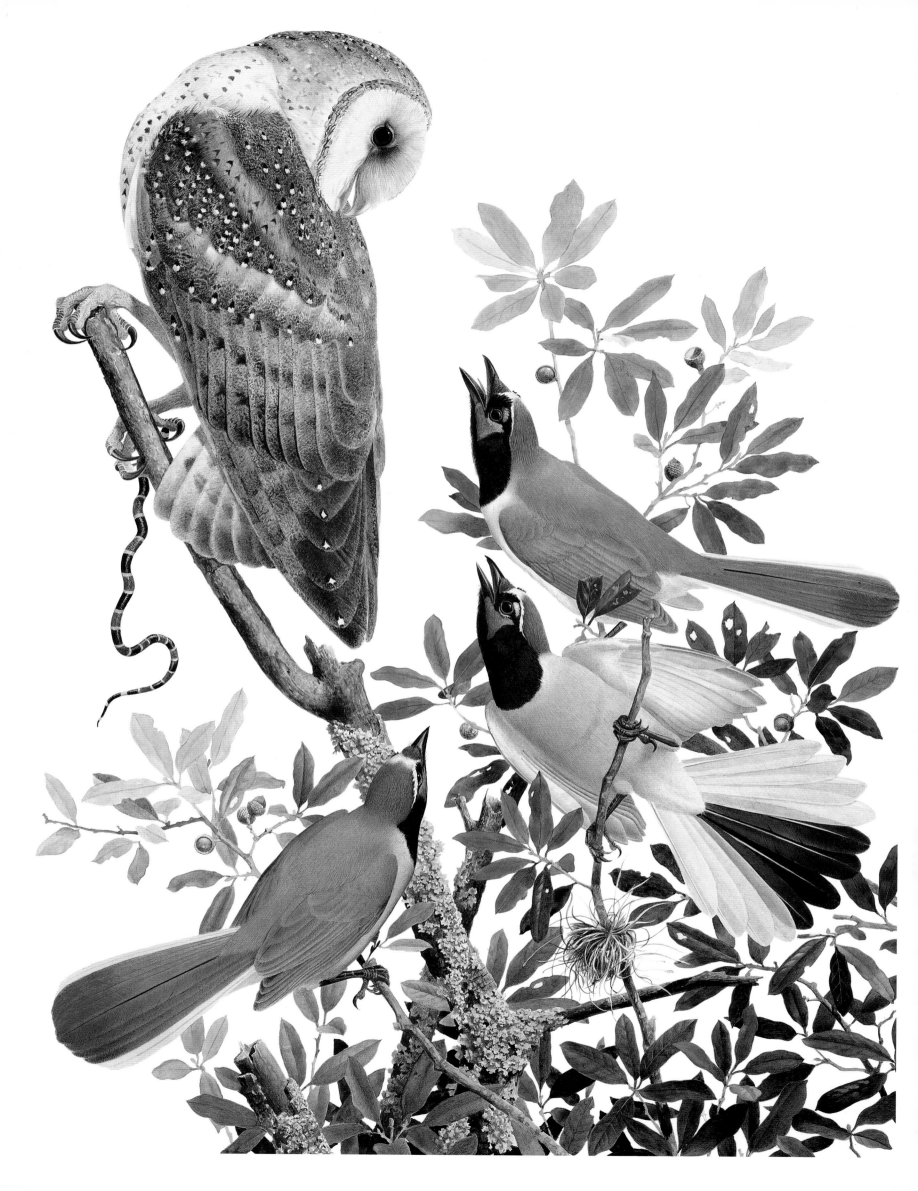

Of Birds and Texas

STUART GENTLING & SCOTT GENTLING

WITH AN ESSAY BY JOHN GRAVES

UNIVERSITY OF TEXAS PRESS

AUSTIN

FRONTISPIECE
*Green Jays and Barn Owl painted by Stuart and Scott Gentling
to commemorate the 100th anniversary of the
National Audubon Society in Texas.*

First edition, 2001

Requests for permission to reproduce material from this work
should be sent to Permissions, University of Texas Press, Box
7819, Austin, TX 78713-7819.

♾ The paper used in this book meets the minimum require-
ments of ANSI/NISO Z39.48-1992 (R1997) (Permanence of Paper).

LIBRARY OF CONGRESS CATALOGING-IN-PUBLICATION DATA

Gentling, Stuart, 1942–
 Of birds and Texas / Stuart Gentling and Scott Gentling ;
with an essay by John Graves.—1st ed.
 p. cm.
 Includes bibliographical references (p.)
 ISBN 0-292-72834-4 (alk. paper)
 1. Birds—Texas—Pictorial works. 2. Art publishing—Texas.
I. Gentling, Scott. II. Title.
QL684.T4 G46 2001
598'.09764'022—dc21 00-053636

KATHARINE, CINA,
AND RAMONA

CONTENTS

PREFACE

*T*his book in so many ways marks the completion of a massive publishing project that began more than twenty-three years ago. In 1977, Scott and I and our then partner in the art business, Dutch Phillips, began to contemplate the creation of a portfolio of elephant folio size color plates of Texas birds to celebrate the opening of our small gallery in Fort Worth's cultural district. We also wanted to take advantage of the enthusiastic public reception of a number of earlier black-and-white bird prints that I had done for Fort Worth's Junior League.

Our original intentions became gradually transformed into an ambitious ten-year publishing venture that produced what many consider to be the most magnificent book in the history of Texas publishing, *Of Birds and Texas.* From the beginning, once we had launched ourselves fearlessly onto the unknown and perilous waters of the book business, Scott and I wanted to produce along with our folio a smaller sized trade edition for the general public and for our original subscribers. Reading the text on the large pages of the elephant folio was awkward, even though it was very much intended to be a work of literature.

If we had not meant for our book to be read, we never would have asked author John Graves to collaborate with us. His contribution, originally titled "Recollections of a Texas Bird Glimpser," has since undergone a few changes, including a new title, "Self-Portrait, with Birds," and has been republished twice, in a small fine art edition by Chama Press (1991) and later as the first essay in the University of Texas Press collection of his work, *A John Graves Reader* (1996).

Scott and I are delighted to be able to include "Self-Portrait, with Birds" in this edition of our book. It replaces the original Graves text. There are other changes as well. In addition to this preface, there are new acknowledgments and a new essay by me, "Of Birds and Texas, Audubon and Us." There are also more illustrations in this new book, including nearly thirty bird studies, or remarques, done for some of our early subscribers, and a frontispiece of Green Jays that was painted to commemorate

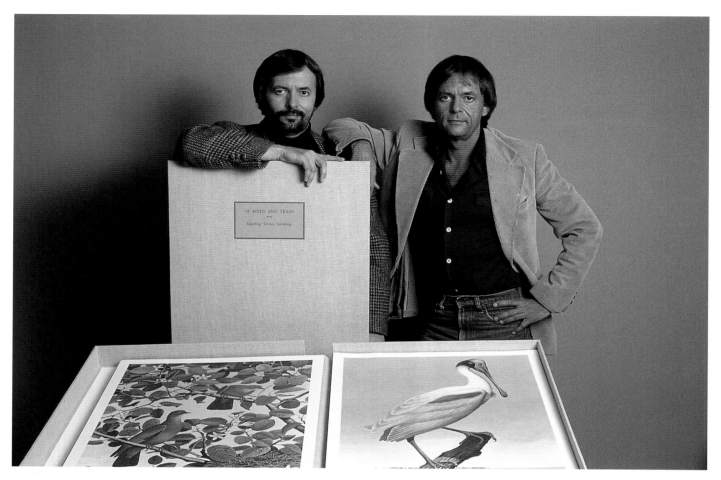

*Stuart and Scott Gentling with the folio edition of **Of Birds and Texas**, published in 1986.*

the centennial of the Audubon society in Texas. In spite of these changes, the new edition retains the title of our original folio because it preserves the spirit of the first *Of Birds and Texas* intact.

The new essay, "Of Birds and Texas, Audubon and Us," is taken from a memoir I wrote nearly ten years ago to record our publishing adventure—our triumphs and mishaps and our strange and wonderful encounter with John James Audubon, the man to whom we had already dedicated our folio. I am pleased that the art of Audubon has finally in the last decade been reevaluated and that he is getting the credit that has always been his due. Even contemporary art critic Robert Hughes has come to regard Audubon not only as a genius but also as one of the great nineteenth-century American artists. With the new essay, I hope the reader will experience some of the excitement we felt at our discovery of a long-lost and very important bird painting by Audubon that was to play a critical role in our lives personally and in the fate of our project.

The original memoir from which I distilled this essay was really meant for me alone as I tried to recall the mistakes I had made trying to bring our behemoth bird book

into being. It is difficult for me even now to imagine the kind of logistical problems we overcame to create a forty-six-pound book that was really an elephant folio comprising a box containing two portfolios with fifty color plates and eighty-six pages of text printed with metal type set by hand. Both the plates and text measured twenty-two by twenty-eight inches. What was initially to be a short record became a kind of stream of consciousness outpouring of feelings, memories, and observations laced with the benefits of hindsight in which I told our entire story as best I could remember.

By coincidence, at about this same time I was contacted by Kit Ward, a literary agent in Massachusetts who had been doing business with our older brother Peter. She could not believe it when he told her that his brothers had actually published a huge elephant folio about Texas birds. Rather than explain our book to her I sent her a copy for her review. She was most impressed. She asked me if we were interested in publishing a trade edition of manageable size. I told her, yes.

In the next few weeks, she tried to interest a number of publishers in the work but met with frustration at every turn. Publishers simply could not grasp the idea that

our book was essentially an art book, not a scientific publication or some kind of field guide. All the editors appeared impressed with what we had done; some were overwhelmed. But what to do with such a book? Scott and I even received a most gracious rejection notice personally written by Jacqueline Kennedy Onassis, who lamented that Doubleday did not publish large coffee table books. Several other book companies were interested but wanted Scott and me to include many more birds in order to appeal to bird-watchers in the field.

Another complication then reared its head. John Graves's text would not be available. I had forgotten that he had called me a couple of years earlier and had asked me if I would mind if he republished "Recollections of a Texas Bird Glimpser" in a small fine art press edition under a new title. I told him to go ahead. Although only 350 copies of the new printing had been done, the publisher would not grant me permission to use the essay again for fear apparently that our new book would compete with his. I appreciated that John was caught in the middle. He graciously offered to write a completely new essay, but by this time my enthusiasm for a new edition had waned considerably, and I simply let matters rest.

In 1994, Scott and I turned our attention to designing the entire painted decorations for Fort Worth's proposed performance hall being planned by Edward Bass and architect David Schwarz. While this project occupied us off and on for more than five years, we still managed to find the time to lay the groundwork for another book, *The One Reed Year,* about the Aztec capital city of Tenochtitlan. Now and then I would be afflicted with pangs of guilt about not doing the trade edition I had promised to our original subscribers, but the odds seemed completely against it ever happening.

Sometime in early 1998, I got a call from Catriona Glazebrook, the new executive director of the Texas Audubon Society, headquartered in Austin. She was about to go to press with the society's first statewide newsletter, and she happened to remember an exhibition of our bird paintings that she had seen at the Heard Museum in McKinney, Texas. They were showing the entire collection of our original paintings from *Of Birds and Texas,* on loan from the Fort Worth Museum of Science and History. She asked me whether I would mind if they reproduced some of our birds on the front pages of their forthcoming newsletters. I sent her some slides, and as months passed basically forgot about it until one afternoon I received a fat manila envelope containing several copies of the newsletter. They were really quite handsome. I im-

mediately called Catriona to offer my compliments and in the course of our conversation she told me that her board of directors had been very impressed with our work. So much so, in fact, that they wondered if Scott and I would mind if they honored us as the official artists for their 1999 centennial. By the strangest coincidence, they were going to start the celebrations with a big bash in Fort Worth at the new opera house, now called the Nancy Lee and Perry R. Bass Performance Hall.

Although I did not think of it immediately, it began to dawn on me that such official recognition by the Texas Audubon Society might just present a new opportunity to publish the trade edition of our folio, perhaps to commemorate their 100th anniversary. The timing seemed perfect. I decided to send a copy of our folio to Austin for the board's perusal. At the same time Scott and I offered to paint a folio-sized picture of a "Texas only" bird that would be reproduced for sale to Audubon society members and the general public. We eventually chose the Green Jay, and painted a group of three harassing a Barn Owl. By sheer luck the Fort Worth Zoo, of which I am proud to have served as a board member for the last twelve years, had several pairs of Green Jays. The owl too had resided at the zoo for the past eight years. When finally completed and printed just before the March 1999 celebration at the Bass Performance Hall, our painting of the Green Jays was the first folio-size bird painting Scott and I had done since our folio debuted in 1986.

With the Audubon centennial and a trade edition in mind, I thought about my memoir of a few years before. If I could revise it and reduce its length, it might make an interesting essay for the new book. The Audubon board and Catriona were encouraging. They were uncertain, however, just how to finance such an undertaking. Several ideas were considered, but ultimately Catriona contacted the University of Texas Press and arranged a meeting in Austin. In the fall of 1998, I received word that the book had been approved by the press for publication. At last it had found a home, and a very good one at that. The University of Texas Press was known for its bird books and also had published *A John Graves Reader.* At last, it looked as if I was going to be able to keep my promise of many years ago to publish our folio in a trade edition.

Although our original folio was dedicated to Audubon on a spiritual level, Scott and I also wanted to recognize for personal reasons one of our earliest and most beloved patrons, the late Shirley Lupton Holmes. Now, with this new edition, we are given the opportunity to recognize three good friends, tireless workers all, who are daily

contributing to the betterment of Texas's rich wildlife heritage. They are Katharine Armstrong Idsal, Caroline (Cina) Alexander Forgason, and Ramona Seeligson Bass. Although Scott and I have come to know all of them through the enthusiastic offices of our dear friend Whitney Hyder More—also an ardent patron and worker for the Fort Worth Zoo—she is not included in the dedication as we have something special saved for her.

Katharine, a painter of considerable skill and strength, comes from a distinguished South Texas ranching family that has served our state and country well over the years. She is a mother of three and is married to businessman Warren Idsal, who shares her passion for politics and conservation issues and appreciates her independent spirit. As a current commissioner for the Texas Parks and Wildlife Department she is a savvy lady whom I see less and less these days because she is always on the road inspecting our vast parks system. She plans to visit every one of them by the end of this year. She is a hunter, and like Cina and Ramona, she sees hunters as an important part of a healthy wildlife program for Texas.

Strangely, I really don't remember exactly when I met Caroline Forgason—Cina to her friends. I think it was in San Miguel de Allende. I do remember that we hit it off immediately and sat and talked well into the early morning hours discussing just about everything from art to zoology. Like Scott and me, she is no ornithologist but has a good working knowledge of birds and wide experience gained from her world travels, her service on the board of The Nature Conservancy of Texas, and a lifetime as heir to a conservationist ranching tradition established long before it was fashionable on her family place, the mythical King Ranch. She has an almost girlish enthusiasm for the out-of-doors and wild things that is infectious. It makes me at times forget that she has a keen knowledge of conservation issues, a clear vision, and a toughness that can match Katherine's. Her husband, Mark, is a perfect partner for her as a hands-on, day-to-

day rancher with years of experience in land management issues.

And then there is Ramona Bass, the last on my list of dedicatees but who in so many ways ought to be the first, since I have known her the longest. A woman of inexhaustible energy and definite ideas about how things should be done, Ramona has taken on conservation causes that are international in scope, one of the most important of which is a ten-year captive breeding program for Africa's black rhino. Although she is an executive board member of the Fort Worth Zoo, she has labored like a field hand with great success to bring our zoo into the twenty-first century, making it one of the finest animal collections and education resources in the country. She is the guiding genius behind the zoo's remarkable forty-million-dollar "Texas Wild" exhibit. When it is completed in 2001, it will provide a much needed resource for educating not only kids but also grown-ups. By highlighting conservation issues that concern Texans, the Fort Worth Zoo also hopes to instill ideas that can be applied to the world as a whole. Ramona and her husband Lee, whom I have known since we were both kids, were instrumental in helping us launch *Of Birds and Texas,* and in fact several members of the Bass family were among the first patrons of our folio project, providing moral as well as financial assistance by purchasing early subscriptions when our project was little more than a dream.

"We're the three terrible South Texas ladies!" Ramona declared when I told her about our new bird book dedication. They have been good friends forever, so it seems more than fitting to honor them together for their dedication to saving and improving our rich ornithological heritage. Try as I might, I can't think of Katherine, Cina, and Ramona as the three "terrible South Texas ladies." But they are simply too dynamic to be called the three graces, so I guess the terrible ladies will have to do. Scott and I are truly fortunate to know them and to be able to officially thank them for their friendship and support.

ACKNOWLEDGMENTS

This book would not exist if Catriona Glazebrook, past director of the Texas Audubon Society, had not taken an interest in us and our work. My contact with her, tentative at first, became one of genuine friendship as she learned more about us, our paintings of Texas birds, and the mysterious folio we had produced more than a decade earlier. Catriona introduced me to Joanna Hitchcock and Theresa May of the University of Texas Press, and it was largely her doing that Scott and I were chosen to be the official artists to celebrate the 1999 centennial of the Audubon Society in Texas. I will always be grateful to her for rekindling my old enthusiasm and for setting into motion the events that led to the publication of this book.

Scott and I will forever consider ourselves lucky that we were able to collaborate with author John Graves on our original elephant folio and to have his essay included here as part of our new book as well. We have been honored to call John a friend since 1960, when we were introduced to him by Dutch Phillips, whose parents were John's boyhood friends on Fort Worth's west side. It was the same neighborhood, with adjacent woods and Trinity River bottoms, that we lived in and explored as kids. The year of our meeting marked the publication of John's best-known book, *Goodbye to a River,* which in many ways is as treasured a work of literature as Thoreau's book about Walden Pond.

I had the pleasure of attending one of John Graves's creative writing classes in 1962 at Texas Christian University. I could not then have even dreamt that one day Scott and I would actually co-author a book with John that would become something special in the history of Texas publishing. John is a cautious and wily sort. Though he showed genuine interest in our folio project when I first explained it to him and was supportive in his way, he did not commit himself until we had shown him the first twenty or so of our bird paintings. From that moment on, he became a quiet source of confidence and inspiration. Just simply knowing that he was working with us gave Scott and me hope that together we might actually create something that would prove

a work of literature as well as an attractive collection of paintings with commentaries. If our new book succeeds as well as our folio succeeded, John Graves will be in no small measure responsible.

Scott and I again wish to thank Harry Tennison for writing the foreword to our original folio, which is also included here. Both Harry and his late wife, Gloria, have played an important part in our lives since we were children. It was to Gloria's sister, the late Shirley Holmes, that our folio was personally dedicated. We have shared together with the Tennisons and the Holmeses many happy and sad times—experiences that forged a very special relationship. Harry is well known as a hunter and conservationist working with many world organizations to save endangered wildlife. As the founder and president of Game Conservation International he has sponsored many projects that have given back to nature far more than he has taken as a hunter. In 1989, I was with Harry and Gloria in Zimbabwe to observe the capture of black rhinos for a breeding program sponsored by the Fort Worth Zoological Association, which Harry helped to organize almost fifty years ago.

Although Ralph Carr's name is not on the cover of this book or the original folio, he has been an indispensable source of help from the very beginning and has at first hand overseen our book through all its incarnations. He has represented Scott and me off and on in Fort Worth for thirty years. I simply could not have carried out the many necessary and burdensome publishing duties without him.

Many thanks to David Wharton for his excellent photographs of our paintings for this book. He is the son of the late Bob Wharton, who did all the photography for our original folio. David has been a good friend and a valuable aid in much of our other work as well.

Deserving of our deep gratitude is Don Otto, director of the Fort Worth Museum of Science and History, which purchased all our original bird paintings from *Of Birds and Texas*. He has cooperated in every way by making the pictures available for photographing and also permitting the Texas Audubon Society to organize an exhibition of the paintings to tour the state in celebration of the Audu-

bon centennial. Our thanks also to museum curators Dennis Gabbert and Chris Hailey.

Since this book also contains the landscape paintings that were part of our original folio, we would like to thank those patrons who generously permitted their pictures to be used again. We also would like to thank the owners of the thirty or so watercolor bird studies, or remarques, which have been added to this new edition.

I would like to mention Garland and Mollie Lasater, who have been special friends of ours and our book project from the very beginning. As chair of the board of the Fort Worth Museum of Science and History, Mollie was a great help in balancing our interests with those of the museum.

Thanks to Shannon Davies for seeing the merit in our work and for helping me edit the new edition. I'm probably an ideal author for Shannon to edit; I have rarely disputed her suggestions, asking her instead just to make me look good and reasonably literate.

As far as the staff at the University of Texas Press is concerned, I would like to thank director Joanna Hitchcock and editor-in-chief Theresa May for their enthusiasm, not just for our bird book but for possible future projects as well.

Finally, I want to express not only my gratitude to but also my love for Nancy Ferguson, my companion for more than twelve years. I first met her on January 10, 1988, when she came to our studio to pick up a folio purchased by her grandfather, Harold Gish. I'm the last person to believe in love at first sight, but that's what it was. Since that day, she has been a constant source of inspiration and a great help to both Scott and me. She never gave up on the possibility of our one day publishing a trade edition of the folio. She has gamely put up with my artist's antics, possibly because she is a talented artist herself. A great lover of dogs, she has at times concentrated her considerable training skills on me—with modest success. She is a world traveler, a passionate hunter, and now an occasional taxidermist after having persuaded me to resurrect my own skills in that field, which had been dormant for almost thirty years. I am very fortunate to have her in my life, and I hope to spend the rest of my days showing her my gratitude.

OF BIRDS AND TEXAS,
AUDUBON AND US

Fifteen years have passed since my twin brother Scott and I published our elephant folio *Of Birds and Texas,* a book we dedicated to a man we never even met. His name? John James Audubon. As I look back, I can see the profound role he played in our development as artists, and I am better able to appreciate just how closely our publishing efforts in the most uncanny way paralleled Audubon's own experiences. Now, after all these years, our folio is being published in a trade edition, fulfilling a dream to make *Of Birds and Texas* available and affordable to readers everywhere. As a tribute to this event I offer the following account, gleaned from my written remembrances, of how in the course of creating our book we had the strangest encounter with John James Audubon himself.

Audubon is still a controversial figure, criticized by revisionist historians for his bloody deeds as a hunter and his less than honest approach to self-promotion. He is often taken to task by many contemporary wildlife artists and ornithologists for the melodrama and exaggerations of his bird portrayals and the anthropomorphism reflected in his written ornithological accounts. There is some truth to these criticisms, yet, in my opinion Audubon still remains the greatest American artist ever to paint birds. The understanding and full appreciation of his paintings and artistic legacy is a matter of taste and not of science. Still, no matter how his work is viewed, few will deny that Audubon's double elephant folio, *Birds of America,* with its 435 life-sized paintings in four massive leather-bound volumes, is among the greatest publishing monuments ever erected by art to nature, and that indirectly Audubon's most important legacy may be the famous organization which bears his name, the National Audubon Society, founded many years after his death.

Memories fade or can play tricks with the passage of time, so early in 1993 I began writing a memoir about the many adventures we experienced in the nearly ten years it took us to accomplish the ambitious task of privately publishing *Of Birds and Texas.* It took me nine months to write my memoir. For the first time since our book's August

1986 debut, I forced myself to dig back into the past through reams of correspondence and other materials. I wanted to record the story of our project in order to remember just how we were able with such modest means to create what many critics claimed to be the most stunning and prodigious book in Texas history. I also wanted to remember the mistakes we made and what a disaster it almost was, had our project and our lives not been touched personally in a most mysterious and wonderful way by the very man to whom we had dedicated our book.

Though I would have to do much research to remember the many logistical details of the project, our discovery and purchase of a long-lost Audubon painting and the part it played in the successful publication of our book is as clear in my mind as if it had happened yesterday. At the time, however, I had no idea just how intimately that discovery was to connect both Audubon's and our own destinies or how our book *Of Birds and Texas* would become directly linked to the two most important American bird books of the nineteenth century, Audubon's *Birds of America* and, surprisingly, Alexander Wilson's *American Ornithology,* the first great book of birds published in America. Before I discuss our encounter with the painting, however, I would like to tell of a far more important discovery, Scott's and my first encounter with Audubon's *Birds of America.*

John James Audubon and his book, *Birds of America,* came into our lives one November Saturday afternoon in 1956 as I was looking at bird books in the library of the Fort Worth Children's Museum. I was thirteen years old at the time, and I believe it was my first visit to the reading room, which I had discovered more or less by accident. As I was perusing several old books, a new volume caught my eye. It was a pristine copy of the Macmillan edition of British engraver Robert Havell Jr.'s prints created for Audubon's double elephant folio.

I had been interested in birds since I was at least four or five years old, and for the previous couple of years had been struggling to learn the art of taxidermy from a correspondence course, practicing on neighborhood songbirds which I often drew before surgery. I was aware of Audubon's name, of course, through the National Audubon Society and a few of his more famous bird plates illustrated, oddly enough, in the drug advertisements of my father's medical journals. I was quite unprepared, however, for the overwhelming impact of seeing all 435 Audubon plates together in one book! I was quite stunned when I turned to plate 206, the Wood Ducks, which I had never seen before. At that time the Wood Duck was

my favorite bird, and I had tried without success to draw and paint it many times from the few photos found in my modest ornithological library and from sketches I made of the Wood Ducks in the Fort Worth Zoo's waterfowl exhibit.

It was the beginning of a love for Audubon's work that has remained with me to this day. I took the book home, got some tracing paper, and began to make a pencil and watercolor copy of that wonderful Havell plate 206, still, in my mind, the most beautiful illustration of Wood Ducks ever done. I do not remember just how much painting I actually did before I was bogged down and quite frustrated at my clumsiness with watercolor. Enter brother Scott! He already knew how to paint reasonably well with watercolors. In fact, I was using Scott's tin of paints and brushes, which I had appropriated from his model train work table where he fabricated and painted marvelous little HO-gauge buildings and accessories for his train diorama.

Occasionally Scott would come over to stand behind me and make helpful suggestions which, of course, only made me more frustrated when I couldn't quite understand what he meant. It eventually became obvious that I was making a daub of the watercolor. I guess I wanted to have the painting badly enough to swallow my pride and ask my brother to fix it and finish it for me. What followed was literally the beginning of a long apprenticeship for Scott and me that would lead us both to careers in art.

It was Scott who finished that first Audubon copy, but by then I had already begun copying another Audubon painting, plate 246, of the American Eider. This time I attempted to do the painting the size of the actual elephant folio prints. Unfortunately, I figured the scale incorrectly, and my drawing turned out to be much larger than it should have been. It took me weeks to draw the eiders, but I do not remember if I ever touched a paint brush to it, for Scott had become so interested in the challenge of doing a large Audubon copy that he asked me if he could paint the picture. By the time he finished the eiders in the first months of 1957, he was already planning to do other Audubon copies, perhaps even contemplating the possibility of copying all 435 plates from *Birds of America.* He actually did do several more Audubons before his increasing interest in painting other subjects led him elsewhere. We eventually gave the Wood Duck painting to a neighbor, but we have kept the eiders to this day. It remained rolled up in a closet for thirty-six years but is now framed and hanging over Scott's harpsi-

chord. I sincerely believe that our lives as artists began with that painting.

By the time the eiders were finished, our father had bought us our own copy of the Macmillan book. We also began to bring home other books on Audubon from the public library and local book stores. Several of these have become our close companions over the years. We eventually acquired several very influential books by Audubon's finest biographer, Alice Ford, who not only wrote the best life history of the artist but also published books on his paintings of insects and mammals and even his 1826 journals. Stanley Clisby Arthur's 1937 biography, *Audubon: An Intimate Life of the American Woodsman,* was also carried with us on our many expeditions around the country tracing Audubon's peripatetic footsteps.

Our first "Audubon" trip was by bus on our own at age fourteen to Natchez, Mississippi. Scott and I had been there before at the age of ten, but that had been a family vacation. Natchez had history by the bucketful. We saw our first framed Audubon prints there hanging in the antebellum plantation houses, which were largely still unrestored in those days. We even saw an original Audubon, an 1820 view of Natchez done in oils, hanging at Melrose plantation. I guess Natchez was a place for firsts, because Scott and I also bought our first works of art there on that trip—three original Audubon animal prints, two of which we still have today. We spent all our food money for those prints and would have starved the last day of our trip if a kindly tourist hadn't bought us a meal.

When we finally got our drivers' licenses the following year, our parents let us borrow the family station wagon for improvised pilgrimages that took us to New Orleans and St. Francisville, Louisiana, where some of Audubon's best early work had been done. We then drove up along the Mississippi through Natchez again and other Audubon sites all the way to Henderson, Kentucky on the shores of the Ohio. It was here in 1810 that Audubon met the "father of American ornithology," Alexander Wilson, scouring the frontier towns for new birds to paint for his nine-volume *American Ornithology,* then being printed in Philadelphia. It was the first book of American birds to be published in this country.

Of course Wilson was also looking for subscribers. Audubon didn't sign on. Perhaps he could not afford to subscribe. He was an unenthusiastic and not very successful frontier storekeeper and married to boot. How he must have envied bachelor Wilson's freedom, and perhaps he began to have fantasies about some day publish-

ing his own book of birds. His bird drawings were still rather primitive pastels, but some of them were already showing a vitality that compared favorably to Wilson's birds. Audubon couldn't help noticing that the immigrant Scotsman was in frail health. Indeed, he had only four more years to live. Whatever Audubon's early ambitions there in Henderson may have been, he certainly could not have possibly dreamt of how magnificently he would one day surpass Wilson's work and how Wilson's legacy would haunt him throughout his career. One of Alexander Wilson's staunchest Philadelphian supporters, a man named George Ord, would become Audubon's most vehement and influential critic when Audubon's birds were unveiled to the world. But all that lay many years in the future. In the meantime he would have to endure business failure—even being jailed for debt—and the loss of every practical career option to be forced finally to focus on the development of his unique artistry and his unrivaled firsthand knowledge of the birds of America.

As Scott and I got older, birds continued to be of interest, though we produced only a few bird paintings during those years, and these were all original compositions. In our last two high school years, we, along with friends Tom Loffland and Dutch Phillips, established one of the largest collections of ornamental pheasants in Texas, which we had to give up when we went out of state to college. We gave a pair of Malayan-crested Firebacks and a pair of Himalayan Impeyan Pheasants to the Fort Worth Zoo, an organization that I have had the honor of serving as a board member for many years.

In 1961 Scott and I both entered Tulane University, the only school to which we applied, not just because it was a good school but because it was in New Orleans and in Louisiana, an area that we had come to love from our Audubon trips. It was at the Tulane library that we saw our first original Audubon folio on display. By this time I was not drawing or painting anything. Writing was my main preoccupation, especially short stories, while Scott was painting more than ever and exploring new styles and techniques. He enrolled in the art school at neighboring Sophie Newcomb College but was dissatisfied. College life with only part-time study of art was clearly frustrating. He was already beginning to investigate full-time art schools when a sort of deus ex machina decided his fate for him.

The Fort Worth Art Museum annually presented a juried exhibition of artists' work from around the county and always invited a nationally prominent artist or curator to judge the entries. The juror for that spring of 1962

was Walter Stuempfig of the Pennsylvania Academy of the Fine Arts in Philadelphia. Without Scott's knowledge, Emily Guthrie Smith, a prominent Fort Worth artist and family friend, took two of Scott's paintings to the museum to show Stuempfig. One of these was a small but exquisite original watercolor of a Black Tern. Stuempfig was so impressed with Scott's work that upon his return to Philadelphia he persuaded the academy's board of directors to issue Scott an invitation to come and study there in the fall. Scott went, and he remained at the academy until the winter of 1966.

I went on to complete my studies at Tulane and graduated in 1965. I spent one semester at Texas Christian University, which is where I had the opportunity to study creative writing with John Graves, who even then was considered to be one of Texas's finest writers. John, whose book *Goodbye to a River* has often been declared the finest book in Texas literature, would one day play a very important role in the creation of *Of Birds and Texas*. In my senior year at Tulane I began to paint and draw again and became deeply immersed in the study of the pre-Columbian cultures of the Americas. After graduation I bowed to practicality and decided to enter the University of Texas School of Law.

In the first week of attendance I knew that law was not for me, and I immediately applied to the Pennsylvania Academy of the Fine Arts. Because of the Vietnam War and the problem of maintaining a student deferment, I could not go to Philadelphia right away. I spent most of my last days in Austin as a lame duck law student painting, drawing, and copying a manual on the Aztec language which I found in the rare book section of the university's main library.

I did not enter the art school to join Scott until the fall of 1966. By this time I was an old man of twenty-three surrounded by whiz kid painters and draftsmen. Although still a student, Scott was rarely seen around the academy. After more than a year of making etchings on the same academy press that had once been used by Thomas Eakins and Mary Cassatt, he preferred to paint at home. Over the years his work had won great admiration at the school, and when he appeared on campus he was treated somewhat like a celebrity. He was a hard act for me to follow, and quite frankly I preferred to learn watercolor technique from Scott privately rather than follow the classes at school, which were more centered on painting in oils. During my student days at the academy I can remember Scott painting only one watercolor of birds, a pair of Pileated Woodpeckers from a specimen we found at art-

ist John Chumley's farm in Virginia. This painting would someday be one of our first published elephant folio size prints. Scott did not return to the academy with me in the spring of 1967, and I ended my academy days in late April in order go to India on a hunting trip with friend Tom Loffland.

Scott and I corresponded frequently during his first year at the academy, which was the first time in our lives that we had really been separated. I remember Scott writing to tell me of a strange and quite unexpected discovery he made one cold winter evening. He was attending a practice session of his amateur baroque orchestra at Old Swede's Church, a seventeenth-century building in the old town near the Delaware River. He happened to arrive early, just as the sun was setting. Since he was the only one there, he decided to explore the churchyard cemetery until the other musicians arrived. The graveyard was covered with fallen leaves, the tombstones overgrown with ivy. While strolling among the stones, Scott suddenly felt strangely compelled to stop and scrape the ivy from one particular grave marker. It was the grave of Alexander Wilson! Scott had had no idea that the Scottish naturalist was buried in this churchyard or even in Philadelphia.

There was another gravestone right next to Wilson's. Scott knew that the "father of American ornithology" had never married and had left behind no kinfolk in the New World. He pulled the ivy back. In the waning evening light he could barely make out the inscription. It was none other than the grave of George Ord, Audubon's sworn enemy. George Ord, it turned out, had been the executor of Wilson's estate and had once even owned the Audubon painting that we would discover while working on *Of Birds and Texas*. For Scott and me this was just one of several almost surreal confrontations with Audubon's past that would have a major impact on our lives and on our book.

For many years after we returned to Texas from Philadelphia, we concentrated on the painting of landscapes, portraits, and still lifes. Scott joined Valley House Gallery in Dallas and received a very successful response to his work. In just one month, more than five thousand people came to see his 1966 one-man show, a gallery record. In many ways our interest in Audubon's life was put on the back burner, though our love of his work never diminished. In 1966, *American Heritage* magazine came out with a two-volume set of photo reproductions of all the original paintings executed for *Birds of America*. It was the first time the originals had ever been published. The sight of them when compared to the Havell prints

OF BIRDS AND TEXAS, AUDUBON AND US

from the great folio was truly a revelation and to some extent rekindled our interest in drawing birds.

That renewed interest, especially for me, culminated in a series of large-sized pencil drawings of Texas birds for the Fort Worth Junior League in the '70s and early '80s to promote their Mayfest celebrations at a city park along the banks of the Trinity River. The series began with the first festival, and I was given very little time to come up with a suitable image for a poster. I suggested Trinity River birds, and this appealed to them. I went to our portfolios to see if we had something appropriate, and found a line drawing of a Green Heron, a local river inhabitant that Scott had partially drawn in the early '60s. I added the missing legs, shaded the plumage, and got the drawing to the league on time.

Scott and I signed the prints, which turned out to be quite a success, so much so that when the next Mayfest came around, the Junior League came to us again for another bird drawing. This time I drew a completely new picture—a pair of nesting Painted Buntings, which was an even greater success than the first poster. It rather started a tradition. In the following years I completed seven more Mayfest posters all based on my pencil drawings of Texas birds. The image size of these posters was twenty by twenty-six inches, a standard size for which ready-made chrome frames were easily available. Three of these posters I later colored by hand, very closely following the practice of Robert Havell's colorists when they added watercolor tints to Havell's black-and-white engraved and etched aquatint prints just off the press. Those three hand-colored posters, of the Snow Goose, Bufflehead, and Northern Bobwhite, became the first paintings for *Of Birds and Texas*. Thus, without realizing it, I had taken the first steps on a very long and arduous journey toward the publication of our own elephant folio, a journey which would eventually prove to be similar in so many ways to Audubon's own path.

In December 1977 Scott and I, in partnership with prominent Fort Worth architect and pre-Columbian art collector Mariana Thomas and childhood friend Dutch Phillips, opened a small art gallery on Boland Street in Fort Worth's museum district. It was called the New Gallery. To celebrate our opening we decided to issue two folio-size color prints of Texas birds, not only to call attention to our new place of business but also to capitalize on the tremendous popularity of the black-and-white Junior League posters. If these colored plates proved successful, we would issue two more bird plates every year or so until we had produced twenty-five color plates, which

we would then put into some kind of portfolio with a brief written introduction and description of the plates.

The first two prints were made from Scott's 1972 painting of Kentucky Warblers on an oak branch and my 1976 painting of a Harris's Hawk. The following year we published Scott's 1966 painting of Pileated Woodpeckers as well as my hand-colored Junior League print of a roosting covey of bobwhite quail, painted in 1978. At this stage we were painting all our birds with botanicals against stark white backgrounds, in the manner of most Audubon paintings. We would later abandon this approach to introduce completely painted backgrounds in all our paintings for *Of Birds and Texas*. The bobwhites painting would thus reappear in our book in its third and final version—with the addition of blue sky and an autumn landscape.

Our association with Dutch and Mariana lasted until 1981, when we amicably dissolved the partnership. Dutch and Mariana went on to build a handsome new gallery building across the street, while I purchased our little building and remodeled it into a small office and display space for Scott's and my art only. By this time Scott and I were talking almost daily about undertaking a major publishing venture involving birds, possibly even a book rather than simply a random collection of prints. The colored bird plates had proved so successful that people were constantly calling to find out when we would issue another set. We had always fantasized about publishing several books in our lifetime. Why not start with a book— a spectacular elephant folio—of bird paintings in honor of our childhood hero and spiritual mentor, John James Audubon?

Scott was skeptical at first. He well knew that the major burden of the actual painting would probably fall on his shoulders while I pursued the business and public relations aspects of the project. I am not sure whether we would have ever entertained anything more than a pipe dream if it had not been for a single event that quite unexpectedly happened to us in the spring of 1982. Travis Beck, an old college friend of mine who lived in East Texas, literally kidnapped Scott and me on the pretense of taking a day's journey to the Texas coast to witness the annual spring warbler migration near Port Aransas. The trip turned out to be a nine-day-long, twenty-one-hundred-mile bird-watching expedition to practically every geographical region of the state, many of which Scott and I had never seen before. We did not even have our toothbrushes or a change of clean clothes!

Beck, who never showed the slightest interest in birds when I knew him at Tulane, had become a dedicated

birder while serving as a Green Beret captain in Vietnam. He planned our abduction well. He packed everything we needed into the back of his camper—food, bedrolls, binoculars for each of us, everything to make us comfortable as we journeyed from the coast westward along the Rio Grande Valley to Big Bend National Park and then back home through the lower west Texas Panhandle. While I knew that Texas was inhabited or visited by more varieties of birds than any other state, now more than six hundred species, I am embarrassed to admit that it took just such an expedition to make me realize what a fantastic range of birds and habitats we had throughout Texas. With swamps, sea coast, coastal plains, prairie, desert, mountains, deciduous woodlands, and forests of pine, all part of a huge central flyway drawing migrating birds from both sides of the United States and from Canada, Texas was almost a microcosm of the bird life of North America. We would not be creating a book that was just about Texas. By painting birds that were also well known in the rest of the country while including examples unique to our state, we would be producing a book which would have a much wider appeal than simply to collectors of Texana. From the beginning, however, we hoped that any book we might create would be a completely Texas production, published in Texas as a collaboration of Texas artists and craftsmen.

That strange and unexpected trip around the state allowed us to see the wider possibilities of our project. Even before we got back to Fort Worth, Scott, who was becoming more enthusiastic, was beginning to toy with a possible title, "Of Birds and Texas." We explored other titles, but from the beginning and throughout all the many changes that we made to the original concept, "Of Birds and Texas" remained our favorite. We never seriously tried to change it.

Travis Beck liked the title. Besides his consuming interest in birds, he was a bibliophile and a serious collector of what are called artist's books, fine art limited editions of poetry and prose illustrated and autographed by internationally famous artists like Picasso, Matisse, and Salvador Dali. He had quite a collection. He also had become very knowledgeable about fine art book printing, and he was familiar with the Austin book world, a thriving group of publishers, rare book dealers, important librarians, printers, and binders. His knowledge of these connections was to aid us immeasurably when we published *Of Birds and Texas*. Travis actually introduced us to Austin printer David Holman and to bookbinder Craig Jensen, the very craftsmen we employed in the creation of our

book. For months after we returned from our birding expedition he continued in his own quiet and gentle way to urge us to aim higher than a portfolio of prints with some sort of text. He was aware that we knew John Graves, whom he regarded as the best writer in Texas and one of the best in the country. He constantly reminded us that a contribution by Graves would add a very special dimension to our book that would make it a truly exceptional work of art.

Patrick Bennett, in his book *Talking to Texas Writers* (1980), said of John Graves, "He is the writer most respected by other Texas writers." His 1960 *Goodbye to a River*, printed in thirteen languages, has long been regarded not only as a great Texas book but also as an American classic. He certainly would add an extra literary appeal that might attract the notice of critics and collectors both in Texas and outside the state. I had talked to John as far back as the late '70s on one of the rare occasions when he and wife Jane left their hardscrabble farm near Glen Rose and came into Fort Worth for one of our gallery openings. Always a cautious man, he seemed genuinely intrigued about possibly contributing an essay to whatever we might produce if we finally got our act together. He suggested that we give him a call as soon as we got a substantial number of bird paintings completed. He would come into town and we would discuss the project seriously.

The years 1982 and 1983 seem a blur to me now as I try to sort out the events of those days. The remodeling of our little gallery building into an office and showroom was done with the book project in mind. Although we continued to have small invitational shows there, we never really thought of the place as a gallery, since we were not really open to the public except by appointment. I worried that our space was simply too small to have a major exhibit of our bird paintings when the time came for us to debut the project. It was our intention to follow Audubon's example and exhibit our bird paintings to secure as many early subscribers as possible, which in turn would impress potential bankers when we went searching for financing. We also had hopes of attracting a corporation or wealthy collector to purchase the entire planned collection of forty bird paintings. The purchase price, along with a hefty number of names on our subscriber list, would, we believed, get us the loan we needed. The exhibit would simply have to be in a larger space to accommodate the number of people we wanted to attend.

My old friend and former agent Ralph Carr had just the sort of gallery space that we needed for such an open-

ing. He had always been an enthusiastic supporter of our work, and he volunteered his space without hesitation. By the end of 1983 we had about three fourths of the bird paintings completed or well under way. We also began to think seriously about a May 1984 debut at Ralph's gallery. Ralph in the meantime had proved most valuable with business advice, marketing insights, and project strategy. He eventually agreed to join the project as business manager, which relieved me of a tremendous amount of distraction and allowed me to attend to the bird paintings and the details of book design.

By May we were ready, as hoped, to debut our bird paintings and our proposed book project to the public. We were also fairly certain that we had worked out the basic design and format of our book. Before we moved the paintings over to Ralph's gallery, John Graves came into town to take a look. I remember him walking around our little gallery not saying anything as he examined each work carefully. Our bird paintings were hanging on every wall and lined up on the floor. After what seemed like the longest silence he turned to me, looked at me over his reading glasses, and said, "OK, what do you want me to do?" I told John that the essay was entirely up to him, that I didn't care if he even mentioned a bird. He now knew what we were doing. I trusted him to write something that would be an integral part of our book.

Scott and I by this time had definitely decided to write commentaries to accompany each of the colored plates. Since each plate was going to be preceded by a protective cover page anyway, why not use that page to discuss the picture, relate incidents of our growing up in Texas, and convey our lifelong love of both natural history and the work of John James Audubon. From the outset we had made up our minds to dedicate our book to Audubon. In our commentaries we could describe interesting details of Audubon's life and offer insights as to why we have always regarded his work so highly. Scott also suggested that we add ten color plates of our Texas landscapes to let the public know that we did other paintings besides those of birds. These landscapes would be placed in a separate portfolio along with all the introductory texts, including John Graves's essay. Another portfolio would house our forty bird plates with our personal commentaries. The two portfolios would then be placed within a handmade linen-covered box.

We arrived at the portfolio and box format as a result of suggestions from John Chalmers of the Harry Ransom Humanities Research Center of the University of Texas at Austin. He was introduced to us by Travis Beck in the

first weeks of 1983. Chalmers told us that a book of the size and weight we were contemplating would not hold the binder's stitching and would eventually fall apart. This view was also echoed by Craig Jensen, who was at that time the research center's young conservator. Both men showed Scott, Travis, and me a magnificent publication from the British Museum called "Bank's Florilegium" which had the same portfolio and box design that we were finally to use. Jensen would later leave his library job to become the "binder" for *Of Birds and Texas*.

On the same day that we visited the Humanities Research Center, Travis took us by to meet David Holman, whose Wind River Press was getting more and more recognition as one of the best fine art, limited-edition presses in the United States. His press room in a small outbuilding behind his house was so neat and clean that it could have been a hospital operating room. His presses were immaculate, highly polished, and surrounded by stacks of paper.

Over lunch that afternoon we talked to David about what we wanted to do. He told us that even though he had a small shop, he could handle the printing of the text by handset metal type without difficulty. The color printing was another matter. He simply did not have a color press large enough to accommodate that part of our project. I continued to visit David several times in the last months of 1983 to see him at work and to get some sense of the man and what it would be like to collaborate with him. He was only in his late twenties, somewhat youngish, I thought, for a project of this size and expense. There was no doubt that his work was highly thought of, but I had been warned by savvy book people that David's high standards were often a cause for costly delays in meeting deadlines. Later, I learned that such delays were standard practice in the field of fine art book printing. Finally, with some trepidation, I told David that I wanted him to design and print our text. By that time I had ceased to consider him as printer of the color plates, and I began to plan on farming out the color printing to several North Texas commercial printing companies at the same time. This would greatly speed up the color printing of our book.

Ralph Carr and I picked a Friday evening in May 1984 to publicly present our bird paintings at Ralph's Seventh Street gallery on Fort Worth's west side. Scott and I knew we were jumping the gun somewhat, since so many of our pictures were not completed to our satisfaction. But one of Ralph's greatest talents was his ability to read the social pulse of Fort Worth. Since he had joined our project

he had made a few tentative contacts with bankers and financiers who might be interested in becoming involved with us in some way. He had the gut feeling that we should take advantage of this enthusiasm while it was still fresh. He believed it was the right time to promote the project even if we were not artistically quite as ready as we wanted to be. Still, the paintings, even those which were not finished, were handsome and would make a good show and a good impression. I gave my consent and immediately began to design an appropriate invitation and book brochure while Ralph concentrated on the client mailing list.

The weather for that May evening of our opening could not have been more beautiful. There had been a considerable buzz about town concerning the upcoming show, and Ralph was constantly getting calls from people wanting invitations. On the night of the opening people began arriving an hour early, always a good sign. Most of them were holding copies of the illustrated brochure I designed describing our forthcoming book. We had mailed them out by the hundreds along with the invitations. By the time the doors officially opened, the gallery was filled with people. In fact it was packed. I am not sure what we would have done if the public response had been lukewarm. We were hopeful, but nothing had prepared us for this incredibly enthusiastic turnout. Ralph's large showrooms were jammed wall to wall with people. It stayed that way until well past closing time. More than ninety people subscribed that evening, some buying more than one copy. Two subscribers bought five copies each, and one Dallas client phoned in an order for ten copies. With a sales price of twenty-five hundred dollars per book, our project debut was a very successful one indeed. It gave us much needed confidence that our book would have genuine appeal and was commercially viable.

That observation was shared, I believe, by most of the guests. As luck would have it, several people who would later prove to be very important to our venture were there that night and had a chance to see the public reaction for themselves. John Graves was there. So was David Holman. One of the bankers who was to help us finance our book stayed all evening. And most importantly, the director of the Fort Worth Museum of Science and History, Don Otto, visited the show with several influential museum board members. This was the same institution, once known as the Fort Worth Children's Museum, where I had discovered that book of Audubon prints so many years before.

The general excitement attending the show and the fact that most of the social elite of the city were there

ordering copies must have made a profound impression on the museum people, because a month later the board of directors of the Fort Worth Museum of Science and History voted to purchase the entire Gentling bird painting collection. This purchase commitment, along with the many subscriptions we were obtaining, convinced a bank to loan us the money to publish *Of Birds and Texas*. I naively thought that we might even be able to get the book done by Christmas of 1985.

As I look back to 1984 and the events following the debut of our birds, it seems to me that I never had a single day when I was not involved in at least five or six different aspects of our publication. I am basically a one-project-at-a-time person, but it was not unusual to find myself talking with lawyers about contracts in the morning, meeting with Ralph or prospective clients in the afternoon, and working on the final book design or the text, or drawing bird compositions in the evening. I was also still doing some final remodeling of our little office building while we kept most of the bird paintings at Ralph's gallery for public display. Our afternoon strategy discussions at his place were centered on increasingly practical problems, like packaging design, as well as the storing and actual assembly of the boxes, with thousands of pounds of separate text and color plate pages. Just how were we going to organize more than 140 of those book-page containers so that we would be able to put the book together efficiently? Each one of those boxes weighed more than 120 pounds. These daunting problems of storage and assembly caused me more insomnia than any other problem except financing.

We had hoped to get our purchase contract from the Museum of Science and History within a few weeks of our show. This, of course, would then allow us to get the bank loan and publishing could begin. But such timely action was not to be. Our 1985 deadline was beginning to look more unrealistic and the day-to-day expenses of our project were mounting. We escrowed most of the money we made from early subscribers, but we did get permission from good friends to use some of these funds in trade for a watercolor study of a Texas bird painted on the title pages of their books—"remarques," all of which are being reproduced in this edition of the book.

By the middle of June, Ralph and I were talking to various commercial color printing houses in Fort Worth and Dallas. We even had a Dallas company print one of our plates, American Oystercatcher. We were so impressed with the work that we began negotiating a deal with this company and two others to do the color printing, with

each company reproducing an assigned number of paintings. All was going well when I received a long letter from David Holman. What he had to communicate was certainly a surprise. He offered to print not only the text but all the color work as well—and at a price well below what we would have to pay to the other commercial printing houses. If I agreed in writing, he would immediately begin to look for a color press and would be set up and ready by the time we got our bank loan. He pointed out that if our book was printed entirely by his Wind River Press, it would have a much enhanced prestige among finicky rare book collectors. For me that was the most persuasive part of his offer.

From the beginning I was always trying to upgrade the design and format of our book. Whenever there was a choice between saving money or compromising quality, I chose quality. Here seemed to be an opportunity to improve the status of our book and save money at the same time. David further sweetened the deal; he would enlist the services of his father and mother at no extra cost. Both William Holman and his wife Barbara were highly praised book designers and typographers in their own right. That they eagerly wished to be a part of this history-making venture was enough to persuade me.

Ralph and Scott were not persuaded. They felt that we had a much better chance to meet our very exacting deadline with the three printing companies doing all the color work simultaneously rather than relying on Holman, who did not even have the equipment in place. The cost of possible delays if David had problems acquiring a press or installing it could more than offset any possible savings we might have with his lower bid. Too many things could go wrong. We should not take any unnecessary chances. But I was adamant and I guess rather persuasive, because I got Ralph and Scott to acquiesce in favor of having the entire project done by a master printer. I mailed David a special delivery letter accepting his offer. For all the reasons given by Ralph and Scott, this was possibly the biggest single mistake I made in the course of publishing our book.

By the end of 1984 we had much to be hopeful about in spite of some annoying delays and other complications. The project was indeed gathering momentum. Perhaps too much momentum, for I sometimes felt as though events were moving too fast for me to meet my artistic obligations to the project, namely the completion of the introductory essays and plate commentaries and the composing and drawing of the few remaining bird plates. Scott kept a steady and unrelenting course working on the bird paintings; he was often at the drawing board sixteen hours a day—day in and day out. I saw to it that he had absolutely no interruptions. The only "rest" that I remember him having was when he stopped painting long enough to write some of the plate commentaries. It reminded me so much of Audubon's labors, so beautifully recorded in his journals.

In spite of our delays with the museum purchase contract, our written agreement with Craig Jensen for bookbinding and shipping boxes was ready to sign. John Graves was now at work on his essay, "Recollections of a Texas Bird Glimpser," and he too was ready to sign his contract. Our Austin attorneys had also drawn up David Holman's contract based on his July offer. It would be ready for his signature as soon as we got our bank loan, which was finally being processed on the basis of the Museum of Science and History's expressed intent to purchase all our bird paintings. All in all as we entered the Christmas season we had every right to believe that *Of Birds and Texas* was really going to happen. It was now mainly a matter of time and money. It had been quite an eventful year, but as Scott and I looked forward to a brief respite from project business in those last two weeks of December 1984, fate had one more surprise left for us.

I was enjoying one of those blissful nap time states between sleeping and waking when I heard the afternoon mail arrive. It was about two o'clock on a Saturday afternoon a week before Christmas. Scott was still asleep. I couldn't stop yawning as I sorted through the advertisements and other holiday junk mail, pausing now and then to open a Christmas card. I was thinking about going back to sleep when I noticed a small, nicely printed catalog from a place I had never heard of, the Philadelphia Print Shoppe. I almost put it down to read it later with the rest of the mail, but there was something about the booklet that drew me closer. I went to the window and sat down for a better look.

It was a calendar for the coming year of 1985, each month illustrated with a print or drawing for sale, mostly nineteenth-century works by Catlin and Currier and Ives, as well as maps, early American city scenes, and prints of birds and flowers. I was beginning to lose interest when I turned to the page for August. What I saw made me feel giddy, like I was descending in a fast-moving elevator. It was a small black-and-white reproduction of what appeared to be a painting of a pair of blackbirds. No, grackles. In fact Boat-tailed Grackles beautifully drawn in a very familiar style. I rushed to my painting table to get my glasses. The legend under the illustration read, "Great

Crow Blackbird, pen and watercolor drawing attributed to John James Audubon. Signed in an engraver's script, 'Drawn by John James Audubon from Nature.'" There was more information at the back of the catalog: "August—Probably John James Audubon's original drawing which was submitted to Charles Lucien Bonaparte for his Supplement to Alexander Wilson's *American Ornithology.* When Audubon sent this drawing to the publisher, it was too large for the engraver to transfer onto a copper plate. So Alexander Rider redrew the picture for engraving and credit in the book was given to both men. Watercolor and pen and ink on paper. $18,000."

This just had to be the painting that I had read about many times in all the Audubon biographies. If so, it was Audubon's very first scientifically published bird drawing! His anger over the way that this elegant grackle painting had been altered by Alexander Rider, a Philadelphia publisher's assistant, made him forsake America to seek a more skilled and sympathetic publisher abroad. The story was fresh in my mind because by coincidence I had written about this pivotal incident six months earlier in my first draft of our book's dedication to Audubon. But could this really be that very picture, not a fake or some sort of legitimate copy done in later years? Curiously there was a painting of a grackle egg in the lower right corner—an extremely rare element in Audubon's work.

Again my attention was drawn to the lower left-hand margin and that inscription reading "Drawn by John J. Audubon from Nature." The handwriting was difficult to make out in the small reproduction. It was a formal script like those used by engravers and did not resemble Audubon's regular signature. There was no doubt about the painting being in his style. It had the right look. The male grackle, the darker bird, was perched on a branch in such a way as to be somewhat superimposed over the lower female, squatting on her branch with tail raised. She seemed to me to be drawn in a noticeably earlier style reminiscent of Audubon's New Orleans work of the early 1820s. That the painting was described as being done only in watercolor and pen and ink also bothered me, since I knew that his work of that period often included the generous use of pastels as well as graphite pencil and egg white as a kind of varnish to highlight beaks, claws, and eyes and as a fixative for pastel.

I put the catalog down. In my excitement I wasn't really sure what to do. I did not want to wake Scott, who was resting from a painting schedule that had begun at five o'clock in the morning. I decided to take a walk up the block to cool down. What was I daring to think? Ac-

tually trying to buy that painting with the kind of money problems we had facing us? I walked outside without thinking about taking a coat. It was cold and windy, but I hardly noticed it. Buy the Audubon? It was crazy. Unrealistic. And surely somebody knowledgeable had seen the catalog by now and had grabbed the picture. It had probably been posted a week or two ago, what with Christmas delays in the mail. Such thoughts already made me feel a visceral sense of loss. But I kept thinking, if the painting was indeed the original Audubon in question, it would not only be his *first* published work, it would also be the *only* original Audubon bird painting in the world published in the artist's lifetime remaining outside a museum! I well knew that the New York Historical Society owned all the originals for his *Birds of America* and that there were few Audubon paintings of any kind in private hands. If the grackle painting was authentic, what might it be worth? Definitely more than eighteen thousand dollars. A whole lot more.

We already owned Audubon's handwritten manuscript on the Red-shouldered Hawk, plate 56 of *Birds of America.* We planned to publish it as the commentary to our own book's plate of this hawk, since it had never before been published in its original unedited version. Audubon would then be actually contributing commentary to our own book. To discover, prove the authenticity, and publish a long-lost and extremely important Audubon original bird painting, which would be published in our book for the first time as Audubon originally designed it, would give *Of Birds and Texas* an absolutely unique connection to the great bird artist! There was also the painting's potential value as, God forbid, collateral. Before I had even reached the end of the block, I had convinced myself that we had to buy it if at all possible. I turned around and ran back home.

The chances of our getting the painting, I knew, were still remote. It was Saturday afternoon. Most eastern art dealers are usually closed by this time, and, anyway, it would be amazing if some savvy collector had not already grabbed it. I could tell as I walked into the house that Scott was still asleep. I picked up the catalog and went straight to the telephone. I must have let it ring fifteen times. "Closed," I thought with a gnawing feeling of disappointment. I was just about to hang up when a man answered, obviously trying to catch his breath. He identified himself as Don Cresswell. He had indeed left the shop early but had discovered that he had forgotten something important and had driven back several miles to retrieve it. He could hear the phone ringing as he was fum-

bling for his gallery keys. Had I called a minute or two earlier or a few minutes later I would have missed him.

I identified myself and told Mr. Cresswell that I had just received his catalog and was looking at the curious little grackle painting that they claimed was an Audubon. I tried to sound professional, detached, mildly curious. Did he perhaps still have it for sale? Yes, he still had it. He was really very surprised that I had a catalog. He had only mailed it out the day before. Yes, it was indeed for sale, and I was the very first person to make an inquiry from the catalog. I was later to learn that William Reese, a prominent art and book dealer from New Haven and an Audubon authority, called Cresswell at his home late that same Saturday afternoon about the painting. By another odd coincidence Reese had delivered a lecture on Audubon in 1978 at Fort Worth's Amon Carter Museum. His subject? John James Audubon and his Charles Lucien Bonaparte connection, including Audubon's painting of the Boat-tailed Grackles. Reese later told me that if he had called the Philadelphia Print Shoppe first, he would have bought the painting on the spot.

I told Don Cresswell that I was rather puzzled by his description in the catalog, which stated that the grackles were done only in watercolor and pen and ink. Did he not detect any evidence of pastel crayon? He asked me to wait a minute while he went to get the picture, which was unframed. When he returned I could hear him unwrapping the tissue paper covering the work.

"You're right," he said with an almost childlike sense of surprise in his voice. "My partner and I had wondered what that surface was. It is so much more dense than just watercolor."

I asked him if he could hold the painting at an angle against strong light? He said he could.

"Are there any shiny areas that looked varnished?"

"Yes, indeed!" he said, now quite excited. The eyes, feet, and beaks all varnished!

"That may be egg white," I said. I did not tell him that the use of egg white or possibly gum arabic was a technique apparently unique to Audubon.

I then asked him if he could see any evidence of graphite penciling on the feathers to highlight the fletching? Audubon often did not have the time in the field or during his many travels on the frontier to add this touch, but if this painting was a special presentation piece meant to impress Bonaparte and others, he would have taken extra pains.

"I just can't believe it!" he said, now even more genuinely astonished and pleased. "I'm embarrassed that we

never noticed. It really is very elaborately penciled. My partner and I have always thought that we had an original Audubon painting here, but I'm afraid there simply is no concrete internal evidence to prove its authenticity conclusively even with this exciting evidence of Audubon's technique. The signature is certainly questionable."

He went on to explain that he had kept the painting around the shop for months, not offering it for sale until the Christmas catalog came out. He and his partner had always believed that their painting was genuine. What else could it be? With no clear and unbroken provenance and a questionable signature, however, they simply felt that they could not ask more than eighteen thousand dollars for it. He told me that after Christmas, if the painting had not sold, they were going to take it to an Audubon authority in New Haven to take a look at it.

I had heard enough to satisfy me. I told Cresswell that I was extremely interested in the painting. Could he stay in his shop for twenty minutes while I talked to my brother about a purchase? He said he would. I hung up the phone and went into Scott's room. He was already awake and had been listening to bits and pieces of my conversation.

"Take a look at this," I said, handing him the booklet. He put on his glasses. There was instant recognition. I told him about my conversation with the print dealer, especially his confirmation of the presence of pastel, egg white, and graphite on the drawing.

"What should we do?" I asked, barely able to contain my enthusiasm.

"Call him back," Scott said.

Scott and I discussed finances for a couple of minutes more. We knew that we didn't have nearly enough money at the time, but we might be able to scrape together an amount sufficient for a substantial down payment. If they accepted, it would give us time to somehow come up with the balance in a couple of weeks. We just knew that someone out there would soon see the catalog, would recognize the Audubon, and would have some idea of its worth. We thought that it had to be worth between two and three hundred thousand dollars. We worried that even if they accepted our offer, some wealthy collector out there might make them a better offer, too tempting to refuse. We knew we would be on pins and needles until the grackles were actually in our hands.

Cresswell picked the phone up on the first ring. Would he hold the painting for us until Tuesday, when he would receive our cashier's check for sixty-five hundred dollars as a down payment with the balance promised in two weeks? Yes, he would. I nodded affirmation to Scott who

was standing by the telephone. Suddenly he tapped me on the shoulder.

"Stu, if he has agreed, don't tell him to hold the picture. Tell him to consider it sold."

That was an important distinction. Cresswell duly noted it and agreed. He also mentioned that he had some additional information about the painting and the controversial Audubon–Rider print of it that had appeared in the Bonaparte–Wilson supplement of 1825. He would Federal Express it to us on Monday.

"By the way," he said, "would you mind if I went ahead and showed the painting to that Audubon expert in Connecticut?"

"Please don't," I said. "My brother and I want to research this painting on our own and test our conclusions later with the experts."

After I hung up the phone, Scott and I went back to his room to discuss how we were going to raise $11,500 in two weeks. We were both exhilarated that our offer had been accepted, but we knew that too much could happen in the next few days until our check was cashed and we had a receipt in hand. Our excitement instantly became paranoia. Somebody could yet get the painting today before we could act. After all, it would only be our word against Cresswell's. Scott was worried too that I had given him so many good clues as to the picture's authenticity that he just might want to keep it for himself.

What followed was one of the longest weekends of our lives. We both agreed that we could make the best of the next couple of days by going through our extensive library to find any material on Audubon that might be of help. We spent the rest of that afternoon and all day Sunday going through every book we had on the bird artist. We carefully reread the sections in the Alice Ford and Stanley Clisby Arthur biographies having to do with Audubon's 1824 trip to Philadelphia and his attempt via "our" grackle painting to enter the elite world of American scientific publishing. By the time we finished our research, we had made some new discoveries and had arrived at fresh insights which would help explain some of the mysteries that have intrigued historians about this important incident in the artist's life. One day I would tell this story as my commentary to plate 33, Great-tailed Grackle, in *Of Birds and Texas*.

AUDUBON IN PHILADELPHIA

In April of 1824, John James Audubon arrived in Philadelphia and rented some modest rooms at the corner of Fifth and Minor Streets. It was the end of a long and tedious journey by riverboat and shank's mare all the way from Louisiana. The City of Brotherly Love at the time was the leading center of science and learning as well as the most important publishing city in the country. It was here that he hoped to find patronage and a possible publisher who might present his work to the world. He had no clear plan about how to do either. He would improvise, introduce himself around town, and show his work to the local worthies, as he had done in Cincinnati, Saint Louis, Natchez, and New Orleans, and a hundred little towns along the way.

*The large tin boxes protecting his precious portfolios crammed with bird paintings were already waiting for him. As he opened them to see if they had made the journey in good condition, he must have been wondering just how he would be received in this cold northern city, once the home of America's most famous ornithologist, the late Alexander Wilson (1767–1813). Wilson's great achievement, his nine-volume **American Ornithology**, had been published there between 1808 and 1814. These were the finest books on American birds yet produced, surpassing Mark Catesby's charming but primitive work, printed in London almost a century earlier.*

Audubon was thirty-nine years old and practically penniless. By most standards measuring success at the time, he was an abject failure, and he knew it. But as an artist, he was no failure, for he knew that his paintings of birds were the finest yet created in this country or probably anywhere. And he was certain that he had gained in the field by direct observation a world of new knowledge and fresh insights about the birds of America which would render much of Wilson's work obsolete. In the presence of great or learned men, he tended to feel shy and diffident. He was self-conscious about his lack of formal education, thick French accent, and difficulties with the English language. Unfortunately, he often tried to mask these deficiencies with behavior that others thought arrogant and uncompromising.

So instead of assuming a humble demeanor as he faced the big city, he immediately made it known to all who would listen that he had come from the frontier with a new ornithological project that would surpass all the work done by Alexander Wilson and his armchair naturalist supporters. So certain was he of the value and obvious beauty of his

work that he just knew the paintings alone would be his best argument. He was being naive, however, if he thought that the very men whose reputations and personal fortunes were bound up with the legacy of the late Scottish naturalist would be open-minded or eager to embrace an expensive new project that might overshadow *American Ornithology.*

Philadelphia was a conservative city whose social and cultural life was controlled by a quiet, firmly established oligarchy. It did not take long for Audubon to be made painfully aware that the scientific and literary leaders of the city, with few exceptions, were firmly committed to Alexander Wilson and that any newcomer, regardless of the merits of his work, would be greeted with indifference or outright hostility.

Three of the most important of these men would decide to oppose him. The head of this anti-Audubon faction was George Ord, the close friend and biographer of Wilson and also one of the executors of his estate—and the man whose tombstone Scott found in 1962 right next to Wilson's in the graveyard of Old Swede's Church. He was a gifted naturalist in his own right, armchair or no, and he was exceedingly proud of the role he had played as editor of the eighth and ninth volumes of *American Ornithology.* Ord's close ally was Alexander Lawson, the finest engraver and printer in Philadelphia. He had worked closely with Wilson to produce the etched and hand-colored plates for all the Wilson books. His interest in *American Ornithology* was more than an artistic one. Like Ord, he owned a percentage of all royalties from sales of that publication.

Titian Peale was the third member of this establishment to oppose Audubon. He was the son of the celebrated Charles Wilson Peale, whose museum, housed on the second floor of the old Independence Hall, was the most famous institution of its kind in America. Though he considered himself to be primarily a naturalist, and no armchair naturalist at that, the twenty-four-year-old Peale was already making a name for himself as a painter of natural history subjects. In fact, he was presently engaged as the primary artist for the four-volume supplement to Wilson's *Ornithology,* being published by Ord and Lawson at that time. Apart from being a member of the famous Peale family, the young Titian had another genuine claim to fame. He had been overland to the far west, all the way to the Rocky Mountains, as a participant of the celebrated Long Expedition of 1820.

A fourth man, Charles Lucien Bonaparte, was initially in the Wilson camp but would eventually become an admirer of Audubon's pictures and would try in his own way to befriend the artist. Prince of Canino and Musignano and nephew of Napoleon Bonaparte, Bonaparte was only twenty-one years old when he met Audubon, but he was well respected in scientific circles here and in Europe as a gifted ornithological taxonomist. It was Bonaparte who was sponsoring the publication of the four-volume Wilson supplement and underwriting its cost. Most biographies dealing with this important period of Audubon's life have sympathetically portrayed the young Bonaparte as a man caught between what would become the Wilson and Audubon camps.

As soon as he could find a public venue to rent, Audubon, with the help of a few supporters to whom he had carried letters of introduction, set up a small exhibit of his best paintings for the Philadelphians to see. He was buoyed by the generally warm reception of his work by the public, so much so that he began to make critical statements about Alexander Wilson's birds. George Ord made his hostility to Audubon and his work clear from the moment of their first meeting. Ord considered Audubon to be no more than an undisciplined amateur. He was especially critical of the artist's singular approach to the painting of birds amidst botanical arrangements drawn from their natural habitats. To Ord the addition of flowers and botanical drawings—and even full landscape views—were nothing more than romanticized distractions that violated the scientific purity of bird illustration. Lawson and Peale were of the same mind. In fact, Lawson went a step further, telling Audubon that his work was too soft and painterly to be translated through etching and engraving. He suggested that he should look to the examples of Wilson and Peale and follow the practice of depicting his birds in more or less strict profile, preferably on a single branch uncluttered by superfluous flora decoration. If Audubon had seen Titian Peale's work by then, he must have found it almost impossible to keep from laughing out loud. Peale's work was primitive. He wasn't even as good as Wilson.

Charles Bonaparte wanted to be more sympathetic to his fellow emigré Frenchman, but he needed the goodwill of Ord, Lawson, and Peale in order to accomplish his aim of publishing the Wilson supplement. How could he encourage the bird artist without threatening his collaboration with his Philadelphia colleagues? Audubon's paintings might not display the scientific purity demanded by Ord and Lawson, but they did exhibit an undeniable skill and sophistication not seen before. Besides, unlike poor Wilson, who was lying in the graveyard at Old Swede's Church, Audubon was still very much alive and thus available for future projects. In spite of Lawson's flat refusal to print Audubon's work, the prince believed that Lawson would defer to the wishes of his royal

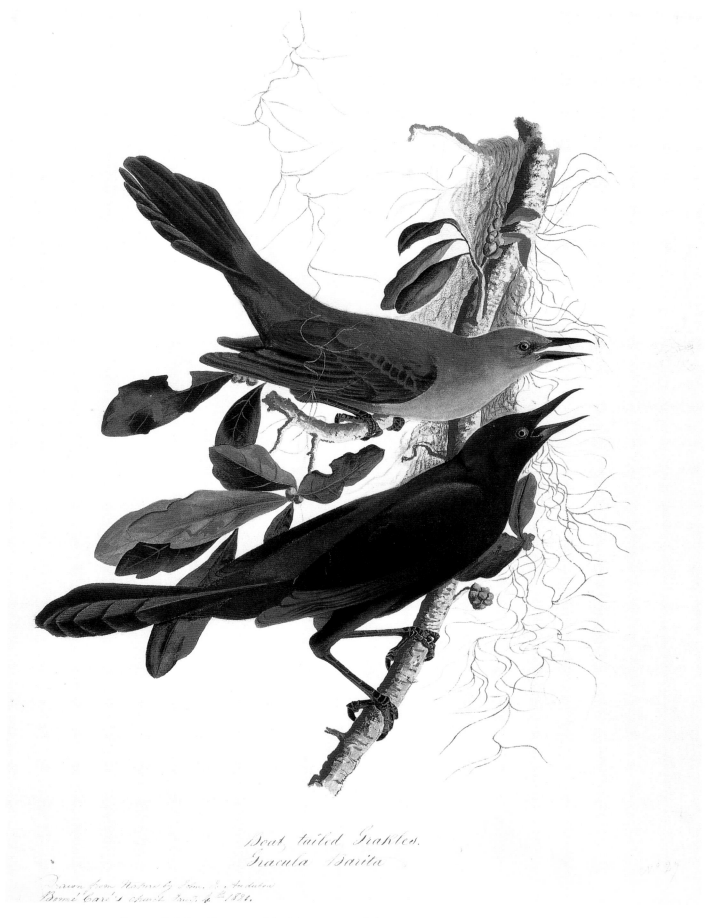

Boat, tailed Grakles.
Gracula Barita

Drawn from Nature by John J. Audubon
Bonné Carré's church Jant. 4th 1821.

Boat-tailed Grackles painted by John James Audubon at Bonnet Carre's Church, Louisiana,
January 1821. 1863.18.032. Collection of the New-York Historical Society.

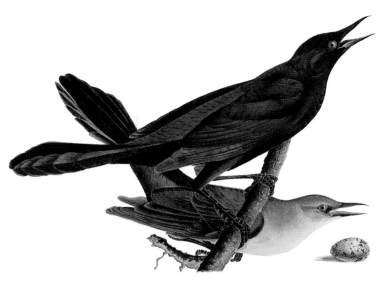

Grackles revised by Audubon for Charles Lucien Bonaparte in Philadelphia, May 1824. Rendition by Scott Gentling. Collection of the authors.

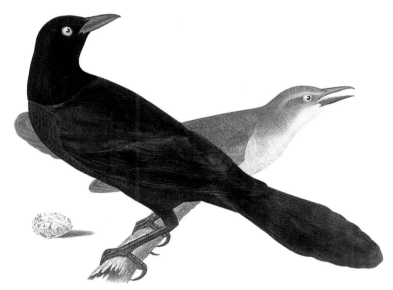

Engraving for the grackles plate in volume 1 of the Wilson supplement. Both Audubon and Alexander Rider received credit. Collection of the authors.

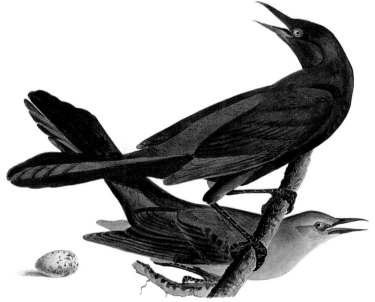

Audubon's grackles revised by Stuart and Scott Gentling to fit the plate size of the Wilson supplement. Collection of the authors.

benefactor if Audubon could be persuaded to compromise somewhat and submit an illustration basically conforming to the printer's demands. With this in mind Bonaparte paid a visit to Audubon's lodgings one afternoon in May.

The prince's visit was well timed. In the month that Audubon had been in Philadelphia his fortunes had sunk to their lowest ebb. He was not just penniless now but in substantial debt. The small exhibition he had held to raise funds to pay his expenses had not been financially helpful in spite of the praise he received from some quarters. Nor had he been able to attract a sufficient number of paying students to satisfy his growing list of creditors. It was true that he had made some sincere friends among the art and science community in the city. The prominent painter Thomas Sully and the naturalist Charles Alexander LeSeur became staunch allies. And there were others as well, but the warmth of these friendships was scarcely an antidote for the venom of those self-appointed philosophes, Ord and Lawson. As Bonaparte inspected the paintings in Audubon's portfolios that May afternoon, the bird artist must have been ready to accept any proposal that might get one of his bird drawings in the supplement and the name of Audubon out to a wider public.

A painting of a pair of Boat-tailed Grackles perched in a live oak tree festooned with Spanish moss caught Bonaparte's eye. It was a picture Audubon had painted more than three years earlier on a flatboat moored at Bonnet Carre Church a few miles above New Orleans. Wilson had not illustrated this distinctly southern species. Would Monsieur Audubon be interested in redrawing these birds on a smaller sheet of paper conforming to the plate size of the supplement? Would he place them on a single bare branch in accordance with the other birds in the Wilson books? For once Audubon's fierce pride did not get the better of him. He knew he had little choice if he were to show anything for the long trip east. He answered that he would repaint the picture if Lawson or others would make no changes in the new work. The prince agreed and offered the artist twenty-five dollars for the picture, a substantial sum for such a small commission, which the prince hoped that the artist would regard as a sign of respect and not charity.

Taking his time over the next few days, Audubon put all his skill and refinement into the new grackle painting even though it was smaller and more austere than the picture he had done in Louisiana. He followed strictly the measurement of the plate size provided by Bonaparte, and he eliminated any background elements that might offend Lawson or Ord. In the lower right-hand corner, he added a new element, a life-sized, brown speckled white grackle egg to make the picture scientifically harmonize with the Wilson plates,

several of which had illustrations of eggs. He accepted the fact that what was about to be his first published bird painting, his publishing debut, was in essence a compromise of the very qualities by which he had hoped to establish his own reputation. He thought that, besides getting his name before the public in an important scientific publication, he just might placate Lawson and perhaps even Ord. As far as Titian Peale was concerned, these elegant little grackles, compromise or not, were beyond anything the marginally talented young Philadelphian had done or ever was likely to do. And the public would see the difference.

Lawson certainly noticed the difference. So did George Ord. Because Bonaparte, who was paying the bills for printing the supplement, gently insisted on the inclusion of the Audubon in the book, they had to do it. From the outset, though, they were determined that the public would never get a chance to appreciate Audubon's stylish refinements or be able to compare his grackles with the rest of the paintings in the supplement. It was more than a year later when Audubon, then back with his wife Lucy and his two sons in Louisiana, received his copy of the new Wilson supplement. He was outraged. The basic image in the book could be recognized as his by anyone who had seen the painting he presented to Bonaparte, but his simple, elegant three-quarter view of the male bird had been replaced by a stiffly posed, thick-legged bird whose body, now in strict profile, was pointed in the opposite direction with its head looking over its shoulder. The female was clearly based on his original drawing, but it, too, lacked any of his customary subtlety and looked like it had been done by a different hand.

The plate was insulting enough, but to add further injury, a phrase was engraved in the lower left-hand corner which read, "Drawn from Nature by John J. Audubon and A. Rider." Another artist had reworked his painting and was sharing credit for it. But that was not its real message. This was an obvious effort by Lawson and Ord to embarrass him before the scientific community. Readers would be forced to assume that Audubon's painting had to be "corrected" by another hand to make it scientifically suitable for publication. The insult was deliberate and public and aimed to minimize this contribution to the Wilson supplement, small as that was.

Audubon immediately wrote to Bonaparte to express his outrage, and the prince responded by offering a rather lame excuse. Lawson had informed him that Audubon had not correctly followed the plate dimensions that Bonaparte had dictated so that the grackle painting was an inch too long to be engraved in its original format. Since Audubon had already left Philadelphia and was not available to make revi-

sions, and the prince knew that he would have resented it if Titian Peale had been asked to make the needed changes, Bonaparte went out of his way to bring in a new artist, Alexander Rider, to do the work. It was either this or Audubon would have to be excluded from the book, and the prince certainly did not want to deprive him of this important opportunity. Audubon immediately saw through this excuse. Alexander Lawson, a master printer, could easily have made the few adjustments that would have preserved the basic shapes of the birds and the elegance of Audubon's superior drawing style.

Audubon had learned some hard lessons in Philadelphia that were to have a profound impact on the way he was to conduct himself with fellow scientists. Getting proper credit was the name of the game in the small world of science and publishing. And having control over one's work was just as important. He would never let others dictate his fate again. The ill treatment he received at the hand of the Wilsonites convinced him that there was not enough room in America for two major ornithological publishing projects. If he were to make a name for himself and get his work before the public, he would have to go to Europe, where there were enlightened minds, established patronage, and engravers and craftsmen of great skill capable of bringing to the world the kind of book that he was now formulating in his mind, a book that would surpass every ornithological publication yet produced. But how? He was utterly without means. Oddly enough, it was Bonaparte and a Philadelphia printer named Fairman who first suggested that he could get his glorious bird compositions published only in Europe. When Audubon asked the prince if he would consider underwriting the cost of a trip to Europe to find a publisher, Charles Lucien Bonaparte, Prince of Canino and Musignano, politely declined.

From where he now stood, back in Louisiana, his horizons must have appeared bleak indeed. He had returned to his beloved Feliciana woods as a failure. He had no money and no prospects. He could barely think of his past bankruptcy and the jail time he had served for debt without breaking into tears. His sense of manhood had been sorely tested, because he often was unable to support Lucy and their two sons and, in fact, frequently had to live off his wife's earnings as a tutor and nanny to the children of the nearby plantation owners. He earned what he could by doing portrait drawings, teaching the violin and flageolet, and serving as a dancing master. But when the pressures became too great or when the woods beckoned, he would drop everything and disappear for hours or even days into the cane breaks and loblolly thickets in search of adventure and new birds, often earning the undisguised contempt of the local gentry.

Still, one thing remained constant—his faith in his own abilities. He knew that his paintings of birds were unrivaled and that, in spite of his limited scientific training, his first-hand knowledge of the lives and habits of American birds was not shared by any living artist-naturalist. But how could he earn the respect or even the attention of men of science and letters in the Old World when he could not do so in his own adopted country? He and Lucy would get the money for Europe somehow, and he would go forth armed only with his beautiful paintings, some precious letters of introduction, and a granitelike determination to face whatever fortune had in store for him. He was determined to overwhelm all existing bird books, not just now but forever, with a monumental creation that would include **all** the known birds of America. And what is more, each bird would be depicted life-size, from the largest crane to the smallest hummingbird. Such a work would have to be printed on double elephant folio pages measuring 26½ inches by 39½ inches, an awesome format never before contemplated, and there would have to be more than four hundred of these hand-colored plates! The sheer audacity of it might get him the attention he needed.

It would be almost two years before he and Lucy would have enough money for him to make the trip to Europe, his first step toward eventual fame. After a false start with a printer in Edinburgh, he settled on a London printer who was to handle the entire folio project, establishing his own fame in the bargain. His name was Robert Havell Jr. There in his London shop between 1827 and 1838, Audubon's great **Birds of America** was born. Havell and his team of printers and colorists employed a special combination of engraving, etching, aquatint, and hand coloring to produce prints with an incredible range of light and dark values, textures, and softnesses, the very painterly qualities that Alexander Lawson had pompously proclaimed impossible to reproduce. Havell's work and **Birds of America** would be universally recognized as the highest printing achievement of the nineteenth century and one of the greatest books ever. Audubon could not have prayed for a better answer to the snub he had received in Philadelphia.

Although he achieved fame and acceptance far beyond his highest hopes, John James Audubon was rarely far from controversy. For example, he was never able to settle his differences with George Ord and company, and these seemed to become more bitter with the passing years. Ord even went to the trouble of denouncing the bird artist to his scientist friends in England and on the continent. With Charles Bonaparte, Audubon remained cautious and occasionally obsequious in his correspondence, while in private he never forgot the in-

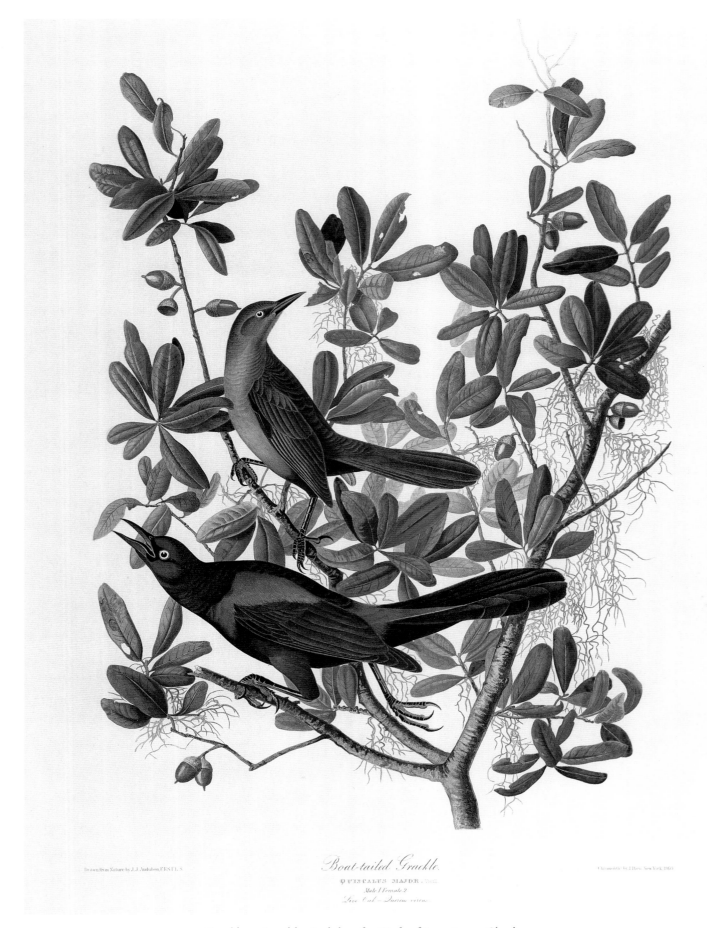

Boat-tailed Grackle.
QUISCALUS MAJOR.
Male 1 Female 2
Live Oak Quercus virens

Grackles painted by Audubon for **Birds of America** *at Charleston,
South Carolina, 1832. Bean Print. Collection of the authors.*

jury by Ord and Lawson that Bonaparte had silently permitted. His treatment in Philadelphia had given him an unforgettable initiation into the dog-eat-dog world of science and publishing, where achieving proper credit was paramount. For the rest of his life he would fiercely promote and guard his professional reputation, often becoming quite niggardly about sharing credit with deserving collaborators.

*More projects lay ahead for Audubon until his death, perhaps from the ravages of Alzheimer's disease, in 1851. His commentaries to his bird paintings, in **Ornithological Biography**, were published in London between 1831 and 1839. In the United States, with the help of sons Victor and John Woodhouse Audubon, he published the small octavo-sized edition of his birds with text (1840–1844) as well as the famous **Viviparous Quadrupeds of North America** (1845– 1848). Both these later works were produced in Philadelphia and to great critical acclaim, a fact that must have brought much satisfaction to Audubon as time went by—and more than a little revenge for 1824. He would never forget how he and his art had been treated, though in the wake of all the adulation of his later years down to the present day, his little grackle painting and its curious story passed from the scene and was all but forgotten.*

I am glad that Scott and I had our hands full doing Audubon research after our fateful call to the Philadelphia Print Shoppe. The activity helped to calm our nerves, though paradoxically the more we read, the more we realized how important the grackle painting was, if authentic. Every time the phone rang we just knew it would be bad news from Philadelphia. But no bad news came. On Monday as soon as the bank opened we arranged for a cashier's check to be made out to Don Cresswell; then we immediately took it to the post office to send by overnight express mail. We were profoundly relieved when we received a large manila envelope in the express mail that Tuesday morning. As I was signing for the package the phone rang. It was Chris Lane, Don Cresswell's partner, informing us that they had gotten our check and had deposited it. The painting was now officially ours and would be shipped to us as soon as they received our final payment in two weeks. A receipt for our deposit would arrive by express mail on Wednesday. Now all I had to do was come up with $11,500 in fourteen days! While we did not yet have the painting in our hands, and anything could happen to keep us from getting it, I felt a great relief. At least one major plateau had been reached.

When I hung up from talking to Chris Lane, I came back into Scott's room. I was almost jumping up and down with the feeling of victory. I was talking so much I didn't notice that Scott wasn't paying any attention. He was sitting motionless on his bed, leaning forward to examine something under his painting light. In one hand was an eight- by ten-inch glossy color photo of our grackle painting; in the other hand a xerox of the infamous Audubon-Rider print that had been published in the Wilson supplement.

"Look here," he said in a low, serious voice.

I bent over into the glare of the light.

"See the two grackle eggs?"

I could plainly see that Audubon's original egg drawing had been moved from the lower right-hand corner of the painting and redrawn in the lower left corner of the print. The egg's image had been reversed, as is often the case with an etched reproduction. This reversal was a good hint that the etched image had been copied directly from the original drawing. But that was not what Scott wanted me to see. Suddenly it was there right in front of me, the internal evidence we needed to authenticate our painting! The eggs were the reversed images of each other. Their brown markings or specklings were exactly mirror images. If you knew nothing about birds, this little bit of evidence might slip right past you, but ornithologists know that in the world of birds speckled eggs are like fingerprints; no two are marked alike.

Even though the matching eggs were our best evidence, we had found other important clues in our library that previous weekend. We had been intrigued from the beginning about the writing on the painting. Whether or not the handwriting was Audubon's, it was the way it was worded that merited study. "Drawn by John J. Audubon from Nature" was not his usual word order. He almost always wrote "Drawn from Nature by John J. Audubon." Did that conclusively mean that another hand had written the phrase? We decided to go through our entire *American Heritage* two-volume set of reproductions made from Audubon's original paintings. We read every one of Audubon's own handwritten inscriptions for all 433 paintings for *Birds of America*.

Several hours later, when we were finished, we had found only seven examples of the use of "from Nature" at the end of the inscription. A couple of those examples were very interesting indeed. Four of the paintings had been painted in New Orleans in 1822. The remaining three had been painted in Philadelphia in April and May of 1824, which is when our grackle painting was painted. One of the Philadelphia paintings was of a pair of Tree Swallows in flight. There is a lightly pencilled floating

feather to the viewer's right. In the lower left corner, incongruously painted against the white background, is a single swallow's egg. As with the egg in our painting, there was no logical pictorial relationship to the rest of the composition. The eggs were just there. It was obvious that the eggs in both paintings were included in Audubon's works to enhance them scientifically, as Alexander Wilson had occasionally done in *American Ornithology*. Another swallow painting by Audubon also had a similarly included egg—plate 68 of the Cliff Swallows, begun in 1820 and augmented possibly around 1825, according to *American Heritage*. Scott and I had every reason to believe that the egg was added in Philadelphia in 1824. We later read that Audubon went on to New York City after his Philadelphia stay to deliver a lecture on the migration and habits of swallows at the prestigious Lyceum of Natural History. Thus we had two swallow paintings, each made more scientific with the addition of an egg illustration.

All in all, we had every reason to believe that we did have an original painting by John James Audubon and now could prove it. We managed to raise the balance of the money in time to make the purchase complete by asking several of our subscribers to *Of Birds and Texas* if we could use their deposit money. In a very real way our book made it possible for us to buy the Audubon, and in fact if it weren't for *Of Birds and Texas,* we would never have known about the little catalog with the grackles inside. Our older brother Peter had played a role, too. He had become interested in Audubon prints because of our book project, and while purchasing several from the Philadelphia Print Shoppe as well as a bound book of original Wilson prints, he had placed our names on the Print Shoppe's mailing list.

Our painting arrived by UPS on the afternoon of January 10, 1985, the very day we signed our loan agreement at the bank. By coincidence it was the first month of the bicentennial year of John James Audubon's birth. I let Scott unwrap the package. He slowly opened the foam cord portfolio, pulled back the tissue paper, and held the painting to himself just out of my sight in a mock, teasing way. He took his time, enjoying my obvious impatience. He then slowly handed it to me with a very knowing smile. Suddenly, here it was in my hands, this important fragment of the great bird artist's remarkable life story, a ten- by fourteen-inch piece of paper, somewhat yellowed by age but with images still remarkably fresh, clear, richly colored, and pure Audubon. You could tell that the paper was very old. It even smelled old, with more than a hint of mustiness that reminded me of the antebellum houses of Natchez that Scott and I first visited as boys. This was the very painting that had caused him so much pain and that had spurred him to go abroad to publish his monumental *Birds of America*. Yes, his first published bird painting and probably the only one in the world published in Audubon's lifetime still left in private hands. For almost twenty years we had been fascinated by John James Audubon and had made his life and art a major study in our own lives. But somehow his history was almost like a fable, made distant and abstract by the passage of so much time. Now, here in my hands, here in Scott's bedroom, was something that made Audubon's existence very real and tangible. I had to admit to myself that there was something unsettling, even a little depressing, about the experience. It was as if we had come to the end of a journey of two decades; it was also as if we had somehow intruded into his life.

In the months ahead there would still be the problem of getting an official authentication for the painting from experts whose opinion would be respected. I managed to call or write a number of important dealers in nineteenth-century American art, offering the information that we had gleaned from our own research. They all responded with enthusiasm and congratulations. I received a return letter in April from none other than William Reese of New Haven, who would have bought the painting had he contacted the Philadelphia Print Shoppe before me.

He wrote, " . . . I once more admired the photo of the Audubon. I really don't think there can be any doubt, although I still want to see the original to be sure, but it is so distinctive a piece that I can not imagine anyone else doing it. It also fits so perfectly with the whole Audubon-Bonaparte story and the published print in Bonaparte's work that it must be right. Do get ahold of a copy of the *Prints of the American West* and read my article [the paper Reese delivered in Fort Worth in 1978] . . . This picture is plainly a further major piece of evidence in the alteration of the original by Audubon in the print as it appeared. . . . I really congratulate you on getting this piece; I only wish it had been me."

Reese's approval was reassuring, but Scott and I knew there was one institution in the United States whose opinion would not be questioned, The New York Historical Society in New York City, which owned all but two of the original paintings for *Birds of America*. The paintings had been sold to the society in the early 1860s, more than a decade after Audubon's death, by Lucy Audubon, who was in desperate need of money. She was paid only six thousand dollars. In the bargain the society also acquired

a host of other Audubon watercolors of birds and animals as well, including the first 1821 version of the grackles, painted in Louisiana, from which our painting was made. This earlier painting had never been published, so it was only my guess that our Bonaparte grackles had been made directly from that 1821 work.

Carol Anne Slatkin, assistant director of the New York Historical Society, responded quickly and enthusiastically to my packet of photos and information. She felt certain that the painting was good, but in order to officially authenticate it she would have to look at the actual painting. The bank that had taken possession of the painting shipped it to New York for her to examine. My brother and I could not have wished for a better endorsement. Not only did she declare the painting genuine, but went on to confirm that our grackles had indeed been copied from Audubon's unpublished 1821 painting, done on the flatboat above New Orleans. Ms. Slatkin's letter offered additional insights about how our painting and the Bonaparte-Wilson supplement print influenced Audubon's final 1832 version of the grackles that was eventually published in *Birds of America.*

She concluded her letter: "I'm sure I hardly need to repeat what an impact there is when one sees all three Audubon Boat-tails next to one another and the *Birds of America* engraving. The New York Historical Society does not own three versions of any other Audubon watercolor—not to mention one which figured so prominently in Audubon's career, and in the playing out of American nineteenth century natural history—and it is a remarkable experience to observe the phenomenon . . . Scholarship is rendered all the richer by the discovery of this missing link in the Audubon oeuvre, and I am deeply grateful to you for providing me the opportunity to see it. If I can be of any further help with the picture, I hope you will not hesitate to call me."

With this letter from the center of Audubon studies, we now had the official authentication we needed. Our painting's authorship would never be questioned again.

As I look back on those eventful days, I think of 1984 as a year of guarded optimism in which our dreams of one day publishing a monumental book on Texas birds were given a practical form and direction. What had begun as almost a fantasy had become a real project with a life of its own, a complex collaboration of artists and craftsmen pursuing a definite goal. Our impossible dream was now really possible if only we maintained the will and the resourcefulness to overcome the many hurdles that lay ahead.

Time and space will not permit me to tell of all the many crises that we were to survive in 1985. True to Ralph and Scott's warning, David Holman ran into complications with his new color printing press, which was really a used press. We also had some major difficulties concerning our contract negotiations with him as he began to realize that perhaps he had made too low a bid to do all the color printing. By the time we finally had an agreement, we had already begun to negotiate with another nationally renowned printer. We lost so much time and money while haggling with David that by the time we came to terms, our budget was already seriously compromised. When our bank loan was finally approved, we already knew that it would not be enough, but now there was no turning back. We had promises to our subscribers to keep. We were committed to Holman for the color work, and we were not to see a single color plate until July, some five months later.

In the meantime there were paintings to finish as well as plate commentaries to write. I also had to complete my revision of the dedication page to Audubon and compose an introduction of substantial length, an onerous task considering my other responsibilities. To do the foreword I had chosen Harry Tennison, president of Game Conservation International and an old and dear friend. John Graves too was still plugging away down on his farm near Glen Rose, Texas. All this writing had to be finished, edited, and proofed in time to be sent to San Francisco, where it would be roughly set in metal type, which would then be shipped to David Holman, who now had an impressive new studio in an industrial park outside Austin. I should mention that we had already chosen for our book a beautiful paper called Mohawk Superfine. It was specially milled for us to allow for more velvety blacks and dark colors than is usually found with most acid-free papers. It was expensive.

Increasing costs inevitably became the most pressing of all our problems, and it was frustrating to see our available funds begin to shrink away while we still had no tangible results for money already spent. After that first five-month delay in beginning the color work, only two plates were printed before worked stopped again as David completely disassembled his press and put it back together. We knew that we were going to have to raise more money sooner or later. It turned out to be sooner. By the end of October I could not meet a large payment required by the Holmans and the Holmans' color separators in San Antonio. Work stopped again. I was able to get an emergency loan by mortgaging our house. Our mother mort-

gaged her house as well, but this still was not enough for the Holmans to restart their printing.

Bill Holman rightfully concluded that we would not have nearly enough money to finish the book. The printing of the text had not even begun. I kept some of the worst news from Scott, but he could see that I was as close to despair as I would ever be in those days. For the first time I think the Holmans began to have some sympathy for our problems. They had gotten to know us better and finally realized that we were not rich with inexhaustible deep pockets. They seemed to be trying to understand and appreciate the struggles and sacrifices we were enduring for our book. After all, being in the book publishing business, they must have seen it many times before. If we could guarantee sufficient collateral to secure their loan, the Holmans would try to get the necessary moneys from their Austin bank to start work again, at least for the time being.

We did have one last important piece of collateral left that by itself would be enough to secure the needed money. Although the grackles had not yet been officially authenticated at that time, the Holmans were willing to accept our Audubon discovery as genuine and sufficient collateral. They were able to get the loan and at last work again resumed. By this time the year was almost over. As we entered the 1985 Christmas season, Scott and I had little enthusiasm to celebrate even if we had indeed survived a year that was marred by major crises. As New Year's Eve arrived, our birthday, I could not help but ruminate on this, the last day of Audubon's bicentennial. I never felt more sympathy for that eccentric and driven bird artist and the many publishing trials he endured, or felt closer to him spiritually, than I did at the end of that anniversary year, though his achievement was against far greater odds and on a scale that dwarfed our own.

By the spring of 1986, I was trying to keep focused on the fact that once our book was completed and ready for delivery, we would be able to use our escrow money to pay all of our most pressing outstanding debts. I knew that our money problems were not over, and eventually, when our well began to go dry again, I was forced to contemplate the frightening possibility that we could go bankrupt and fail to finish the book while we still had all the funds we needed escrowed in the bank, where they could not be touched. I could now see that it would take about $150,000 to put our project over the top. That would cover the Holmans' loan and provide enough money to pay all the remaining printing and binding costs with a little left over for promotional expenses.

Our banker told us that we could get that amount if we could obtain a co-signer for the loan and provide the collateral. Since it would be paying off their Austin note, too, the Holmans said they would release our Audubon painting to the care of our bank, and Harry Tennison with great grace agreed to provide the needed co-signature. This time our project was truly saved, the eventual publication of *Of Birds and Texas* finally guaranteed. With success now at last in sight, Scott and I should have had cause to celebrate, but somehow we just knew that we would never have possession of our grackle painting again. It still pains me deeply to think about it even after all these years. If I take any comfort at all from this, it is in the knowledge that *Of Birds and Texas* was actually saved by John James Audubon's long-lost painting of a pair of Boat-tailed Grackles. One could almost believe that he had reached out from the grave to save us in our moment of direst need. We had had a deep connection with the man, both spiritually and personally, linking our book forever to our childhood hero and mentor and to his *Birds of America*. After the New York Historical Society declared the grackles genuine in February 1986, Hirschel and Adler Gallery in New York placed its value at between two and three hundred thousand dollars. The printing work finally began again for the last time and proceeded smoothly until we received the last printed page of text in early August.

We had little time to savor our triumph. More than two hundred books had to be assembled, signed, and delivered immediately. We were about nine months behind our promised publication date, but we had lost no subscribers. Two had died, but their families honored their subscriptions. The assembly of the more than 140 separate pages into the two portfolios and the linen-covered box was a gargantuan task. Just thinking about how the book was going to be assembled almost made me an insomniac as I contemplated one Rube Goldberg solution after another.

It was my carpenter friend Steve Bennie who solved my problem in a minute with his typical practicality. For three years I had worried about this phase of our project. Steve lived at our studio, and I don't know why I never sat down to discuss the problem with him until the last minute. He suggested that we assemble a single row of industrial shelving four levels high in the very center of our long warehouse. As the cartons of pages arrived they would be stacked in a special order and would be opened on the end so that we could easily retrieve the pages. We would then use an industrial platform dolly, pulling it

down along the line of shelves and assembling the elephant folio pages into the portfolios and boxes as we went.

Simple it was, but the work was back breaking. The August heat was often more than 100 degrees in the warehouse, so we rarely loaded more than ten books a day. There were some days we drove out at six o'clock in the morning to beat the heat. We would load ten books, then come home for lunch and possibly a nap, finally returning to load ten more books in the evening. I don't think I was ever so tired or dirty or sore in my life as in those first hot days of stooping and reaching and lifting at the warehouse. The books were assembled backwards so that when we got home to sign them on our long signing table—a plywood slab on sawhorses in the living room—we could open each portfolio to examine each page for flaws. When we finished, the book would be in its proper order. We would finally sign and number the signature page, which had already been presigned by John Graves. Scott and I had some wonderful conversations while we did this work. Occasionally we stopped and simply looked at the prints and the beautiful text pages so elegantly designed by David Holman. A page that gave Scott and me so much pleasure was the one of Audubon's grackles, the "Great Crow Blackbirds," reproduced for the very first time in our book as he originally painted it. In a very real sense we had helped to wipe away the gross injustice done to him more than 160 years earlier. We reveled in the thought that Audubon had thus become a very real part of our book and our lives, and that we had by sheer luck and coincidence become an undeniable part of his fascinating legacy.

Our book was done to be sure, but there would be little time to rest in the months ahead. We worked without a break to assemble and deliver books to our faithful subscribers, beat the bushes for new ones, and try to secure as much publicity as we could with barely any budget left for promotion. The sheer magnitude of what we had done insured a certain amount of newspaper and magazine coverage, but I had to hustle for just about every bit of it. One of my biggest mistakes was not having figured enough promotion and advertising money in our original budget.

After we had signed the books to be immediately delivered, Scott began doing the watercolor bird studies—the remarques—for the subscribers who had allowed us to use their subscription money before the book was published. I only had time to do a few of them, but Scott actually relished the work. He spared neither time nor labor, and these little studies are among his most beautiful paintings of birds, with less stylizing than in our book's color plates, which were very much an homage to Audubon's style.

We were now able to use our escrow money to pay off many of our outstanding debts. We worked closely with the Museum of Science and History with only moderate success to try to speed up their schedule of payment. They had eight years to pay for their purchase, and this would later make for problems. As time went on, it was becoming painfully obvious that we were not going to get our Audubon painting back. We had already paid huge sums to the people involved and to the bank in both principal and interest. Our banker had shown an extraordinary faith in us and our project when times were really tough. I realized that he was only trying to help when he began to talk about the possibility of selling our Audubon painting at auction at Sotheby's. Still, my heart sank low. If the sale were successful it would indeed eliminate enough debt to make the remaining problems with our finances very manageable, and it would save huge potential interest costs. He was polite and conciliatory, but he also knew that Scott and I had no choice. The painting had not really belonged to us from the time we used it as collateral for the Holmans' Austin loan, which now seemed so long ago. It was now the property of the bank, though the word "seizure" was never used.

After much preparation and maneuvering, the sale would take place at Sotheby's in New York on May 28, 1987. With the help of Preston Kirk, a resourceful public relations man from Dallas, I was able to get important publicity for us and our book through the attention generated by the Sotheby's sale. Until I met Preston, most of my work of the previous months had been centered on trying to get some of the bigger magazines, newspapers, and TV people to take an interest in our book. It was difficult to approach these people directly through proper channels. You could put together the most beautifully printed press kit, filled with photos and lively quotes, and they simply would put it on a pile with all the other beautiful press kits. Editors and reporters tend to rely on public relations people whom they know personally to bring them important newsworthy projects. There are exceptions, of course, but don't count on your being one of them.

I don't remember how Preston Kirk heard of us. He gave me a call in, I believe, late February to ask if he could see our book that afternoon and perhaps talk to me about what a public relations bonanza he thought our story was. I told him that we really did not have much money for that sort of thing, but Preston was a very good

salesman and I was ready to listen. We met at our studio office and I went through the book for him in what had now become a sort of presentation routine. He was likeable and soft spoken, but witty and confident. Later we sat in the office and talked until it was dark outside. By that time he had sold me on hiring him for a limited PR campaign. I really did not have five thousand dollars to spare, but he convinced me that we could achieve some very positive results, even with that amount of money.

In the next two and a half months it was truly amazing to watch him in action as he approached editors and TV people. If I had continued to try on my own, I would have wasted most of my time to little avail. As the day of the Sotheby's sale drew near, Preston had molded our "story" into several easily digestible news items. He had prepared a handsome mailout. Such press kits were usually important only after you had made personal contact with somebody on the staff. And that somebody did not have to be a news person; it could be anybody who could get the ear of the editor. Preston's biggest coup proved to be CNN. He had a friend who worked for that news channel in Houston. After examining our mailout he called Preston to tell him that CNN in New York just might like the story and that he would call a colleague there for us and lay the groundwork. It was only a week before the auction. CNN New York took the bait. They immediately contacted Sotheby's to ask if a camera could be installed discreetly in the balcony to film the bidding. To my great surprise Sotheby's said yes.

I confess that Sotheby's and Preston's excitement became contagious. As everything seemed to fall into place, I forgot at times what it was we had lost. I even found myself hoping there would be many buyers in the audience on auction day. Since our Audubon painting had been taken from us, I at least wanted the bank to get as much as possible for it. I knew enough about auctions to realize that people do not participate in order to pay world record prices but to get deals at as low a price as possible. The Sotheby's people were truly gracious and helpful. They put a full-page ad in *Antiques Magazine* showing the grackles in all their glory, and they reserved two pages in their catalog to discuss the painting and its special history.

I had one worry in spite of all this. Original Audubon paintings came on the market so rarely that there was not a well-established record of prices. This presented us with a strange situation in which the painting's very rarity might actually work against its potential performance at auction. Also, though beautifully painted, the grackle painting was really quite small compared to the many grand

Audubon compositions familiar to his aficionados. Previous estimates from various appraisers had ranged from seventy-five thousand to four hundred thousand dollars, which made it clear to us that nobody really knew its possible value. And Sotheby's could not reassure us that the painting would fetch anything near the estimated value of two to three hundred thousand dollars quoted in their catalog. When it came down to it, the little Audubon was simply an art anomaly. When the day of the auction finally arrived, it would not only be our bankers who would be sitting on the edge of their seats.

Mercifully, Scott and I were so busy in those weeks before the auction that we did not have time to think about everything. The matter had been truly out of our hands from the time the bank put the Audubon painting in its vault. I did get nervous, however, when our banker called to inform me that both he and his wife were going to be in New York for the sale. We, of course, had to be there for the CNN interview after the sale, but I was really hoping that he would have remained at home. Yet it was the bank's painting, after all, and not ours. Our banker now had a better right to be at Sotheby's than we did. As we checked in at the Essex House at South Central Park the night before the sale, I was having unsettling thoughts about us sitting there in the Sotheby's auction room the next day, our banker and his wife sitting there too, and about all my assurances to him that we had indeed discovered a painting of great value finally being put to the test on national television.

It was a hot and muggy May morning that Thursday in New York. The Audubon painting was to be auctioned by Sotheby's during the first session, which began promptly at quarter past ten. Preston Kirk called to wish us luck. He said that the CNN setup was in place and that Sotheby's people would be waiting at their front door. There was a special excitement in his voice. He said that if the auction went well, he might have some additional news to tell us, something about an interview with *People* magazine. Scott and I took breakfast downstairs in our hotel in a remarkably calm and quiet way, hardly talking about the sale. I felt it was rather like partaking of a last meal before an execution. When we finished we caught a cab and rode over to Sotheby's on the other side of Central Park.

Scott and I had bought things at Sotheby's off and on for many years, but we had always placed our bids by phone. Neither of us had ever set foot in their showrooms. Even at nine o'clock in the morning the place was jammed with people milling about from room to room, catalogs

in hand, examining all sorts of items, tagged and displayed on long rows of tables. I was very impressed by how well dressed and elegant the people were, and yet the atmosphere was not at all snooty. If anybody was supposed to be there to meet us, it would have been impossible to find him or her in that crowd. However, a woman at the reception desk had our names on file and told us which floor to go to in order to find the Department of American Art. I'm not sure what I expected to see when the elevator opened on that floor, perhaps velvet-covered furniture and wood-paneled walls. Whatever I was thinking, I was surprised as we entered Perry Rathbone's offices. It reminded me of a college professor's cubicle, tables piled with reference books and newspapers. Rathbone greeted us warmly, and as he offered us coffee and chatted with us, I couldn't help but wonder if our host were related to the Rathbones of Liverpool who so warmly befriended Audubon on his 1826 trip abroad to find a publisher. I never asked him. For all the coincidences which had happened to us since we discovered the grackle painting, it would not have surprised me if he were related. He was helpful in every way, and so was his staff. Unique as the little Audubon painting was, its possible value at most was no big deal by their standards. Yet they received us with a warmth and personal attention that utterly belied the snobbery commonly associated with fine art auction houses.

One of Mr. Rathbone's assistants greeted us and took us aside to brief us on how the auction was going to be conducted. Since the Audubon painting was item number 38, it would be coming up on the block fairly early in the morning session. Two seats had been reserved for Scott and me among the spectators and bidders where we could easily be seen by the CNN camera. The assistant walked us down the aisle to show us our seats. She told us it was going to be a standing room only crowd. For the first time I felt queasy and really nervous. We followed the assistant out of the auditorium and immediately ran into our banker and his wife. It was the first time we had seen each other since we had gotten to the city. They both were glowing with anticipation and seemed to be enjoying themselves immensely. There was no time to stop and talk. People were already beginning to file into the auction chamber. Our guide suggested that we take our seats. She pointed over our heads toward the CNN camera perched on a balcony to our left. She wished us luck and then vanished back into the crowd.

As Scott and I took our seats, I could see the cameramen checking their lights and gear. Occasionally they would swing their camera around and point it directly at us, then turn it to face the brightly lighted stage, where a lectern stood at stage left near a large empty easel. The auctioneer was already testing the microphone. Scott and I spoke little to each other. I'm sure that he had the same roller-coaster feeling in the pit of his stomach. Both of us had been given a catalog for the sale, and I turned to item 38. In the blank space below the colored reproduction of the grackles, I began to sketch the scene. It helped to keep my mind off thoughts of our impending fate. From time to time I could see some in the audience looking in our direction. They had obviously noticed the TV people pointing their camera at us.

Suddenly the loud chatter evaporated, and all eyes turned toward the stage. It was exactly 10:15 A.M. The auctioneer began to speak. There was no ceremony, only a brief introduction which I could not hear very well. The first item was brought out and placed on the easel. It was a portrait of a gentleman by Gilbert Stuart. I kept on sketching. The gavel seemed to hammer down the sale almost immediately, and the next item was brought out, a small still life. "Bang" went the hammer. Another still life was brought out. It too went quickly. I looked up briefly as each new work of art was brought out, but I kept on drawing. In my melodramatic way I felt like one of the prisoners of the French Revolution, lined up at the foot of the scaffold with my back to the guillotine, hearing the blade fall and the next victim called forward. I could feel the tension building within me. Now and then I'd say something inconsequential to Scott. He would say something equally inane to me. I tried not to think of our banker somewhere out there in the audience, and I could not help but notice that more people were looking at Scott and me, then glancing back up to the camera, which was aimed directly at us with its red filming light on. You could tell that the audience knew something special was happening here this morning. This, of course, only rattled me the more. Part of the excitement that day, I was later to learn, was generated by the art world's curiosity about whether or not the prices of American art were holding their own after the savings and loan crisis of 1986. It was unsettling to see some of the items brought to the stage and not sold. What if that happened to us? Was Scott thinking the same thing? He was a picture of perfect calm.

Item number 24, a miniature of a gentleman by James Peale. "Bang." Sold for thirty-eight thousand dollars, much lower than the estimate. There was a slight moan from the crowd. I returned to my drawing. I really tried

to focus on what I was sketching. In no time, it seemed, I heard the hammer on item number 35. My heart was pounding in my throat. The hammer fell quickly on 36, then 37. Scott nudged me as item 37, an awful Victorian picture of a big-eyed little blond girl, was unceremoniously removed from the easel.

"We now have item number 38," declared the auctioneer in a voice so low that again I could hardly hear him. ". . . a small painting in watercolor and pastel of a pair of Boat-tailed Grackles by John James Audubon."

"Was that all they were going to say to introduce such an important painting?" I thought. It was such a brief description! And the painting? It looked so pitifully small on that huge easel!

I scarcely had time to think about this before the bidding started. Only now everything began to seem in slow motion, the bidding gradually rising to seventy-five thousand dollars, where it was hovering. Would that be all?

"Seventy-five thousand!" declared the man at the podium. "Do I hear eighty thousand? . . . Going once . . . Do I hear eighty thousand for this exquisite and very important picture? . . . Going twice?"

"Somebody, speak up!" I prayed.

A paddle signaled from the back of the room.

"Eighty thousand. Do I hear ninety thousand?"

Apparently there was another sign from the audience. Or was it by telephone? There were several people sitting next to phones just behind the auctioneer. They had been discreetly giving him bids all morning.

"I now have ninety thousand," the speaker said. "Do I have one hundred thousand?"

He paused, but only a second.

"I have one hundred thousand," he said. "I now have one hundred thousand dollars."

The auctioneer was sensing momentum.

The bid seemed instantaneous.

"One hundred fifty thousand?"

Again, another bid.

"Do I have two hundred thousand dollars?"

What occurred next came so quickly, and the speaker announced it all in such a low voice, that the whole thing was over before I realized it. "Bang," went the gavel, followed by polite applause from the audience. The little Audubon painting had just sold for $253,000. The auctioneer announced that it was the highest price ever paid at auction for an Audubon bird painting, and the audience applauded again. I didn't know exactly how to feel. The price was actually lower than I thought the painting was worth. Still, it was an auction record and made it

almost certain that CNN would broadcast the news nationwide all day, which they did.

The painting was now gone out of our lives for good. Sold, I was sure, to some client who would remain forever unknown to us because of Sotheby's policy of confidentiality. It was true that the painting had not been our property for some time, but that did not negate the fact that it had been a real part of our lives. It had come into our lives out of the unknown, by the most incredible stroke of good fortune and coincidence. A brief moment of light. Now, in all likelihood, it was about to return to the shadows. I know that Scott was thinking the same thoughts. We didn't shake hands or pat each other on the back as the gavel hammered down. We both felt strangely tired. The final loss of that Audubon, I think, hit him even harder than it hit me.

One steamy morning in the summer of 1989, just before Scott and I were to leave for our first Mexico trip in seven years, I drove down to the office to pick up our mail. There was only one letter in the mailbox. When I saw its return address I did a double take! A triple take! It was addressed to "Gentlings." In the upper left corner in a neat, clear hand was written "A. Ford, Newtown, Pennsylvania." Alice Ford? *The* Alice Ford, Audubon's best and most famous biographer, whose books we devoured as kids when we first discovered Audubon and *Birds of America?* The dust of our crisis-filled publishing days was now beginning to settle at last, but it appeared that the spirit of Audubon was not ready to let go.

I waited until I got home to read the letter to Scott. Alice Ford! I still could not believe it. She had to be a hundred years old. Scott could not believe it either, and he begged me to let him read the letter out loud first.

Dear Gentlings,

Thanks to the magazine piece by Donna Pate (Ultra Magazine, 12 August 1987) which an Austin niece sent me I learned about "Of Birds and Texas" a while back. The glimpses of it there were really exciting, but here in the boondocks (Newtown, Pennsylvania) I don't know who might have a copy for me to see if I am lucky. It will— already has—put you right up there with Fuertes, Audubon and where you and your brother deserve to be. You may know my biography of Audubon (U. of Oklahoma Press 1964) but perhaps not the recent revived and amended edition from Abbeville. In it this time, I went into the whole matter of the **Great Crow Blackbird** *thanks to eleventh hour research breaks and after many years of trying to discover whether it still existed and, if so, where? The data*

in the (Sotheby's) catalogue missed fire at a few important points, but it was a brave try . . . What stunned me, and it is why I am writing to you, is that Hirschel and Adler sold the grackle drawing almost immediately after their bid won it. I am very anxious to learn who acquired it, and hope you can help me . . . So do please help me out if you can, and provided you know who bought the grackle drawing. I wanted to show it in color, but the publisher treated the recent edition as if it were a reprint which indeed it wasn't! H & A decline to identify the buyer who, I feel sure, would enjoy what more I could tell him about the drawing with such an extraordinary history.

> *Sincerely,*
> *Alice Ford*

We had experienced so much more than our share of unusual encounters in the course of publishing our book that the sudden contact with Alice Ford seemed almost routine. Of course it wasn't. The letter offered the first information we had been given about the buyer of the grackles, Hirschel and Adler Gallery in New York City, the same people who had appraised our Audubon painting for our bankers.

I had always hoped that some day the people who made the purchase would eventually contact us for more information about its fascinating history. It never happened. In the two years that had passed since the sale Scott and I had tried, and to some extent had succeeded, in putting the loss of our Audubon out of our minds. Our pain had been assuaged in great measure by an incredibly accurate and beautiful copy of the grackle painting that Scott made for us. It was even done on a piece of Whatman paper (Audubon's favorite) with a watermark date of 1823 which had been given us by John McCoy in the early 1960s. John, who was Andrew Wyeth's brother-in-law, had been Scott's watercolor teacher at the Pennsylvania Academy of the Fine Arts.

The real pleasure of Alice Ford's letter, however, was the news that she had published a reproduction of our grackles along with further research in her updated Audubon biography. After our return from Mexico I had no trouble finding a copy. Sure enough, when we opened to pages 166 and 167 there appeared a good illustration of our grackles on one page, and on the other, there were three black-and-white reproductions of Alexander Rider's pencil "correction" of Audubon's original, the Audubon-Rider print that had appeared in the Bonaparte-Wilson supplement, and, finally, the actual print of the boat-tails that ultimately appeared as plate 187 of *Birds of America.*

I couldn't help but feel that old, sinking sensation in the pit of my stomach, a sadness born out of an irretrievable loss. We were not mentioned by name in the book, because it had been published before Ms. Ford had heard about Scott and me. I was disappointed that our story could not have been at least a footnote in this, the best of Audubon's biographies. Her 1985 edition, however, had a wonderful amount of new background material that had been inaccessible to us. The book included a letter written by that old, indefatigable George Ord which offered new proof that our grackle painting had actually belonged to Audubon's enemy.

We know that Audubon never really got over the way he was treated by George Ord, Alexander Lawson, and Charles Bonaparte. What a pleasure it must have given him when *Birds of America* almost immediately—and forever—eclipsed Wilson's *American Ornithology* and the four-volume Bonaparte supplement. The Great Crow Blackbird affair was eventually forgotten by all but the immediate players in the drama, just as the grackle painting itself disappeared, not to resurface until almost 160 years later. Many people—Philadelphia Print Shoppe owners Don Cresswell and Chris Lane, Carole Anne Slatkin of the New York Historical Society, Audubon biographer Alice Ford, and even Ord, Bonaparte, and Audubon himself—have all helped to shed light on this brief but important moment in the life of the man Scott and I consider to be the greatest painter of American birds.

And my brother and I believe that we too have helped in the search for truth. By publishing his grackle painting for the first time in our own book as he originally painted it, we rectified an old grievance and brought ourselves closer to our childhood hero in a more personal way than we would have ever thought possible. Even Audubon himself, referring years later to the grackle affair, wrote, "Le temps de'couvre la verité." He was more correct, I think, than even he knew. The Alice Ford letter had opened painful wounds for Scott and me, but it was good to think deeply about the old bird painter again two years after the auction and to have new information about the fate of the grackle painting. Somehow, the contact with Alice Ford seemed a fitting epilogue for our strange encounter with John James Audubon.

But Scott and I were in for another special surprise. Shortly after our return from Mexico, a letter arrived from Suzanne Low, a bird book researcher with whom I had corresponded about the time our book came out. She had just compiled a digest of important American bird books for the American Museum of Natural History and

had heard about our project. We corresponded back and forth for several months, but I had not heard a word from her in two years. She had remarkable news.

> Dear Mr. Gentling:
>
> I hope you will remember me and our correspondence and phone calls of 1986–87. I got in touch with you, because I was so interested in your discovery of the Audubon painting of the Boat-tailed Grackles at that time known as the Great Crow Blackbird.
>
> In one of my many moves between our Florida house and our house here part of my files turned up missing including my correspondence with you so I am writing to you to ask you if you will refresh my memory as to how, when, and where you discovered the painting as I and my colleagues have become interested in the whole curious story.
>
> We all from time to time have funny things happen that cause us to say "Isn't it a small world," but I think you will agree that what I am about to tell you beats all. About a month ago my husband and I were staying with one of our married daughters. We went to tea with some friends of hers and there on the wall was your Audubon painting of the Grackles!! She told me that they had bought it at Hirschel and Adler in New York. They would love to know more about it so I told her what I knew and said I would try to find out more by writing you . . .
>
> You will be pleased to know that your painting is beautifully framed and beautifully hung in a lively house.
>
> Looking so much to hearing from you.
> Sincerely,
> Suzanne Low

Suzanne Low had also written to Alice Ford about the painting. I could tell by the tone of her voice when I talked with her on the telephone that Ms. Ford, touchy and territorial about her own research, was not well disposed toward Ms. Low, although she did want to know to whom the painting went after Hirschel and Adler bought it at auction. Ms. Low insisted, and properly so, that the anonymity of the new owners be protected, which meant that we would never know the new owners. I am not sure that Scott and I really wanted to know, and not wishing to be drawn into another Audubon controversy or be reminded of our loss, I decided not to get involved. I ceased corresponding with both women, an emotional decision that I now somewhat regret. Scott and I did send Alice Ford a gift copy of our book for her eighty-sixth birthday and in recognition of her splendid life's work on John James Audubon.

Ironically, what our book project gave us, it eventually took away. We can never be deprived, though, of the role we played in bringing that little grackle painting back from obscurity by publishing it for the first time as Audubon would have wanted it to be seen. And had it not been for that painting, our book could not have been published. We helped to correct an old injustice that angered Audubon for the rest of his life, and he in a very real sense repaid that favor. I'd like to think that if he knew our destinies, which first came together in that museum library more than forty years ago, were to be joined again in the publication of *Of Birds and Texas*, he'd also be pleased.

Perhaps the most rewarding legacy of the nearly ten years of labor on our book was the critical reception it inspired. The praise was unanimous except for one caveat. Several critics lamented the fact that our huge folio was physically difficult to enjoy without effort. From the beginning I wanted to do a smaller version for the convenience of the elephant folio owners and the general public, but budget considerations made it impractical. The publication of this edition realizes that goal.

SELF-PORTRAIT, WITH BIRDS

As a student and observer of birds I remain a fairly rank amateur despite long-standing interest in them, and I suppose it's for this reason that I have trouble separating bird memories from memories of people I've known. Some of these individuals were just around when birds were around also, while others furnished me with bits and scraps of ornithological knowledge, or tried to. A few of them knew a great deal, so that if I'd always been receptive to their instruction I might know much more now than I do. But personal interests have their seasons, and in these latter days I find that I'm grateful for just about any awareness that a rather casual pattern of life has let me acquire, without complaining too much about its quality and scope.

In the simpler times I knew when growing up in Fort Worth, even we town young-sters had some almost unpeopled pieces of countryside, in the Trinity West Fork bottomlands and elsewhere, that were ours in exchange for a bit of legwork and a degree of sangfroid toward the question of trespass. Later on there were Depression country jobs in summer for a dollar or so a day and keep—wheat harvest, fence-building, and so on—and I can't remember a time when wild live things weren't a part of consciousness and when knowing something about them didn't matter.

Not that this led me into much contemplation of birds as a pleasure in itself, except during an occasional standard moment of marveling at redness, blueness, the sweetness of a song, or the slow-wheeling gyrations of vultures. As kids will, I derived most of my attitudes from adults whom I liked, and in terms of birds the main adults involved were a couple of uncles in South Texas, whose enduring devotion to feath-ered creatures was of a restricted and traditional sort. Bird hunters rather than bird watchers, they had an intricate stock of lore acquired in an era of such casual plenty that market hunting had been common. They weren't bloodthirsty, those uncles, and in truth they were closer to natural things than many nature-lovers I've known. They believed in selective clean killing, in conservation, and in the game laws, and were

somewhat amused by people not familiar with the appearance and general habits of the countryside's more noticeable common birds, from field larks and mockers to swallows and hawks and herons. But their real passion flowed toward dove and quail and waterfowl, game species that could be sought by rightful sporting methods, shot flying, and afterward served up on dinner tables.

Good shotguns and good dogs were central in their lives, as were the patterns of terrain and weather. Loving the names of familiar hunting grounds—the Mustang Motte, Cheapside, Alexander's Bull Pasture, the Post Oak Tank—they would roll them off their tongues like poetry. At least it sounded like poetry to me, and the hunting that I did with them, though only occasional, was the finest I've ever known because their absolute faith in the ritual's rightness gave it so much meaning. Over half a century later, it is still easy for me to call up the half-scared exhilaration of trotting along a hillside with them toward a place where frozen spotted pointers aimed their heads at a patch of scrub live oak, wondering all the while if I would ever manage to drop two quail on a covey rise as the uncles did routinely.

Both of them were avid about their hunting—birds nearly always it was, never deer and such—but the health of the older one was failing a bit by the time I started going out much with them, and he was often willing to mosey and pause and explain things. It was he who once picked up and brought over to me a plump small-headed bird, streaked in brown and tan, that one of us had brought down by mistake during a flurry of shooting in a sunflower field full of doves. I asked what it was.

"Plover," he said. "I wanted you to see one. In my daddy's time they used to come through in thousands, millions maybe. Shooting, they said you could fill up a wagon, and a lot of damned hogs did." He gave a short whickering whistle that I'd heard myself without knowing what bird it came from. "You can hear them best on cloudy nights in spring and fall when they're flying over low," my uncle said. "It always makes me think about how things used to be."

The other uncle, a lawyer and sometime judge, was too single-minded about the chase to spend any time on instruction afield unless you used a gun carelessly or approached birds wrong, at which juncture his instructions could be pungent. What you learned from him you learned by example, and it always had to do with the hunting itself. To learn it you needed young legs and good wind, since he seldom stopped to rest and would often

break into a lope when dogs came down on point. He kept at it hard even after his left arm was sheared off by a truck that sideswiped his car, handling a light twenty-eight-gauge double almost as well as he'd handled a twelve before. In his late forties his heart gave out quite suddenly at the end of a long day spent following his dogs after quail. If he had the time to reflect on it, I imagine that he must have seen that kind of death as right.

My father, on the other hand, had begun to ease away from hunting before I got well started, and I suspect he'd have quit entirely long before he did if he hadn't wanted me to know some things that he had known. Two or three times each fall and winter we would drive three hundred miles for those outings with the uncles in the rolling, long-settled, very Southern region along the lower Guadalupe, where he had been born and reared and they still lived. All of his best stories were about growing up there in the 1890s and the early years of this century—about town characters and feuds and black people and quirkish buggy horses and such things. Death being the thing that lets you see a father clearly, I know now that a deep homesickness for that small and satisfying world stayed with him all his life, even though he'd had to get out young to escape my grandfather's old-style despotic love. But those are other matters.

By the time I had finished with college and a war, Papa had stopped hunting altogether and had turned into a bird-watcher, albeit a somewhat unconventional one. My mother had always maintained a little feeder in winter, but now they had a big affair kept filled all year long, which hung from a hackberry limb outside their breakfast-room window. The neighborhood was an old one with trees and much shrubbery, and their seed mixtures and suet logs brought in some rather special birds like grosbeaks and house finches and nuthatches, in addition to proletarian throngs of English sparrows and a full assortment of other usual species. Without often using binoculars or leaving their yard for the purpose, they piled up a quite decent life list of sightings during the next few years, a period when I came home only occasionally from wherever I was living at the time.

One winter and spring they even had a magpie, either a drastically misplaced vagrant or someone's escaped pet. Hopping and swaggering in gaudy black and white about the lawn, he uttered harsh or querulous sounds and terrorized smaller birds at the feeder, which interested him chiefly for that reason since he craved meatier sustenance than was provided there. Staunchly anthropomorphic,

Papa named him Gus and doted on him, ignoring his bullying ways and his tendency to rob nests, and putting out grisly scraps of steak and raw liver and fried egg on the immaculate St. Augustine grass for his delectation. But in June Gus vanished for good, having either decamped toward his native high-Western climes or, as Papa grimly surmised, been assassinated by some youngster tiptoeing down the alley with a BB gun.

However, he kept a BB gun of his own and used it with enthusiasm on neighborhood cats that stalked his feeder, cackling in glee when a pellet bounced off one's hide and it leaped skyward and squalled and fled. Probably he'd have used worse weaponry on them if it hadn't been for my mother. The BBs were deadlier against sparrows invading his martin house atop the garage or the wren boxes nailed up here and there, and he hated blue jays as well, rather illogically since their evil ways were not much different from those of their corvine kinsman Gus. One of the few times I ever saw him truly enraged, shaking in fact, was when he sighted a jaybird that was methodically pecking out the brains of a baby dove snatched from its parents' nest. Papa shouted and hurled a garden trowel, the only missile at hand, and the criminal flew off screeching in either anger or derision. But the dovelet by then was so horridly damaged that it had to be coup-de-graced.

2.

Bird people in general belong to the quiet, gentle, thoughtful branch of humanity, and during much of my life such folk have caused me a good deal of pain, usually through my own fault. I am drawn to them nearly always. But I've got a certain chameleon inclination that's tied in with a hodgepodge of interests and a diverse taste in friendships, so that at one time or another I've managed to cherish laconic West Texans, owl-eyed professors, rightist-leaning Mississippians, leftist-leaning New Yorkers, hard-drinking ex-Marines, bearded environmentalists, and individuals of a number of other differing types, many of whom have not cherished one another at all when and if they met. All of this seems to be especially hard on one's quieter, gentler friends when one's Mr. Hyde tendencies or acquaintances heave into view. They're disappointed or hurt, whereupon one's own quieter, gentler self has to feel guilt and remorse for having betrayed them thus.

This may in part explain why, when young, I was already a bit leery of the sort of people who could have taught me most about birds, and also why in college at Rice I fell into a lifelong friendship with John Delabarre Staub, later to be known as the Mad Surgeon or the Horrible Doctor, who combined extremes in himself in a way that I could never approach, and energetically loved or hated whomever he cared to without fretting over complications. People tended either to love or to hate him too, uncomplicatedly. With small alert dark eyes and red hair and a profane tongue, Jack was troublesome all his life and never the least bit restful to be around, whether his drive of the moment was directed into some obsessive interest or just into being awful. Beautifully mannered when in the mood, able to charm the gentlest of people if he liked them, he was nonetheless usually hell on peaceful atmospheres and quiet gatherings, being always bored by standard conversation and poised to leave or to stir things up.

He was one of those persons who seem to change little from infancy to age, too stoutly constituted to be much swayed by things that happen to them. After his funeral a few years ago a group of his friends, some of whom barely knew one another, sat around past midnight recounting Staub tales by the dozen. One of these involved his practice of climbing, at the age of about four, up a tree outside his family's River Oaks home and trying to poot on the heads of unwary sidewalk strollers. Later this Rabelaisianism would take such forms as talking back to highway patrolmen, crashing through French doors while walking on his hands at formal parties, or antagonizing large and stupid goat-ropers in roadside bars, so that friendship with him often led to a need for action or diplomacy.

But his ruling trait was a capacity for focused passions, which during his life ranged from medicine (somehow it fitted in) to coon hounds, Valencian-style pigeon shooting, and huasteca music. Most, though, had to do with one or another aspect of the natural world, birds and bromeliads being the most lasting of these, and when something seized his interest he could learn about it faster than anyone else I've known, while exhibiting an equally remarkable resistance to subjects he found dull, like fishing or metaphysics or inquiries into the why of things. Life itself was his why and he needed no other.

When we met he had already been fascinated by birds for years and knew a great deal about them. With Jack, though, the point was in knowledge itself and not in showing it off or imparting it, so that it would have been hard

to learn much from him even if I'd been trying, and I wasn't. On the tall-grass coastal prairie west of Houston where we spent a lot of time together, something would fly by and he might observe if he felt like it that it had been a sora, or a Cooper's hawk, or a little blue heron, or whatever, but if I asked how he'd known he would grimace and say with finality, "God damn. It just *is*."

Suburban spraddle these days, that prairie was then a fertile flatness dissected by wandering wooded bayous and dotted with shallow ponds. It was grazed by Brahman cattle and lightly inhabited by white people who ran ranches and scattered farms, and black ones who lived in clusters of shacks near wells and garden patches and did much of the farms' and ranches' work, as their families had done back into days of slavery. Bosses or workers, Jack knew them all and had special friendships with some, the most notable of whom was a cranky, vigorous black man named Jim Burnett, part Indian and about seventy years old, who had wide, deep, lifetime knowledge of the region's wild things and subsisted almost entirely on undomesticated meat ranging in flavor from possum to sandhill crane.

We hunted meat there too from time to time, most often by sneaking one of the ponds. This required slithering along on elbows and hipbones through mud and damp grass for a couple of hundred yards, then scrambling erect and firing as ducks rattled frantically skyward from the water, sometimes dark thick hordes of them. It was an anciently prodigal place, part of the belt of level, mild, humid richness where the continent played out against warm Gulf waters and hundreds on hundreds of thousands of geese and ducks and cranes and raptors and smaller birds brought their autumn migrations to a stop and spent the winter months.

Standard hunting, however, interested Jack much less than the bird projects he nearly always had going—catching and doctoring cranes that were afflicted one year with a strange limbernecked disease (he never managed to cure one), studying the pompous, lovely courtship rituals of prairie chickens atop low salt domes, noting the progress of eggs and chicks in nests that he'd found here and there. Being with him on the prairie, whether afoot or horseback or in a car, was often like trailing a madly surging force that dragged you along behind, though his exultation in seeking and seeing could infect you too and make it worth the trouble.

There is not room for all of Staub here, or maybe anywhere else. I remember him as he was then mainly in

clear picture-bits of time. . . . With, for instance, blood running down his chin from biting crippled ducks in the head to finish them off, a technique he had learned from the prairie Negroes and liked because it was efficient and uncouth. He was bellowing directions as to a downed pintail's whereabouts at a mild and scholarly friend who had thought that going hunting with us might be fun, and looking at Jack's chin the friend bent over and was quite sick . . .

Or somehow maintaining himself upright in the swaying, fragile, thorny branches of a mesquite tree and peering raptly at the young in a caracara nest, while I held our horses and the enraged parent birds wheeled screaming about his red head . . .

Or waist-deep in stagnant brown water and mud at midnight, waving a flashlight and shouting recriminations at Jim Burnett, who was shouting recriminations back at him while the rest of us white boys stood there, waist-deep too, listening to owls and frogs and wondering about alligators. There was whiskey along and old Jim had had more than his share, but I don't know which of them had led us to that miry impasse, while in the distance the bell voices of the hounds we were supposedly following grew faint.

"Blame *me!*" Jim yelled. "Run ever'body in the dad gum bayou and then blame *me!* We gwine see how many more coon hunts I takes you on!"

"What we'll see is if I God damn want to go!" cried the Horrible One.

But they did go out together after coon and bobcat for the rest of Jim's long life, both shouting a good bit of the way. Across the gaps of age and color and everything else they were astoundingly alike in some ways, and in those ways the old quarter-Cherokee black man comprehended Jack better than his other friends could, love him though we did.

During those Rice years I knew a few more normal bird people, among them George Williams, a quiet maverick who may have been the best English teacher I ever had. In early mornings and at other odd moments he haunted the undeveloped back section of the college's sprawling property, a lushness of trees and grass and interlaced thickets of Macartney rose, where small birds teemed and in spring their songs obliterated the growl of city traffic not far away. Much later I found out that Williams was a respected bird expert—being, for example, one of those called on to clinch identification of an Eskimo curlew, a nearly extinct species, that turned up in

the '50s on a beach of Galveston Island. Because I liked him and liked being out, I went with him to his rose tangles on occasion, but girls and the coming war and other matters were much on my mind just then, and I seem to have managed without much effort to avoid absorbing any real dose of the ornithological wisdom he would gladly have shared.

I do remember that there were lots of quail. You couldn't shoot there and it would have been impossible hunting in any case among the thickets, but the bobwhites' whirring rise still made my heart jump. That area is now covered mainly by an enormous pink-brick stadium and its paved parking lots.

The truth is that the only thing I can be certain I came to know about birds back then, beyond the smattering left over from earlier years, was that people I cared for could be intensely interested in them in ways not related to killing. I suppose this was a seed.

3.

Some military men, most of them imperial British I fear, have made use of tours of duty in remote and woebegone places to study and record the natural texture of their surroundings and thereby to swell humanity's store of knowledge. The islands of the Pacific Ocean during World War II were remote for certain and plenty of them were woebegone too, at least after the shooting had moved along elsewhere, but I don't recall that any of my associates in that era and place sought thus to enrich their minds and their time, unless you want to count as nature study the hand-grenading of an occasional reef to see what would float to the top. We did have among us a sprinkling of Gooney Bird authorities, people who had been stuck for a little too long on some minute islet with little to look at but water, coral sand, coconut palms, Quonset huts, and albatrosses, graceful birds in flight but comically awkward when taking off or landing. These experts' repertory usually included a canter down the length of a barroom while flapping their arms and squawking, and a final collapse into a kicking, jerking heap. It was a sort of drama whose appeal could wither quite fast.

No doubt the Horrible Doctor would have barged through to the gist of things even there. But he was a long long way from the Pacific islands, in medical school at Duke. I visited him there late in the war and found him studying obsessively, among other things, the genet-

ics of fine blue-ticked coon hounds under the tutelage of an old bacteriology professor who lived in a house in the woods with dogs and children and black people all around.

Neither was my time in graduate school in the East after the war much of a stimulus toward bird study. For the most part I thought little more about such things until the late 1940s in Austin, where I found myself functioning as a junior English instructor at the state university, with five freshman sections containing thirty students each—or at any rate that is my jaundiced and perhaps somewhat (but not much) swollen recollection. Like my fellow unfortunates I was afflicted with ungraded theme papers that formed thick, flat lumps of guilty reminder in the pockets of scholarly tweed jackets (doggedly traditional, we smoked pipes too) and piled up on the mantel at home. Our students seemed chiefly to be either affluent or athletic, and were in general contemptuous of teachers. Nor did our abject love of books, the chief reason we underpaid contemptibles were there, find much fulfillment except in relation to composition texts and an occasional simple novel such as *Babbitt* that even a freshman tackle could grasp.

If one adds to this a marriage not in the best of shape, a powerful but stalled compulsion to write undying prose, and a yen to shake the dust of old Texas from my shoes and roam the world, I suppose it isn't strange that with my background I fled for solace when I could to the pleasures of forest and stream. Austin at that time was not a bad place to be if you were partial to guns and rods. For me its main corridor of such activity was the river that flowed down from the reservoirs above the city. In those days before it was dammed and beautified and its banks converted to parks or prime real estate, this stretch of the Colorado was cluttered with old tires and iceboxes and car bodies and things, but it was also cool and copious and clear, and little frequented by people except around bridges and other points of easy access. Though most of my friends at the university had more scholarly tastes, if I wanted outdoor company I could usually find it among an assortment of fellow river rats on the Colorado itself, one of them a small dentist with a twisted spine and tremendous dexterity in the use of a fly rod.

Below the city during fall and winter good numbers of bluebill and teal and mallard and other ducks swam in tight rafts on smooth runs or fed in weedy shallows, and I would drift at them hiding in the bilge of a green canvas boat, a sort of coracle assembled lopsidedly from a mailorder kit. Or I might stalk squirrels in the riverside trees,

or trudge along boggy islets seeking jacksnipe that rocketed from beneath my feet with a shrill unnerving cry and zigzagged clear of my shotshells' patterns at least three times out of four. In truth, all of that activity resulted in a fairly thin harvest of protein, but I remember it as having furnished a wealth of sanity and peace.

Corruption of a sort was setting in, however. I had started taking a field glass and a bird guide along on voyages in the catawampus coracle, and found myself doing other things that would have puzzled or annoyed my South Texas uncles, had they seen me. Things like letting a fly line lie on the water in idle curves at evening, while I listened to barred owls tuning up their sardonic laughter in the woods, or watched nighthawks and bats taking over command of the bottomland's moist cool green-smelling air, with its insects, from the swallows that had worked it all day.

I also came to know and like a quite skilled bird man, one of the senior figures in the university's English department. A North Carolinian and a specialist in the work of Spenser, he had austere ways that caused his graduate students to hold him in awe and a certain amount of fear, but I had no academic axes to grind and we got along well from the start. He was a widower, and rather oddly I met him through his fifteen-year-old son, whom some colleague had talked me into taking on one of my river expeditions.

This boy Tommy was a thoroughly improbable off-shoot from such a father, full of a raging energy much like that of the Horrible Doctor. It was channeled toward uncivilized things like game and fish and rural Mexicans and cattle and combat with people who got in his way. We did a lot of shooting and fishing together, and years afterward, following college and a three-year head-butting contest with the United States Marine Corps, he managed with scant capital and a full supply of resolve to get started at ranching on leased land in the wild Mexican highlands near Torreón. There he hung on fighting obstacles, most of them climatic or political, though he stirred up some personal ones too, for a decade and a half before dying far too early.

The last time I was with Tommy we met at Port Isabel on the border, for a visit and some speckled-trout fishing after years of not seeing each other. He was browned and hard and cursed the salt air blue in both English and slurred norteño Spanish, switching back and forth between them without being conscious of it. At one point he told me, "The way things are shaping up, in ten years there won't be more than two Americans still ranching in Mexico. But those two will be rich sons of bitches, and I'm going to be one of them."

I suspect he would have been, too, if his body had been up to the drive and the will that had rammed it along through life.

One strays from the point, which is supposed to be birds. (Damn right one does, at one's present age and looking back at people and things that have mattered. . . .) In those earlier years at Austin, the professor sometimes came afield with me and Tommy if we weren't using the lopsided boat, which held two people precariously and three not at all. While we bent ourselves to the ritual pursuit of meat, he would stroll off with his binoculars, and in time I often found myself going with him and letting Tommy hunt or fish by himself. On the cedar-furred heights west of Austin he gave me my first conscious glimpses of golden-cheeked warblers and vermilion fly-catchers and other small splendid creatures, and without ever bubbling or exclaiming he had a gift for making them matter. Or maybe I was just ready to have them matter. His special aptitude was for songs and notes—being able to tell from a grating cheep or a snatch of warbled melody what hidden bit of fluff was sounding off, and often why. In the academic status game of publication, he made a good many points during one period with learned papers discussing references to birds and birdsong in the works of the English poets.

It was the professor, I think, who first pointed out to me a gangling, otherworldly figure on the campus one day and identified it as Edgar Kincaid, who even then, still in his twenties, was on his way to becoming known as the obsessed, eccentric prince of Texas birders. Though I met Edgar at some point during that time, I hardly knew him until a decade later when I was a friend of his aunt and uncle the Frank Dobies, with whom he lived. But I heard the humorous legends that had begun to grow up around him and got to see one in the process of formation.

It involved a screech-owl nest in an upper-story cranny of one of the university buildings. Edgar had apparently noticed the owls as they built it, and thereafter at least once a day and often two or three times, he would ooze from a third-floor hallway window onto a narrow stone ledge, and would inch spread-eagled along it for thirty feet or so to the nest for the purpose of observation. Since he kept this up for a period of weeks before the owls coaxed their young out to broader realms, word of it got around,

and often while Edgar was absorbedly studying owls a clump of student and faculty aficionados, myself sometimes among them, would gather below to study Edgar. Both sides, I guess, achieved edification. What the screech-owls got out of it is uncertain, unless it was some expanded human sympathy toward their posterity, for a part of whatever Edgar learned about them there and elsewhere must afterward have gone into his million-word abridgement and updating of the late Harry C. Oberholser's monumental life work, called *The Bird Life of Texas.*

That was all long ago, and lovable, strange, now departed Edgar Kincaid with his owls is queerly linked in my mind to another bird memory from the same era. It has to do with a roadrunner, as obsessed as Edgar and looking not unlike him, who developed a violent hatred of his own mirrored image in one single pane of one single window. This small rectangle of glass was on the second floor of a building a few yards across a courtyard from a room where I was trying three times a week, at eight o'clock in the morning, to convince a class of freshmen that the language of Shakespeare and Keats was still worth trying to use right.

Not inching spread-eagled but racing full tilt, Br'er Chaparral would come tearing around the building's corner on a windowsill ledge like Edgar's, and at the fateful spot would veer into an assault on his detested reflection, hoping to catch it by surprise. Pecking and spurring at the glass until he knocked himself backward, he would tumble into a hedge below and then down onto grass. Dazed and clearly unhappy, he would take time to rearrange his feathers before trudging back around the corner and instituting another charge. Because I was as interested in him as were my usually languid Pi Phi and Kappa Sig pledges and budding gridiron heroes, his performance did a pretty good job of neutralizing instruction for a week or two. Then he quit showing up, either having suffered so much concussive brain damage that he couldn't find the building any more, or having been cowed at last by the foe who was always waiting in that window and hot for strife.

4 ·

Austin dropped behind with the good and bad I'd found there and some other things as well, including matrimony and the brief illusion that I was geared for an academic life in leather-patched Shetland tweeds. Farther along I would do more college teaching with less illusion and more pleasure, but what came in the meantime was an unreasonably protracted, pigheaded, impecunious, lone-wolf writing apprenticeship lasting for several years and conducted, in the main, more or less on the move and far from my native region.

During those years New York, England, Spain, Mexico, and various other locales felt my tread, not that any of them took notice of it or that I expected them to. All I wanted was to shuck off a few old guilts and inadequacies, and to see and learn and live a bit while engaged in a belated effort to make my work come right. In this war with enemies living inside myself I often felt like a loser with feathers awry, though a little of my writing was being accepted and published from time to time. By rights it should have been a miserable period, and I think it would have been if putting words on paper had been my whole point in life.

It wasn't, though, and still is not, and in truth the period was far from miserable. Those years were loaded with a sense of liberation from old limits, and loaded also with ten thousand things worth doing, from books and museums and places radiant with ancient meaning, to being on trains bound for towns or countries I hadn't seen before, to friends who knew things I didn't and whose minds were alive, to wine and music and bullfights and bright fair ladies.

What they weren't loaded with was the study of birds and other natural phenomena, though after Austin I did maintain a low-grade chronic case of this disease and its symptoms erupted from time to time. Two summers in a row while living in New York I went down to North Carolina to spend some time with my friend the austere Spenserian professor, at a cabin he owned in the high, cool, green country near Asheville. Wordsworth's ideal of "plain living and high thinking" governed in that place— cot beds, cold washtub baths, turnip greens with cornbread, fine book talk, and much communion with the birds that were everywhere in the moist mountains. An old notebook in my desk tells me that in those environs I not only came to know with some confidence, for the moment anyhow, thirty-odd local species ranging from Maryland yellowthroats to indigo buntings, but was also trying with less success to memorize and set down the songs that were known so well to my host. One drizzling misty afternoon we drove fifty miles or so to Mount Mitchell, one of the few sites south of Canada where the

winter wren nests and can be heard tootling its complex, high-pitched music, and did hear the song without sighting the songster, and drove back to the cabin at evening well pleased . . .

Another year there were three months in Devonshire not far from Plymouth, where a close friend from graduate school, abroad that year on a foundation grant, was summering with his family in a thatched stone cottage. Because they had small children and no excess of space, I took a room at a pub with beams salvaged from the Armada's wreckage, whose owner kept fighting bulldogs and a Riley sportster and would pour free whiskey down you after hours. I suppose it was as rosily trite and anachronistic a summer as Americans on the mother island could have dreamed up for themselves, but nonetheless fine for all that.

Most of the day Sam would work at his papers and I at mine, and afterward we would amble through hedge-bordered lanes, up rocky streams, and along cliffs overlooking the sea, trying between long, wrangling, usually literary conversations to identify plants and birds and such. In some part this effort was literary too, because if you have grown up within the glow of British writing, thickly adorned as much of it is with themes and images from nature, when you get the chance you need to explore for yourself the reality of things like rooks and yellowhammers and hedgehogs and scarlet pimpernels. The local vicar, a civilized Scot with whom we sometimes tritely had scones and huge strawberries and clotted cream at tea, was no naturalist-ecclesiastic like old Gilbert White of Selborne, but he had a feel for that vein of inquiry and lent us some helpful field guides. As I recall that interlude, we learned much less about birds than about wildflowers, which don't hop around and hide in foliage and fly away. But we did log up a fair number of avian specimens (who, after all, can miss a skylark or a raven or the word of fear a cuckoo speaks?) and derived a certain leering and unscholarly American satisfaction from recognizing a slightly oversized chickadee known in Britain as the great tit.

Spain, however, was where I spent most of my time on that side of the water, and Spaniards in general, like other Mediterranean peoples—and like, for that matter, most Americans—tend to view nature, if at all, in terms of what it can do for or against them. Somewhere in that tawny and pleasant land there must have been some native bird-lovers, but I met none of them and was only occasionally in rural places. From time to time I did go fishing in the

Pyrenees or on the short, swift, cold rivers running down to the Bay of Biscay from out of the Cantabrian range, where foreigners were seldom seen and a local angling doctor or priest or cobbler was usually happy to show me good pools and runs. The birds I saw and heard along those rivers were often of sorts that Sam and I had half-learned that summer in Devon (including, I swear, a great tit), and their familiarity was an agreeable part of being there. But my mind, like those of my Spanish companions, was chiefly fixed on trout—themselves an obsessive study to which numerous human lives, or at any rate large segments of them, have been devoted without regret. And for perhaps most trout people, birds matter mainly in terms of the feathers they furnish for tying flies.

Thinking back on Spain in ornithological terms, in fact, I see scant further learning or awareness on my part, but mainly just episodes and people with some connection to birds, such as those that follow here . . .

A soft-spoken decent man in beret and smock encountered one day as I walked down a swale in the rolling untimbered foothills of the Guadarrama . . . He was lying at ease on the slope, a short distance away from a collection of small birds that were warbling and cheeping in wicker cages or from twigs to which they were leg-tethered. On the grass he had spread fine-meshed nets to be sprung when enough wild ones had gathered to these decoys. He got very little recompense for his catch, he said, but it was what he did, his living and his father's before him. Species didn't matter much—thrushes, finches, larks, whatever came—because the wine shops in Madrid that bought them from him would pluck them anonymous and gut them and fry them crisp in oil. I had seen them in such places in platters on the bar, and the accepted etiquette seemed to be to bite the head off first and crunch it with relish before devouring the remainder, bones and all.

Dark, quick, forktailed swallows that would flit in hundreds above a bull ring in late afternoon, diving and twisting and seizing the flies that formed a pall over the violent arena's blood and manure and us sweating enthusiasts in the stands . . .

An English painter, a friend who occasionally went for country rides with me on a motorcycle I had . . . He particularly liked one road that wound through General Franco's favorite and heavily stocked shooting preserve outside Madrid. There at some point he would nudge me to stop, and after looking about for gamekeepers would pot a fat redlegged partridge beneath a bush with a small

catapult he carried, stashing the kill afterward in a pocket of his baggy tweeds. He used ball-bearings as pellets and seldom missed, having picked up the knack in youth from a gypsy poacher in Surrey. In the slum studio where he lived with an intelligent and mettlesome Spanish wife, he kept a kestrel on a perch beside his easel, and with Britannic understatement would give me to understand that its talent for hunting was huge. More often than not, though, when we carried it hooded to a park or other open space near the city and launched it at some unlucky sparrow or thrush or whatnot, too many idlers would gather to watch and the little hawk, with or without its quarry, would alight on a utility pole or a tree and refuse to come down for hours, while Tony cajoled it and blasphemed it and tried to shoo Spaniards away.

A luncheon party of hard-drinking expatriates on the terrace of a granite seaside villa outside Palma de Mallorca . . . After coming to the island I had made acquaintances among these gentry and in fact had joined their perennial revels for a while, but in the long run I had work I wanted to do and not that stout a thirst. Most days I would pound out words till lunchtime, hoping they'd turn out right, and in the afternoon would go to the boat club and associate with Mallorcans, who drank very little beyond wine with meals, and took their chief pleasure from sailing small craft across the lovely wide bay, and from the pursuit and occasional capture of vacationing French or Scandinavian girls who liked boats. Except in the cockney sense, they were not bird-watchers and neither was I when among them, remaining content with the gulls and terns and sandpipers that belonged to the sea and its fringes.

For some reason I broke the pattern that day and went to the expatriates' party. Things got active somewhat earlier than was usual even in that set, abetted by softstepping domestics bearing pitchers of iced Catalan champagne laced heavily with gin. Our host and hostess quarreled loudly. A fired American television executive, nursing his wounds abroad, aimed a punch at a Dutch homosexual which missed but made the Dutchman weep. Other lusts and hatreds surfaced. A buxom young Swedish woman managed somehow to let one breast escape momentarily from her dress's neckline plunge for all the world to see—in ornithological terms a very great tit indeed. Lunch was consumed by those willing to interrupt their drinking for it, and finally an enormous yellow cake surrounded by dancing blue flames was wheeled out by the household's young Andalusian cook, a sort of friend

of mine (his sister cleaned my tiny cottage twice a week; our world there was small) who aspired to become a hotel chef and was fond of concocting fancy dishes.

"Over here, everybody!" the hostess called. "Matías has a surprise!"

We gathered and watched brandy flames lick the sides of the yellow cake. Next to me Matías surreptitiously twitched a tiny wire and a trap door flipped open in the top of the cake, but nothing else happened. Pursing his mouth, he reached through the flames, poked his finger into a hole beneath the trap door, and goosed into view a small bird with black-and-yellow wings and a red face, which stood beside the hole and looked back at us, more or less, its lids half-down across its eyes. With some private smugness I was able to recognize it as a European goldfinch, but it was a sorry and draggled specimen by that point, swaying and unwell.

"Oh, my," the hostess said with doubt, and from the carefree assembly came a few cackles and snorts of the kind that some people issue when nervous.

"Fly, cabrón!" Matias muttered to the bird, and nudged it again with his finger.

The goldfinch lurched, shat, and staggered across the icing, leaving tracks. At the rim of the cake it paused for a moment while blue fire singed its feathers, then toppled forward onto the table quite dead.

Against the ensuing babel, Matías was still muttering, but now directly to me. "He was supposed to *fly!*" he said, aggrieved almost to tears.

Maybe in essence that was bird observation in Mallorca . . . Nightingales did sing to us from the island's hillsides in moonlight, though, as they had sung to aboriginal slingsmen and to Phoenicians, Greeks, Romans, Goths, and the other waves of outlanders who had arrived there through the ages. You could hear them from a sailboat while easing along inshore under a soft night breeze from the land, with wavelets going chuck-chuck against the sliding hull.

5.

In the world's late 1950s and my own late thirties I came back to Texas for a visit, and stayed on because my father was ill. Nothing was pulling me elsewhere just then, and home ground seemed as good a place as any for thinking over what might come next. Such pondering was in order, since I had just blown more than two years' labor on

a novel that had turned out badly, and there was in my mind a large and darkish question as to whether I'd better seek out some other line of work, more standard and more gainful.

Characteristically, I guess, when the pondering turned gloomy I stuck it away somewhere and went off to do things I liked, there being plenty of things of that description in home surroundings not visited for years. Many of these involved people, mainly old friends—a philosophical rancher wanting book talk and a little help with his hay crop or calves, a lawyer who liked to sit up late over sour-mash whiskey and debate the plight of mankind, a family doctor whose joy it was to point out just where I'd gone wrong in life, a small-town merchant who collected the inscriptions from country gravestones and knew the tales of gunfights and Indian raids that lay behind them, three or four old cronies with whom I now had in common the mere but sufficient fact that we had hunted and fished together since the stage of Daisy air guns and cane poles . . .

As often as not, though, the things I liked to do were things I did alone. Sometimes with a gun or a rod and sometimes not, driving or walking or steering an old canoe I'd salvaged and patched, I poked around parts of the countryside familiar to me from so long before that to drop down into a limestone valley or to round a river bend, and then to see an elm tree or a cliff or a deserted shack that unconscious memory had known quite well would be there, had the resonant, echoed feel of dreams. So did the touch of the dry Texas winds, and the hill-Southern vowels in country people's talk, and the calls of the region's creatures whether I could put names on them or not.

Furthermore I piled up days on days into weeks haunting libraries: dredging up swatches of regional history that I'd known as a youth mainly in scraps and distortions, sniffing out the identity of wild shrubs and weeds whose leaves and blossoms I carried around pressed between dollar bills in my wallet, poring over pictures and descriptions of birds and small beasts and even bugs.

In some part of all this I had the stimulus of volunteer research and writing for a friend's project to restore some pioneer log houses, but the bulk of it, bookishness and rural roving and all, I did simply because that was what I felt like doing at the time. What it amounted to was a homecoming, a reexploration in adult years of roots and origins, an arrival at new terms with the part of the earth's surface that was and would remain, regardless of all its

flaws, more my own than any other part could ever be. The wandering years, it seemed, had served their purpose. I could now exist where I belonged, chasing echoes, without wondering if there might be better things to chase elsewhere. There weren't, not for me. I'd gone to a good many elsewheres and was glad I had, but I was back home now.

And without much dark pondering having occurred, the work that I wanted to do fell into place and began to speak in my own voice, for better or worse, of these matters and of others.

During this spell of homecoming and realization, not strangely perhaps, birds began to interest me more than they ever had before. Bird echoes in home country were strong echoes and frequently literal ones—a fluting or a chit or a squawk that spoke to old memory, but often without my knowing what creature it came from. This ignorance had never disturbed me much, but suddenly now it did. The time seemed to have come to find out, or at least to pull together and augment the scrappy store of awareness acquired from the South Texas uncles and country doings when young, from parents with a feeder outside their breakfast room, from the Horrible Doctor and George Williams and the old Spenserian in Austin and his green Carolina highlands, and in some degree from just being around for nearly four decades with eyes that had sometimes been open and ears that had sometimes heard things.

For dim and maybe shameful reasons I am an avoider of group activities and attitudes, a shirker if you like. So it is perhaps a measure of the seriousness with which I viewed birds at that time that I not only joined the local Audubon Society but even attended meetings and tagged along on Sunday morning bird walks, Christmas counts, and other such events. Blessedly, I found that many of the Audubonites were themselves staunch group-avoiders by temperament, who tolerated that one aggregation of people for pragmatic purposes like mine. They were a heterogeneous lot with a floating fraction of fringe loners far more cemented in misanthropy than I, the latter tending to stay in the Society's ranks for only a year or so before drifting back to solitude to mull over what they had learned. Reverting to character in time, I did much the same thing myself, but with a few lasting friendships and some gratitude that has lasted too. The best of the Audubonites had wide knowledge and were wholly generous with it, as are most people who love some field of inquiry for its own sake and not for cash or status.

Nearly all of them were likable, even when idiosyncratic. Consider, for example, Mrs. Y., a small and sixtyish widow with maroon-tinted hair and the innocent face of a vireo, who clearly lacked the urge to learn very much about birds but exulted in seeing them and endowing them with human traits and ways. I recall one handsome male oriole, a migrant Bullock's I think, which a group of us watched take a splashy bath in the shallows of a creek, then preen himself in sunlight while perched on a high twig. Finally he cocked his eye at us, uttered a hypocritical alarm note (who did he think we'd been, all that time?) and flitted off into the woods, whereupon Mrs. Y. said in delight, "Oh, look! There he goes to his little wife, all nice and clean!"

Harder-nosed birders, including me, felt protective toward her and feared that one of life's rough edges might lacerate her in passing. Hence we were agreeably astonished when she snagged a rich, tough, retired real-estate man in marriage and started going off with him on far-flung nature tours, anthropomorphizing glamorous fauna in habitats ranging from Malaysian rain forests to the fjords of Norway. But she managed to tempt her love into attending only one of the Society's meetings, at which they showed us some South American slides. He clearly viewed us as environmentalistic subversives in tennis shoes and refused to risk being tainted.

Or there was Mrs. P., the spouse of a subdued attorney who was seldom seen among us either, since he didn't care for birds. She was large, competitive, tweedy, and not overburdened with charity toward minds less quick and forceful than her own. If two or three of the other members knew perhaps a bit more than she did about the organization's main topic of interest, no one ever heard her admit it. The talk of gentle Mrs. Y. and other sentimentalists could set her to muttering and snuffling, and occasionally she got so fed up that she quit the Society and all its works for weeks or months on end, but always came back because she couldn't stand not competing. It was quite usual to have her desert a bird walk soon after it had started, stalking off in disgust with a military spine and her binoculars gripped in both hands. Sometimes she would rejoin us later and announce, glaring about, that she had just identified some species nobody else had seen—a black-headed grosbeak, maybe, or a barn swallow in summertime.

I remember a few polite questions from our other experts in regard to these unusual sightings, but never any very spirited expressions of doubt. For one thing Mrs. P.

did know a lot about birds, and for another there was her aspect. I liked her. Even at her most outrageous she had a spark of fierce intelligent humor, and she kept things nicely stirred up. But I never could blame her lawyer husband for being subdued, or for his want of interest in bird life.

We had a real ornithologist too, a dedicated professional who maintained contact not only with that chapter but with some in other cities, since informed amateurs were a good source of leads and data. Though the members respected his knowledge, some were upset by certain of his practices, in particular his occasional "collection" of museum specimens with a shotgun. This feeling switched strongly toward me after I showed him a nesting population of golden-cheeked warblers in the limestone hills southwest of Fort Worth where I'd hunted and fished since youth, and where in fact I now live. The ornithologist was delighted, for the species had not been previously recorded in those parts, and he promptly shot a few to avouch their official presence. But *Dendroica chrysoparia,* shy and tiny and beautiful and rare, is a sort of totem for Texas birders, and when word of these slayings leaked back to the Audubonites, as word inevitably did, the more puristical of them seemed somehow to blame me more than they did the killer scientist, and I never did get all the damage repaired.

It was trouble that had been waiting to happen, for these folk were already darkly aware that I still went forth with a shotgun myself from time to time, and not in the interests of science. Relations between hunters and other nature enthusiasts can be complex, and they produce some odd connections. One of the brightest of the Audubon ladies, for instance, had started birding as a young bride while accompanying her husband on his forays after doves in autumn, studying more fortunate unsporting species while he blasted away at graceful gray shapes hurtling across the blue. Though in the end she had cured her mate of his blood lust, she looked back on those younger days with nostalgia and viewed my known wrongdoings lightly, sometimes teasing me about them.

Not so the true Thoreauvians, who recognized evil when they saw it, especially after the Golden-Cheek Massacre. These were mainly quiet and gentle people in whose blame there was less anger than silent or muted reproach, and with a long-familiar itch of guilt I was privileged yet once again to see myself as Mr. Hyde.

It was not guilt, however, but practicality that made it tough for old Hyde to fit birding and hunting together within the shape of his own life. Hunting usually takes

place where birds abound, but watching them is another matter. Dove hunting may pose the most conflict, for it entails a lot of sitting and waiting and looking around, and it comes in September and October when many local species of birds are ganging up for migration and northern sorts bound southward have started to pass through. Armed and camouflaged and stool-seated beside a stock tank or a stubble grain field, let's say, you become aware of eight or ten kettling hawks in the sky, buteos of some sort, tailing one another in a lazy-soaring spiral while the spiral itself drifts swiftly southward with one of the season's frontal winds.

You lay your gun down and seize the field glass dangling from your neck. Three good pink-breasted doves come whistling along the wind from behind your right shoulder and you grab up the gun and fire, too late to have a chance of hitting one. By the time that disgruntlement expends itself in bad language, the hawks have become a pattern of mere dots far to the south, unidentifiable even when magnified. Further bad language ensues . . .

6.

My hitch of active duty with the Audubon Society lasted for a couple of years or so, and for two or three years longer I kept on birding alone or with friends whenever I had the time. As a result I turned at last into a fair-to-average student of the subject, achieving not expertise but at least a general familiarity with our local birds and their ways. That was fortunate, for soon afterward the demands of a new stretch of life, with a new set of interests, pretty much swamped ornithology. If serious birding doesn't fit well with hunting, it fits little better with building fences and barns and a house, gardening, handling livestock, tending bees, tilling and sowing and harvesting field land, and any number of other purposeful rural activities that during the next fifteen or more years were central in my mind. For the regional countryside was where that homecoming led me and mine after I married, grew used to the notion of staying in one place, and metamorphosed backward into an ostensible Texan again.

Of existence on this rock-strewn, hilly stock farm of ours, I have written in other books and I won't dwell on it here. Early along, there was much hard work with a reasonable amount of fulfillment, and a perishable if requisite illusion of restoring the place to economic use, nearly

a century after the catastrophic depletion of its primeval soils by too much cotton on vulnerable slopes and too many cows on the grass. All of this required a certain earnest practicality of outlook, and not being in my heart of hearts a truly earnest or practical fellow, I am relieved and grateful in this later time to find that the best thing I've acquired in these battered, cedar-clad limestone hills has been not the mastery of yeoman skills, though I'm glad enough to have done all that, but simple awareness of natural rhythms and ways while living on the land through the seasons' cycle, year by year.

Awareness certainly of the land itself—of what it can and can't be made to yield, of what men have done to it and the revenge it has taken for this. But awareness too of wild creatures and plants, and of the ways in which they function with dirt and terrain and climate to shape a whole pattern of livingness, even in tired and diminished places. Even here. Their pattern will exist when I am gone, and with luck even when our civilization is gone. That the comfort to be found in this thought is of a brownish hue, I grant, but being of sunny disposition I see it as comfort nonetheless in an age woefully short of such reassurance . . . In their vastly differing ways, things squabble for territory and for mates, pair, produce young, feed, and are themselves fed on in their turn, croaking and whistling and grunting and howling and singing and issuing their other noises, if any, along the way. And all life passes back to the dirt and the water for digestion and renascence, quite simply yet very complexly and without ever reaching an end, thus far at any rate.

These things I seem to comprehend best, though never entirely, here on this piece of home ground—in terms of such things as coyote versus red fox populations, or the prosperity during drouth of an individual great blue heron in relation to a specific dwindling creek pool full of minnows and sunfish. And I guess this is why, most of the time, I remain content these days with the birds I can see and hear on my restricted rock pile, like my parents in their shady back yard long ago. Over the years I have had pleasant chances to view new species in new surroundings through one circumstance or another—writing assignments that took me elsewhere, a stint with the Interior Department in the Potomac river basin, treks to Mexico with the Horrible Doctor during a time when his chief passion was bringing back tropical species for an aviary at the Houston zoo, fishing trips to the Rockies or the Florida Keys. But home seems to be where I can discern patterns most clearly, or can best attain the illusion

of discerning them, and home is where the birds have come to mean most to me.

The old, sharp, Audubon Society cognizance of detail—of wing bars, eye rings, streakings and specklings of breast, alarm notes, and so on—has blurred quite badly in my head through the years of absorption with yeoman matters, and I seem fated to spend the latter end of my days as a mere glimpser of birds. But we live our lives among them here, glimpsing many in the course of a country year, and in some ways they have more meaning for me now than when I was studying them more closely. I am most fully aware of birds while nosing around without haste or real purpose, say down a stream or along a wooded slope, conscious of winds and sounds and flitting motions. But I heed them too when performing such unhurried, ruminative tasks as patching fence, pruning fruit trees and vines, or wandering through brush in an effort to find out where some heifer has hidden herself to calve. And these days, agreeably, there seem to be more of such easygoing things to do than of the arduous, earnest ones that prevailed when energy was younger and the economic illusion still thrived.

Even indoors, unless you lead the sort of sealed-off life that is warmed and cooled all year long by machines, birds are often with you. Their songs and calls are audible during much of the year, and if you have the vice of glancing out doors and windows, you're often not really inside at all. The big metal-framed casement of my office at the rear of our barn, for instance, has a view that encompasses, near at hand, a pile of old lumber, some farm machinery and rusted junk, and a few twisted live oaks. Farther out, it widens fan-shape across ten acres of rising, grassy horse pasture with woods at the higher end. Each tree and stump and boulder and fencepost of this unspectacular vista is engraved on my mind, and many a time over the years, sitting at the typewriter, I have been lured away from composition by small natural dramas being enacted somewhere within it, easing out with a field glass to ascertain what kind of flycatcher is assaulting grasshoppers and butterflies from the top wire of a fence, or to analyze the tactics of a bullsnake in its raid on a mockingbird nest.

Hawks are perhaps the worst seducers. I've never learned them right, and when a problematic one shows up, something in me always hopes it may bring final enlightenment. So far none has done so, but some can do interesting things, like the sharp-shin that once zoomed under my office awning in hot pursuit of a junco and

loudly broke his neck against the window. I felt much worse about this than I imagine the junco did, but the mishap did provide some uncommon barred feathers for use in tying trout flies.

7.

Mr. Hyde is still on hand, I guess, though much enfeebled by time. Dedicated hunting does not seem to mesh much better with country life than does dedicated birding, not only because of yeoman preoccupations but also because various sorts of quarry are always around, and going after them becomes less a ritual occasion, planned and prepared for, than a matter of momentary whim. For a long time I did more or less adhere to a pattern of eating wild meat or fish once every week or so, shooting a deer for the freezer most years, and rambling occasionally about the place to see what the Red Gods might provide for supper, whether a widgeon or a gadwall from the weedy stock tank on the hill, a couple of squirrels, a panful of sunfish from the creek, or whatever. Increasingly, though, these deities have seen fit to provide little or nothing—in part because aging legs and eyes and reflexes have reduced the range of my outings and my ability to handle a gun as swiftly and well as fond memory claims I once did. In part too, I'm sure, it's because with the years one's quieter, gentler self gets a bit bossier than earlier in life. Even angling, though I somehow love it more than ever, is a much less intense affair than I used to make of it, for I take my time on the water, gaze about at bugs and birds, and sit down on rocks or grassy banks to ease my joints and to think and putter with tackle. As often as not nowadays I find myself releasing caught fish to the pools and riffles they came from, undamaged save for an instructive sore lip.

Quite possibly old Hyde will wither away before I do, and I'll finish my years as purely a watcher and thinker in relation to natural things. In honesty I don't find myself yearning toward such a state of being, for all my life hunting and fishing done right have been a fulfillment, and a ritual link with past generations of my people—with all predatory people, for that matter, back into times when the planet was teeming with live wild meat across its wide surface, and all of mankind had blood on its chin just like my Horrible Doctor.

But there are occasional signs . . . One morning four or five Aprils ago, I was waked in gray light by the loud

gobbling of a turkey cock close at hand. I rolled up on an elbow and looked out the window, and there he was in the little orchard below the house, not more than fifty feet away. He was blue-headed and bronze-feathered and huge, with red wattles distended and tail fanned wide to show that he craved a fight or a tumble or both, and didn't care who knew it.

It was fine to see him. They have been returning to our part of the country in recent years, aided in part by state releases of fresh stock and by a series of moist springs favorable to hatching. But the main helpful factor has been a dwindling of the region's old native human population, as high land prices have tempted them to sell out and their progeny have emigrated toward urban wages and ways. These people's gradual fading is something I've regretted, for in general they were tough, wry, enduring folk more attuned to life on this hard land than we late-comers are or can be. In terms of wildlife, though, it is hard to feel very bad about the change. If something was meat they killed it and ate it as their forebears had done forever, without a thought for effeminacies such as game laws, conservation, and the survival of breeding stock. They also liked lots of poundage in return for ammunition and effort expended, and in consequence thirty or thirty-five years ago it was hard to find sizable wild creatures anywhere in the neighborhood, except on three or four big ranches with jealously posted boundaries. Jacklighting deer was an honored tactic, as was the wholesale slaughter of turkeys on flock roosts at night. One local told me with quiet pride, in describing such an expedition, "I do believe we got the last one."

I was shaped otherwise, and despite a couple of excesses with ducks on the Houston prairie in college days I've never been much drawn toward carnage. Nor does the restricted type of hunting that I really care for—the wingshooting of small upland species with lots of firing and relatively scant results—include such things as turkeys. The only one I'd ever killed had been on a friend's luxurious deer lease, a deed carried out half-reluctantly and without great joy in the aftermath. A couple of times recently I had watched a winter flock of thirty or more forage through our yard while I sat on the porch, untempted.

Nevertheless, I wanted that big handsome tom in the orchard. If I didn't know just why, I didn't know why not, either. Taking him would be legal, the spring gobbler season being open, and moral enough in terms of the scheme of things, since any hens that he didn't breed

would be bred by his polygamous rivals. His flesh would be put to use. Even his plumage would, though a good many years of my kind of fly-tying wouldn't consume it all. And there he strutted, oblivious and full of himself and more or less asking for it.

The only gun close by was an ancient Winchester twelve-gauge pump of the sort with a visible hammer, a family heirloom kept in the bedroom closet with a handful of buckshot shells. Sliding out of bed and loading this relic, I eased through the door onto an open porch and peered around the corner of the house. He was still magnificently there, and still so charged with lust and ego that there seemed to be no room left for the fabled wariness of his kind. While I watched, he drooped his wings and rattled their flight quills and did a little dance step on the dew-spangled grass, beautiful and ridiculous both, before vibrating all over as he rolled out another proud gobble upon the morning air.

I clatched the old shotgun's hammer back and laid the bead sight on his bald blue head, which at that minimal range with a full-choke twelve would shortly not exist. Except that I looked down the barrel for a moment too long, then raised it toward the sky.

"Damn you, turkey!" I said. "Get out of here!"

My voice and the movement of the gun made him swivel his head to fix on me an eye from which the glaze of self-esteem was quickly fading. He said in alarm, "Pitt! Pitt!" and deflated, his fluffed-out feathers closing down against his body and his widespread vertical tail collapsing to a streamlined wedge. Then he lowered his head and wheeled and ran like hell down the alley between two rows of trellised grapevines, and I fired a blast in the air to speed him as he skimmed over the lower orchard fence and dashed into brush beyond.

Only at that point did I notice that the spring dawn chorus of small birds had been in full throbbing voice, because they hushed when I shot. But very soon a redbird throated chew, chew, and a Bewick's wren itch-itched and trilled, and one by one the others came in until the whole sweet, pervasive cacophony was filling the air again. Sometimes half-awake in bed at that time of year and that time of day, if I'm trying, I can count ten or twelve species by the sounds they make, while hearing other familiar ones that I can't name. It is fine to listen to them, and fine to know the little that I do know about them, and fine to have them there.

It was fine to have the big tom turkey there also, and he wouldn't have been if old Hyde had had his way.

8.

Sometimes birds impinge on our lives here in minor practical ways, as when a specific flicker goes queer for the house's plank siding and starts to chop round holes in it, or when jovial pirates of several species gang up to plunder the orchard's ripening fruit. Sometimes also, types from outside the usual pattern appear—a pair of goshawks that winter in the farthest hill pasture, a parakeet hanging around the corrals and hobnobbing with goats, a golden eagle, a Western tanager, a single night-heron that arrives late one summer and for a couple of months rasps out his lonesome complaint in the small hours, or maybe he thinks it's music . . .

In the main, however, the ones that are part of our lives are pleasantly predictable in their ways, driven by seated instincts and by the shape of the year. The most comfortable presences, old friends sometimes recognizable as individuals with quirks, are the year-long residents like mockers, wrens, cardinals, quail, titmice, buzzards, roadrunners, owls, and so on. But there is a familiar rightness too in the northern species that spend the cold months with us, ranging in kind from small, secretive, brush-loving finches of many varieties, to bluebirds, waxwings, flickers, and huge barking aggregations of robins addicted to cedar berries. Spring takes these away abruptly, but in recompense brings back others that have wintered to the south, of which each sort arrives in its time, with its own sounds and rules of conduct and its own infusion of procreative fever.

Phoebes build nests beneath the house's eaves and overhangs and in the open-ended barn. Wrens stuff theirs into the fan housings of tractors and all other hollow places they can find. Bright summer tanagers set up in the elms and chittamwoods beside the apiary, snatching slow nectar-heavy bees from the air. Yellow-billed cuckoos, our "rain crows," speak no Old World words of fear but cluck prophecies of moisture that all too seldom come true, here on the fringe of West Texas. Crested flycatchers wheep and issue fartish frog calls. Scissortails start squawking loudly at the first hint of dawn and keep it up all day. Golden-cheeks pipe faint thin music on the cedar slopes across the creek, painted buntings squeak theirs in the orchard, and all over the rocky, brushy landscape dozens on dozens of additional species find their territorial niches, announce their claims melodiously or otherwise, and assume their functions of courting, begetting, eating, and being eaten.

Because our neighborhood, by and large, was too starkly despoiled in the old days to be worth much further ruinous human attention now, our resident birds do well enough most years. But those whose genes impel them toward travel face queer poisons and forest destruction and other misfortunes in distant places these days, and sometimes don't show up when they're supposed to, or at all. The rough-winged swallows that used to burrow nest holes in dirt bluffs along the creek were such a casualty a while back, and every passing year or so, whether through real subtractions of this sort or through my own ineptitude and slothfulness as an observer and listener, one or another usual species seems to be missing.

Thus there is affirmation in the continued passage northward and southward of the more spectacular migrants, dramatic in size or numbers or both, which seldom stop here even to rest. In some crystal, melancholy November spell with a new norther blowing down crisp from Canada, the yelps of geese and the grating calls of sandhill cranes may sound at intervals all day long as the big chevroned flights move across the sky, and in the sight of them there is exultation that such creatures can still exist in our people-teeming and extirpative times.

Some years thousands of gulls, startling in this dry hinterland, fly through at treetop height in raucous, disorganized waves, and watching at a lucky time you may sight white pelicans in tight, high, slow-flapping flocks, or even tall whirlpools of silent hawks, rarer now. And all the while, myriads of smaller, less conspicuous birds are also moving through, usually in darkness, bound north or south according to the season. These do often pause among us to rest and feed, and may show up colorfully at times, as when a mixed throng of warblers speckle a newly leaved pecan tree with their bright vernal plumage in May.

Of all these passers-through, the species that means most to me, even more than geese and cranes, is the upland plover (I have never been converted to use of its new name of upland sandpiper), the drab plump grassland bird that used to remind my gentle hunting uncle of the way things once had been, as it still reminds me. It flies from the far northern prairies to the pampas of Argentina and then back again in spring, a miracle of navigation and a tremendous journey for six or eight ounces of flesh and feathers and entrails and hollow bones, fueled with bug meat. I see them sometimes in our pastures, standing still or dashing after prey in the grass, but mainly I know their presence through the mournful yet eager quavering whistles they cast down from the night sky in

passing, and it always makes me think what the whistling must have been like when the American plains were virgin and their plover came through in millions.

To grow up among tradition-minded people leads one often into backward yearnings and regrets, unprofitable feelings of which I was granted my share in youth—not having been born in time to get killed fighting Yankees, for one, or not having ridden up the cattle trails. But the only such regret that has strongly endured is not to have known the land when it was whole and sprawling and rich and fresh, and the plover that whet one's edge every spring and every fall. In recent decades it has become customary—and right, I guess, and easy enough with hindsight—to damn the ancestral frame of mind that ravaged that world so fully and so soon. What I myself seem to damn mainly, though, is just not having seen it. Without any virtuous hindsight, I would likely have helped in the ravaging as did even most of those who loved it best. But God, to have viewed it entire, the soul and guts of what we had and gone forever now, except in books and such poignant remnants as small swift birds that journey to and from the distant Argentine and call at night in the sky.

STUART GENTLING

DEDICATION TO THE FOLIO EDITION

With *Birds of America,* John James Audubon created an unmatched monument to the beauty of his country's wildlife and proved himself one of the truly great bird artists of all time. Since his day, there have been many painters who have surpassed him in the scientifically accurate portrayal of birds, but for Scott and me, his work still stands fresh, unique in spirit, and unrivaled as art. It possesses a vitality and elegance of line and color and composition that continue to excite and inspire us. Though our own artistic interests have taken us in directions far removed from our early bird paintings, we have never lost our original delight in painting pictures of birds, and I suppose we never will. Though we have developed our own styles of bird painting over the years and continue to make changes in the way we approach the subject, the pervasive influence of Audubon's art remains with us.

With these dry-brush watercolors, we have combined our personal visions of the birds and the land of Texas with our own sense of composition, line, and color to bring to you a testament of our love of the people, the history, and the wildlife of Texas. If in doing this, we can honor our state and pay homage to John James Audubon, recognizing the part that both have played in our lives, then so much the better.

John James Audubon by Scott Gentling. Collection of the authors.

FOREWORD TO THE
FOLIO EDITION

*M*y friendship with Scott and Stuart Gentling goes back a long way. I believe that I first encountered them back in the mid-1950s in the auditorium at the old Children's Museum, which is now called the Fort Worth Museum of Science and History. They had come to see a film which my wife Gloria and I had made while on safari in Tanganyika. I remember them sitting next to us on the front row, silently watching me as I narrated our travels to the audience. They seemed so shy, so quiet and polite, but as soon as the movie was over, they began to besiege Gloria and me with a thousand questions, and I don't think they have stopped since.

Each of us has a God-given talent of some sort. Their talent for reproducing something beautiful, perfect in every detail, is what I have admired since I met these two fabulous young men. Because of our long association, our family probably owns more of their work than anyone else in the world. We have had some of their pictures for over twenty years and have watched their reputations grow as the general public has become aware of their work. Their art has that wonderful quality that keeps me going back again and again to rediscover some special detail or to relive the many fond memories which their paintings so often evoke. They usually spend Christmas dinner with us, bringing with them their infectious and mischievous grins which light up the room, giving everyone else the same warm glow. Not only have they become known in our neck of the woods for their artistic abilities, but they have also become local legends for some of their teenage escapades.

From a very early age they grew to love the study of wildlife, especially the birds that inhabited the Trinity River bottom below the cliffs of Rivercrest on the west side of Fort Worth. They roamed throughout the area, collecting birds much as Audubon had done. Stuart usually did the collecting to get specimens on which to practice taxidermy. Though it was only Stuart who did the taxidermy work, the brothers shared a keen interest in drawing, and it was only natural that they would make drawing

studies of the birds which were brought home. I can safely say that their childhood interest in drawing and painting, as well as their love of nature and their early appreciation of the work of Audubon, started these twins on their way to becoming professional artists.

Whether or not the Gentlings were aware that they were on the path to becoming artists in those early days, they certainly made a few interesting detours along the way. One detour in particular nearly scared me to death. They, along with three or four of their friends, had been inspired by the recent news of Russia's successful Sputnik launch. They decided to manufacture a three-stage rocket of their own to be powered by black gunpowder. These rockets were made of soda straws! Since they were too young to buy the gunpowder, they managed to talk me into buying it for them. It may be questionable whether they showed any genius in this project, but they did manage to launch more than a dozen of their three-stage rockets before the Russians. The end of their experiments came very abruptly, however, when one of them accidently ignited a whole can of black powder while priming the launching pad. I will never forget the way they looked when I went down to the hospital to see them. They were quite a sight with their blistered faces and their eyebrows and scalps not much more than singed stubble. They had gotten off lightly, considering what could have happened, and they were more embarrassed than in pain. But at least they had beaten the Russians!

Apparently they were not discouraged from experimenting with gunpowder, for although they did give up making rockets, there was only a momentary lull before they used this explosive on another project. One Christmas they showed up in our driveway with a big cannon. It was a two-thirds scale replica of a six-pound Civil War cannon, beautifully constructed in every detail. It weighed 750 pounds, and it worked. They had come to demonstrate the cannon, and before I could say anything, they fired it off. I am sure that cannon scared everybody within ten blocks of our house. The cannon was eventually retired forever, I think, though it would not surprise me if it were still around. At least I made sure that they did not get any more black powder from me, and our neighborhood remained relatively quiet. With those inventive kids around, however, too much quiet could be as unsettling as a lot of noise. I knew these boys well enough to realize that the rumors of their having constructed a nineteen-foot-tall replica of a guillotine, complete with a sharpened blade and scaffold, at the Gordon's house down at

the end of the block had too much the ring of truth to be discounted.

It was about this time that the twins, along with some of their close friends, began to raise pheasants at a pheasant farm which they had built out of sight behind young Tom Loffland's house in Westover Hills. These were not just ordinary pheasants. The boys had an extraordinary collection of some of the most exotic varieties in the world and certainly one of the largest collections in Texas. If we thought that this promised to be a relatively quiet and peaceful pursuit, we had another thing coming. The spring mating calls of the birds could be heard from one end of Westover Hills to the other, and there were enough escapees from the boys' pheasant farm to keep their combined parents running all over Rivercrest and Westover Hills trying to round them up. I don't know if they had intended their enterprise to be a profitable one, but I certainly was one of their best customers. Once a year I purchased Ring-necked Pheasants from them for the annual game dinner held by the Sportsman's Club of Fort Worth. College activities, I believe, finally put an end to their pheasant business, but memories of it linger on.

The projects that I have mentioned were some of the early activities of the Gentlings in which I played a part. Of course, there were others that we only knew about through hearsay. I would still like to know more about their experiments at the house of our young cousin, Denny Woodson, where they built, I am told, a large and impressive glider wing to be used for manned flight.

Those early years, those early experiments, all must have played their part in the formation of two brilliant artistic minds. For now I am marveling at the immensity of purpose, the genius of perception, and the historic advent of this monumental book. It is a living memorial to the artistry of two young men. It will be appreciated and shared by future generations whose contact with some of these birds will be gone forever. Having been for many years both a hunter and conservationist, I have witnessed the disturbing changes which humanity has wrought upon the earth and its creatures. A publication like the Gentling book is a rare event in any age. It is certainly an artistic triumph, but its greatest success will, in my opinion, be guaranteed if it persuades an often indifferent public to look at nature again through the Gentlings' eyes and, in experiencing the beauty of these works, to realize that the beauty of the world is for everyone and must at all costs be preserved.

Whatever the future may be, I do know that this book,

Of Birds and Texas, will serve as a guide not only to bird lovers but to all kinds of people everywhere. I have had the very special advantage of having witnessed the Gentlings' progress from the point of view of a close friend. I have watched them grow in skill and in stature and seen the promise of their early work fulfilled. I am very proud of the small part I have played in the development of their lives. Although Gloria and I and the rest of our family, in-laws, nieces, and nephews included, claim the two of them as belonging to us, Scott and Stuart Gentling, like all important artists, belong to the world. They have added much to our lives—all of it enjoyable—and I know that they will add a great deal to the lives of all of you who are lucky enough to own one of these books.

INTRODUCTION TO THE
FOLIO EDITION

Scott and I are frequently asked why we are publishing, as our first book, a volume about Texas birds, since for almost thirty years we have been painters of pictures whose subjects have not been primarily those of wildlife. In seeking an answer to this question we must look at the beginning of our careers as artists.

There was no time in our childhood when we were not making something. Our interests were intense and far ranging, and the freedom with which we were allowed to indulge those interests gave us invaluable opportunities to grow in any direction we wished. Although we had been drawing and painting almost from infancy, we regarded this as nothing unusual—just another tool to be employed in the service of our projects. The fact that we were not induced to focus our energies or limit the reach of our curiosity was, without a doubt, the most important element in our creative lives at this formative period. From very early on, our interests covered a broad spectrum, from the study and collecting of such natural history subjects as fossils, birds, animals, and insects to researching pre-Columbian and Old World civilizations and making drawings and models of practically anything having to do with these studies.

Our bedroom became a disorganized workroom and laboratory. Our mother never gave up trying to get us to keep it clean, but even her untiring efforts were to no avail. Anyone brave enough to enter our *sanctum sanctorum* in those days would see two desks practically buried under pieces of balsa wood, glue tubes, and bottles of paint, or models of seventeenth- and eighteenth-century ships, or models of ancient Roman buildings and bridges, or HO-gauge model railroad structures, or piles of bird and animal skins, or stuffed specimens rising from the debris of wires, glass eyes, bundles of tow, borax boxes, and my assorted surgical instruments for the practice of taxidermy. There was also a drafting table in our room which was usually covered with model building materials and drawing tablets, pencils, paints, and brushes.

When our parents held their frequent dinner parties, part of the evening's entertainment was often a brief tour of our quarters. These expeditions were certainly not

my parents' idea, but they would usually give in to the entreaties of curious guests so that a visit to our bedroom became almost a ritual. I can remember one rare occasion when our room had somehow been miraculously cleaned up for a garden club tour of the house. I am sure that Mom was hoping that the room was clean enough so that the tour guests would stand at the bedroom door, look, and then simply pass by. She had not counted on the fact that in the game bird incubator next to my bed some fifty pheasants had chosen the day of the tour to hatch out into the world. Poor Mom! She could do nothing to prevent the logjam of tourists who gathered and remained in our bedroom to witness this unexpected spectacle. Needless to say, the house tour became considerably more complicated. Such scenes were not uncommon in those days, and the general disorder that was seen in our bedroom quite accurately reflected the curious tangle of our interests.

Then in the autumn of 1956, we discovered a book, *Birds of America,* by John James Audubon, containing reproductions of all 435 plates engraved by Robert Havell. It was a profound revelation, and although we were unaware of it at the time, our careers as artists had begun. It is in celebration of this discovery and of the effect it has had on our lives that we have dedicated our book to Audubon's memory. His influence flows like a pleasant undercurrent throughout the pages of this book.

It should be kept in mind that, in addition to the paintings of Audubon, we have been influenced by other painters from both Eastern and Western cultures whose works have been published during the last 250 years. Since we have been particularly affected by our longstanding interest in picture books of American birds, perhaps it would be useful to review some of these and to take a brief look at a few of the artists from both West and East whose works have left their mark on this special art form. Such a review will help the reader to appreciate the historical context in which our own book has been created.

One of the first publications containing American birds was a book published by Mark Catesby between 1731 and 1743 called *A Natural History of Carolina, Florida and the Bahamas.* It is a folio of plates etched and hand-colored by Catesby and his assistants in London from observations and materials gathered during two trips to the American colonies in 1712 and 1725. Of its 220 pictures of New World fauna, 109 depict birds. Although they demonstrate clearly that Catesby was no artist, they have much naive and charming beauty. They were not to be surpassed until the Scottish naturalist Alexander Wilson published

the nine volumes of his *American Ornithology* in Philadelphia between 1808 and 1814, the first book of its sort ever published on this side of the Atlantic. As an artist, Wilson was considerably more accomplished than Catesby, and his pictures have an appeal, despite their general stiffness and want of sophistication.

After Wilson died in 1813, Charles Lucien Bonaparte, a nephew of Napoleon, published a four-volume supplement to Wilson's work entitled *American Ornithology—Birds Not Given by Wilson.* It was issued in Philadelphia between 1825 and 1833. This Bonaparte edition was important in that, for the first time in American publishing, it brought to the task of bird portrayal the services of professionally trained artists, the least talented but most prominent of whom was Titian Peale, a member of the famous Peale family of Philadelphia painters. In the eyes of those who care about bird art, however, the book has another notable claim to distinction. Though Peale and a man named Alexander Rider designed a majority of its illustrations, this publication contained work by a then unknown artist. It was a single plate, the picture of a pair of Boat-tailed Grackles, and the artist was John James Audubon.

Audubon was not to remain unknown for long, of course, for within two years he began publication of what I consider the greatest book of bird pictures of all time, his incomparable *Birds of America.* It was on Bonaparte's advice that he went to England to find a publisher, and there in London this great work was produced and issued between 1827 and 1838. All but the first ten of its more than four hundred hand-colored aquatint engravings were executed by Havell and his workshop of fifty colorists. Its scope will never be equaled or even attempted again. When compared with the size and format of previous publications produced in both this country and abroad, Audubon's book has few precedents. Doubtless, it was his aim to paint birds with scientific accuracy according to the knowledge of the time, but had he painted with only a purely scientific aim in mind, he could have produced a highly creditable body of work without straying far from the format of Alexander Wilson's books. He did not have to portray birds life-size as he chose to do. He certainly did not have to depict them against backgrounds of often extraordinary complexity and richness. The fact that he chose the double elephant folio size of 26½ inches by 39½ inches for his reproductions was viewed in his own time as being so impractical that it bordered on lunacy. Were these choices the acts of a naturalist-scientist or of an artist? Probably both. But where the naturalist

might have been content with a less ambitious undertaking, the romantic idealist, the artist in Audubon, could not. Scott and I believe that, while Audubon's best work is not always scientifically accurate, it has a spirit and an artistic rightness that transcend the demands of science. His work may be of questionable validity to professional ornithologists or to dyed-in-the-wool bird people, but for Scott and me, who are artists first and bird people second, his paintings have never lost their unique appeal.

In terms of production technique, *Birds of America* was one of the last major books published that employed in its purity the process of etching, engraving, aquatinting, and hand coloring. In the 1830s, new advances in stone lithography began to have an impact on the reproduction of pictures for publication, and although with these processes the pictures were still colored by hand, the use of printed coloring lay only a few years ahead. These rapidly evolving changes can be seen in relation to Audubon's own work. By the 1840s, he was relying upon the hand-colored lithographic process for the production of his famous *Viviparous Quadrupeds of North America* in Philadelphia, and not long after his death, his son made an attempt, cut short by the Civil War, to reissue *Birds of America* by means of a completely lithographic process with the colors applied directly to the stones. During the postwar decades, this chromolithographic process was refined and perfected, and the subsequent advances in photographic reproduction have steadily brought us forward to the present era of high-tech photolithographs. It is quite possible to lament the loss of the personal touch found in engravings and stone lithographs colored by the brushes of individual craftsmen, but the fact is that photolithography in its present form produces a print more nearly like the artist's original painting than any other means yet devised.

Along with improved methods of reproduction have come new generations of bird painters and a new awareness of other such painters, old or modern, from non-Western cultures. In this country at the end of the nineteenth century, there emerged an artist whose influence is still felt strongly today and whom many observers believe to have been the finest of all American bird artists. Louis Agassiz Fuertes showed birds for the first time with their own local colors intimately affected by the colors of their surroundings, as they are actually seen in nature. He died in 1927, but his style and approach can still be seen clearly in the work of his two best-known followers, George Miksch Sutton and Roger Tory Peterson.

Some other important influences on current bird painting have come from artists outside this country. From Britain we have the early examples of Selby, Lear, Gould, and others. On the continent two artists have exerted an influence almost as extensive as that of Fuertes. These two contemporaries of Fuertes were Bruno Liljefors of Sweden and Germany's Wilhelm Kuhnert, both of whom took a step beyond most of Fuertes's work by emphasizing the pictorial structure and background environments as strongly as the birds and animals they depicted.

Liljefors, in particular, achieved in his aesthetic approach an almost mystical union of bird and background so that they are viewed as inseparable. He accomplished in a purely Western way a philosophical ideal that had long been the concern of Chinese and Japanese artists, whose work has become increasingly familiar to European and American art lovers in recent times. My own favorite periods of Chinese bird painting are the Sung, Yuan, and Ming Dynasties. This great creative age, a virtual Chinese Renaissance, spanned the years 960 to 1644 of the Christian era. Although it was not the aim of such artists as Mu-ch'i, Li An-chung, and the Emperor Hui-tsung to render backgrounds in the detailed fashion found in much of Western art, I believe that nowhere in painting can there be found a better expression of spiritual harmony than in their work. And while it is true that the painters of the later Ming Dynasty of the fourteenth century and after placed a sometimes disproportionate emphasis on the decorative qualities of their bird pictures, an artist like Yin Hong attained, in my opinion, a visual richness and a poetry equal to those of his predecessors.

This decorative tradition reached its most spectacular expression in Japan from the sixteenth through the early nineteenth centuries, as exemplified in the screen paintings of Sansetsu, Sotatsu, Korin, and others. One special enthusiasm of mine is the early nineteenth-century renditions of barnyard fowl by Ito-Jakuchu. By the end of the eighteenth century, Japan had developed an active publishing trade, and one of the most outstanding books of the era was *A Chorus of Birds,* a set of colored woodblock prints by Kitagawa Utamaro, more widely known in the West for his Ukiyo-e prints of beautiful women. In the elegant use of line to create highly dramatic poses and profiles, these Japanese artists achieved a spirit and a sense of kinetic energy in their work that comes very close to those found in the paintings of Audubon, though it is almost certain that Audubon could never have seen their work. This spiritual affinity must in large part explain the widespread popularity that his paintings continue to enjoy in Japan.

Without a doubt, the representation of wildlife constitutes the oldest tradition in art. Prehistoric cave paintings show it to date back many thousands of years. During historic times in Western culture, however, it has until recently occupied a subordinate place in relation to other fields of painting and sculpture. Even the term "wildlife art" still bears a hint of prejudice, a suggestion that the painting of natural creatures is inevitably a realm for inferior talents.

Whether this attitude was justified in the past or not, it has been changing. During the past two decades or so in the United States and abroad, a revitalization has occurred in the portrayal of natural history subjects. In large part this has arisen from a heightened public awareness of environmental issues and a widening interest in the natural world and its depictions, which in turn has stimulated the growth of a healthy market for the genre. As a result, a good number of highly talented artists have been either entering this field or receiving at long last the recognition they deserve. Among my personal favorites, from this side of the Atlantic, are Guy Coheleach, Al Guilbert, Robert Bateman, and George McLean, but there are many other imaginative and gifted figures.

Although these artists exhibit a fairly wide range of styles and techniques in following their own paths, they clearly are the artistic descendants of men like Fuertes, Liljefors, and Kuhnert. If they cleave today even more closely to the ideal of scientific correctness, it is probably due to the powerful influence of high-speed photography and its ability to capture those subtleties of pose and attitude which eluded even the most sensitive artistic observers in the past. As an art form, the painting of natural history subjects is still considerably more flexible than photography; nevertheless, it is easy to see just how profound is the influence of photos and motion pictures on contemporary wildlife artists. And though, as I have said, a certain range of styles is appreciated by the public, most of the current professional painters working in this genre feel a pervasive pressure from the public not to deviate too far from the standards of photographic realism. Scott and I diverge from this mainstream trend in that we trace much of our style and our approach to painting birds to another source—the works of the Romantic painters of the nineteenth century and especially the art of John James Audubon.

Audubon's work has received its full share of criticism, particularly from scientific realists. Time and again I have talked about his paintings with leading wildlife artists, and more often than not they have tempered their praise of his abilities as a composer of pictures by observing that the forms and poses of his birds are often unnaturally stiff or distorted and that many of the paintings are simply too melodramatic. The implication, of course, is that these qualities are shortcomings which subtract from their value as art. The trouble with this view, I believe, is that *all* the elements of Audubon's pictures—including those qualities of occasional rigid formality and stiffness and the use of distortion in the shaping of violent action—do add up to art, and very fine art indeed, for reasons that have nothing to do with the super-accurate portrayal of wildlife subjects. To put the matter in the simplest terms, his paintings are genuinely beautiful *as* paintings—that is, in the entirety of their composition, line, form, and color—and the best of them have a very special elegance that has rarely been equaled. At the time of the original publication of *Birds of America,* an English critic made the observation that the book would probably have limited public appeal, since the pictures, he thought, were too aristocratic and exclusive for popular taste. His view, of course, was an elitist one, and he was wrong about the public's reaction, but in focusing on the aristocratic elegance of the paintings, he was on the mark.

If Audubon's work lacked strong artistic value, it would very likely have fallen into the sort of quaint obscurity that surrounds the pictures by people like Catesby and Wilson. The fact is, however, that his paintings are more popular today than they ever were, and their value for us continues to grow. We can never know just how many people throughout the world have been inspired to a deeper love of nature by the beauty of his paintings. This durable popularity is based not just in their abstract beauty and elegance, but also in a widespread nostalgia for the simpler and more heroic time in which Audubon lived and painted, that age of discovery and opportunity, freedom and optimism, whose spirit suffuses *Birds of America.* But I believe that, insofar as his paintings do actually reflect the spirit of America's Romantic Age and convey Audubon's own spirit as well, their value as important art cannot be seriously doubted.

Nearly twenty years ago, when Scott and I first discussed the possibility of doing a book on Texas birds, we decided that it would be inscribed to John James Audubon to commemorate his life and his many accomplishments. Though it was only by coincidence that 1985 happened to mark the 200th anniversary of Audubon's birth as well as the year that printing began on our book, somehow it seems appropriate. When we began to work on this project, we had no idea how long it would take to com-

plete the task. In all it has taken us about eight years to create the bird paintings for the book and to bring together the artists and craftsmen and advisors who have helped to make this publication possible.

It may seem odd to many people who are familiar with our landscapes, portraits, and still lifes that we are coming out with a book on birds as our first major publication. It is true that we do not consider ourselves to be wildlife artists in the same sense that this term describes others who have established their reputations in this profession. This book is perhaps best viewed as a labor of love, a personal and, until now, a rather private area of our artistic lives that has always been set apart from the rest of our painting. And yet, our careers as professional artists can be said to date from the time when Scott and I first discovered Audubon's bird paintings. *Birds of America* sparked an enthusiasm for his art that has remained with us to this day. Our early attempts at copying his paint-

ings and at imitating his style gave a direction to our childhood interests in painting, bringing them into focus for the first time. The drawing and painting skills that we acquired through such efforts provided us with the technical means and the confidence to create our own original paintings of birds and to expand our range of artistic expression in other directions.

There is no doubt in my mind that our painting today is the result of a long and natural evolution that began when we first started to paint with a sense of purpose inspired in us by Audubon's pictures. It evolved independently, with its own inner rules and not as a reaction to any trends in contemporary wildlife art. We hope that others will enjoy our paintings for what they are—the products of the personal visions of two artists who have had a long attachment to the study of nature and a quiet reverence for the works of one of our country's most outstanding artists.

The Land

SANCTUARY

This is the famous Spanish mission, Nuestra Señora del Espíritu Santo de Zúñiga, built about 1750 near the town of Goliad. The present building is a 1930s reconstruction of the church rebuilt upon the original foundations. We have chosen this picture to be plate number 1 in our book for several reasons. The missions of Texas represent the oldest tangible remains of European culture on Texas soil. Constructed by Indian laborers working for the most part under the kindly supervision of simple Franciscan priests, these buildings were erected when Texas was an ill-defined territory of Mexico, when Mexico was the center of Spanish power in the New World.

There is a feeling of peace and security about these ancient structures that belies their troubled past. Nearby is the Presidio La Bahía, or Spanish fort of Goliad, where Colonel James Fannin and his men were held prisoners before they were executed by Mexican soldiers acting on orders from Generalissimo Santa Anna. The massacre at Goliad was the single worst disaster suffered by the Texas colonists and their filibustering allies in the entire war for independence from Mexico.

Today only the quiet and peaceful aspect of these buildings remains to make them places for reverence and contemplation. The sanctuary door stands closed, but there is a silent invitation for the viewer to enter. With this book we extend to you the same invitation to come with us and experience the state of Texas, its land and fauna, and a bit of its history from the points of view of two Texas painters and an eminent Texas writer whose lives have been deeply influenced by this state.

SCOTT G. GENTLING (SGG)

LIMESTONE LEDGE

This is a watercolor painting of the Paluxy River near Glen Rose on a hot summer afternoon. John Graves lives not far from here, and I have named this painting "Limestone Ledge" after the title of one of John's books about his experiences while trying to carve an existence out of this hard country. The Paluxy's main claim to notoriety lies in the fact that it is one of the few places on the continent where fossilized dinosaur tracks can still be seen. These tracks, hidden for years beneath layers of limestone in river bottoms or in gullies on nearby ranches, come to light after flash floods erode the mud and break away the brittle rock layers that conceal them.

I like to think that, though the dinosaurs have been gone for millennia, this quiet stream bed is still inhabited by their distant descendants, the herons and egrets whose three-toed tracks in the river mud are only miniature versions of the spoor left by their ancient theropod ancestors.

STUART W. GENTLING (SWG)

DEER STAND

It is a pleasant autumn afternoon in a corner of a pasture on the McKay ranch near Tolar. At this time of day, the white-tailed deer leave their resting places among the thickets and begin to feed in the open fields. All seems peaceful and idyllic. But look closely. The sunlight strikes the edges of boards nailed to one of the tree trunks in a stand of oaks. It is a ladder leading to a hidden hunter's blind.

SGG

LOST AND FOUND

There it is! The culprit. The calf is back in the corral in solitary confinement. Who knows what troubles its owner had to endure to retrieve this runaway? It rests here by the barn, enjoying the sunlight and waiting for the next moment when its keeper drops his guard.

SGG

RED OAK

The red oak, a handsome species, is, I think, rare in Erath County, where this picture was painted. That it is here at all is because it was likely planted by somebody and, by its size, many years ago. But by whom? In the picture there are no tombstones to indicate a gravesite, no foundation ruins left to hint at nearby habitations and out-buildings. Perhaps a house was planned but never built because storms or droughts or economic disaster intervened. Ranchers and farmers here have lived closer to the edge than most other people and probably have a firmer grasp of reality's darker side than do the rest of us. The house, if one was constructed, is now utterly swept away, yet the red oak still stands, evidence, perhaps, of some unknown farmer's faith in the future.

SGG

WILD TURKEYS

The Wild Turkey is staging a comeback in many areas of North Central Texas. Here at "Twin Chimneys," a small farm and weekend retreat of friend Roy Browning near Gordon, the sounds of gobblers can be heard again across the fields and in the woods down by the creek. Only five years ago these same woods were silent of turkey calls. Here the birds are very shy and prefer to remain hidden among the trees and thick undergrowth. A heavy snowfall has forced them out into the open to search for food in the yard and among the outbuildings around the century-old farmhouse.

SWG

SNOW GEESE

The rice fields near Houston are the wintering grounds for thousands upon thousands of geese. Of all the varieties of migratory waterfowl that frequent the area, the Snow Geese are the most exciting to me. They have a purity about their plumage that recalls the snowy tundra of their arctic origins and hence the great distances they have traveled to reach our Texas coast.

Though the country around Eagle Lake where I used to hunt can get quite cold at times, the winter weather is frequently so mild that early morning fog often closes in to obscure everything beyond a few yards. When the geese lift off the lake in the early morning and fly out to neighboring rice fields to feed, they are sometimes hidden from view, but you can hear the sounds of their wings and their calling close overhead. These are thrilling sounds.

By mid-morning the fields are quiet, when the shooting has stopped and all the decoys and dead birds have been gathered. Fog still drifts in and drifts away, and the "snows" silently slip beneath the low clouds, set their wings, and land in the muddy fields nearby.

SWG

WINTER GRASS

There are two times of the year that have a very special quality for my brother and me. One of these is during the late summer when September's change of light becomes really noticeable as the sun shifts farther to the south and the first cool front passes through to relieve the heat and to hint of the coming fall. The other time is in February when spring is still a long way off, and parts of Texas are not yet free from late snowstorms. Again at this time the sun's progress is not only perceived but also felt as it moves northward. Though snow may yet remain in some places, the warming southern breezes are a telltale of the coming time of growth.

In following our daily routines, we seldom sense the shifts of light from day to day. I usually notice these changes on the first clear morning after several days of clouds. My mood at such times is deeply felt but difficult to describe—a strange but not unpleasant kind of emotional emptiness, sometimes tinged with a hint of optimism. It is a benign pause, a suspension or stillness that reflects a comfortable equilibrium in my mind that is neither summer nor autumn nor winter nor spring but on the edge of all possibilities.

This picture has that feeling for me. The evergreen oaks stand firmly in the middle of a large, open pasture, the field blank, still snow-covered but with the warming sun beginning to melt it away. For many people the color white, not black, is associated with death and mourning, but here, in the middle of this seemingly empty and wind-blown field, the melting snow is giving life to dormant roots and seeds, and a patch of grass is greening beneath the oak trees.

SGG

HARVEST

The black people in Floyd Valley in East Texas have their own ways of dealing with creatures that threaten their crops. Many of the older people here are heirs to ancient superstitions. When I began to paint Eddie and Clemmie McGary in the mid-1960s, the long hot days of posing them were made more bearable by Eddie's stories about local history and customs.

The McGarys lived in a two-room clapboard house located deep in the pine woods. The yard around the house was separated from the junglelike growth by a sort of stockade made of branches, and the ground inside this stockade was stripped bare of all plant growth except for a couple of trees near the house and a small patch of garlic growing by the back stoop. The site reminded me of the village compounds or kraals of many African cultures. Like their African counterparts, the stockade and clearing were created primarily as a protection against snakes and midnight animal marauders. Eddie was especially superstitious about serpents of any kind. He had much to say about their evil, magical powers. Most of his fears about snakes were ones that I had heard before—that rattlesnakes and copperheads are always found in pairs, so that if one snake is killed, the surviving mate will relentlessly pursue the killer for years until revenge is exacted or the avenging snake is killed. He was also convinced that any dead snake whose head was not cut off would revive after sundown and seek out those who brought it harm. Eddie was deathly afraid of the harmless coachwhip snake, a species which he thought could make itself into a hoop by taking its tail into its mouth, and then roll after hapless humans, easily overtaking its victims and lashing them by using its tail as a whip.

Some of Eddie's other beliefs were interesting. One afternoon while taking a break from my painting, I wandered out into the yard behind the house. There in the red earth was stuck a double-bladed axe head. Thinking that somebody might accidently step on it, I kicked it over. The next day I noticed that the axe head was back in the ground exactly as it had been the day before. When I asked Eddie about this, his answer was simple and practical. Because his house was built on a hill, it was vulnerable to destructive winds. By placing a sharpened axe blade in the earth so that it was exposed to the wind, the breezes sweeping over the hill would be split by the blade and diverted around each side of the cabin. I had to admit it was a perfectly logical solution.

Eddie McGary was also superstitious about birds. One afternoon while I was working on his portrait, I noticed a sudden worried look on his face. He leaned over and said something to Clemmie. She slowly got up, picked up a broom, and placed it across the open threshold. When I asked him about this, he answered in a whisper, saying that he had just heard an owl hooting in the woods. For Eddie and Clemmie as for many East Texas people, black and white, the owl is an omen of death. Placing a broom crosswise in the doorway was a way of warding off such evils.

Crows are a common and constant menace to area fields and nearby kitchen gardens. Eddie and his grown children living in the neighborhood had adopted age-old methods of dealing with them. One late autumn afternoon not long ago, Stuart and I stopped by Floyd Valley to see how it had changed in the years since we last had painted there. Eddie and Clemmie were gone forever. So were Robert and Annie B. and even Tom and Gene McCoy, who had introduced us to Floyd Valley and its people. Many fields once cultivated now lay fallow. Even some of the ramshackle houses that we had visited long ago and that had echoed with laughter and country conversation and the smell of woodsmoke and pungent cooking odors were no longer standing. But in one field that had belonged to Eddie's son Robert, now overgrown since the last harvest, stood several scarecrows dressed and turbaned like voodoo priestesses celebrating some secret ritual. Around the neck of one of these hung the body of a recently killed crow, magical and fetishlike. Even though they were not really needed at this time of year, these specter figures appeared well maintained, the dead crow more an offering to mysterious field totems than a warning to crop raiders.

S G G

UPDRAFT

Most of our lives are measured in cycles of one kind or another. Days and nights, the seasons of the year, life and death define our existence and provide a rhythm by which we measure our lives. Where it all leads, no one truly knows. Our ultimate destiny is a matter of faith, not knowledge.

This painting, titled "Updraft," is a quiet picture. It is a view of a section of the W. K. Gordon ranch near Glen Rose on a late spring afternoon. The pastures are very green and lush, a rare enough sight for this dry limestone country, and the wildflowers have taken every advantage of the damp weather. In the distance beyond the horizon, vultures circle in the updrafts overhead. These birds are so much a part of our forests and open spaces that they are practically synonymous with Texas. Somewhere on a distant part of the ranch something has died. The vultures and other creatures will benefit from this death, and new cycles will begin. Winter and spring. Death and rebirth. Where the cycle really ends—if there is an end—nobody knows.

SGG

The Birds

TURKEY VULTURE

The Turkey Vulture was always our choice for the subject of our book's first bird plate. Not only is this vulture indigenous to the entire state and a familiar sight to even the most casual observer, it also represents for me the wide open spaces for which Texas is famous as well as the timeless cycles of life and death and nature's constant renewal.

Perched on a branch high above the Brazos River at a point near what was once Dennis, Texas, this vulture prepares for flight by spreading its powerful primary and secondary feathers to catch the summer thermals rising from the river and the land below. These birds circle far and wide above the land, surveying with sharp eyes, noting every feature and detail, every changing aspect of the countryside.

The first Audubon bird print by Robert Havell that Scott and I collected was of the Turkey Vultures, plate number 151 from *Birds of America.* That print has always been one of my favorites and was very much on my mind when I drew this bird for our own color plate.

But while our picture of the Turkey Vulture honors Audubon, it also pays homage to John Graves and his book *Goodbye to a River,* a wonderful narrative about a three-week canoe trip down the Brazos River. All books by John Graves are special, but *Goodbye to a River* will always remain his best loved, and it is hard for my brother and me to explain how profoundly we have been affected by that book since we first read it in 1960. It was an answer to a dream to have Graves collaborate with us in the creation of this book.

<div align="right">S W G</div>

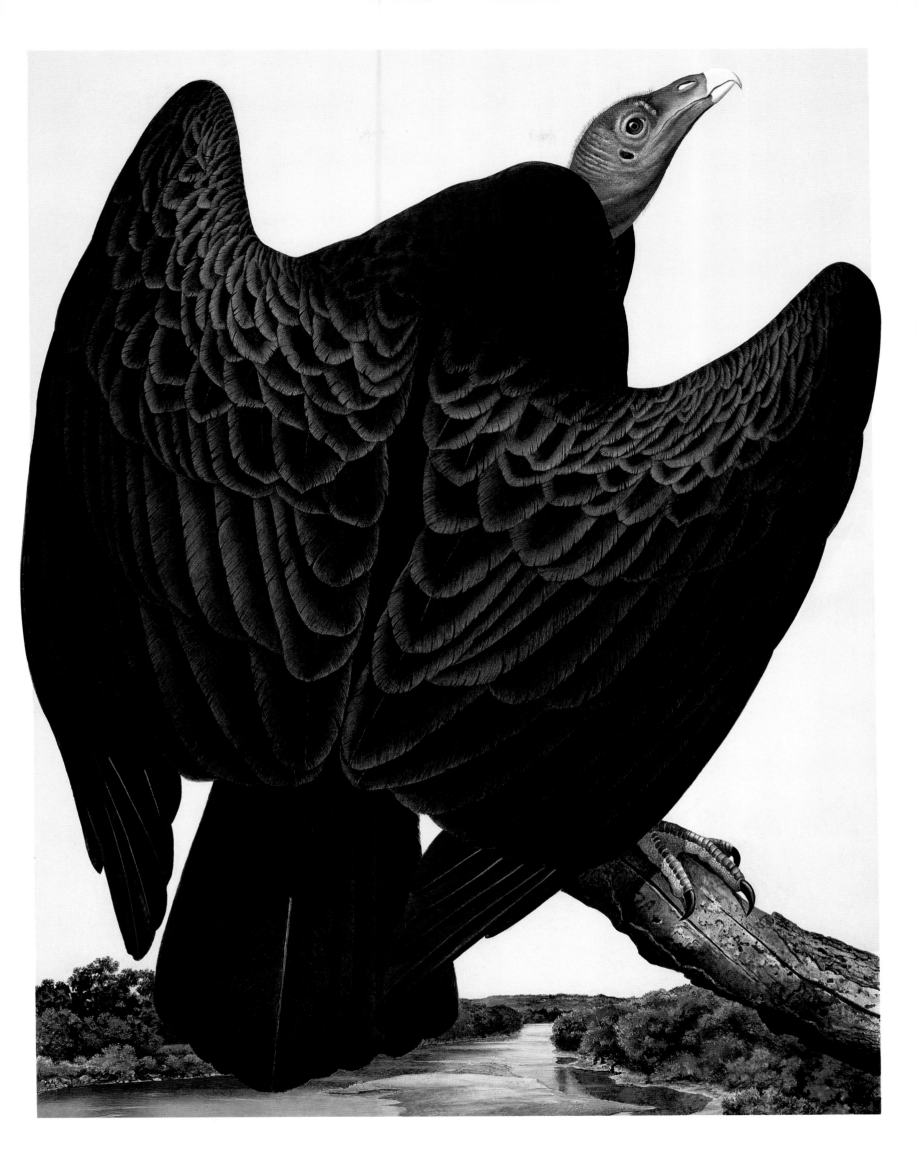

NORTHERN CARDINAL

The cardinal or redbird is one of the best known and most easily recognized birds in Texas. It is also one of our most conspicuous singers. I always know when the frenzy of the Christmas holiday season is really over, for as early as the fifth of January, I have heard male cardinals begin their singing in the pre-dawn darkness just outside my window. In fact, they love to start as early as five o'clock, which on occasion can be a real nuisance.

At this time the males become pugnacious and are frequently seen fighting in a flurry of feathers and twitters as they establish their breeding territories. Cardinals' nests are usually placed in bushes or low trees, seldom more than a human's height off the ground, and they often raise three broods per season. The baby birds abandon what shaky security home base affords about ten days after hatching when they crawl out on adjacent limbs, cheeping and with wings vibrating, to attract the attention of insect-laden parents. This attracts the notice of neigh-

borhood felines, too, who appreciate prey on low perches and often leave telltale small feathers and a lifeless limb or two by the kitchen door.

The cardinal is also a fairly common victim of cowbird parasitism. Cowbirds have devastated certain warbler populations by surreptitiously depositing eggs that produce fast-growing and voracious birdlets that soon displace feeble nestmates. Cardinal parents can also be fooled into raising cowbirds, but they are usually able to raise at least one of their own young. Many a time in spring and summer I can hear a young cowbird's urgent greedy cries for food in nearby trees, but I hear the sounds of baby cardinals, too.

Scott and I have depicted a pair of cardinals who have constructed their nest in thickets covered with wild grapevines. A bachelor male has invaded the nesting pair's territory and has just been discovered by the owner, who will soon drive it off.

SWG

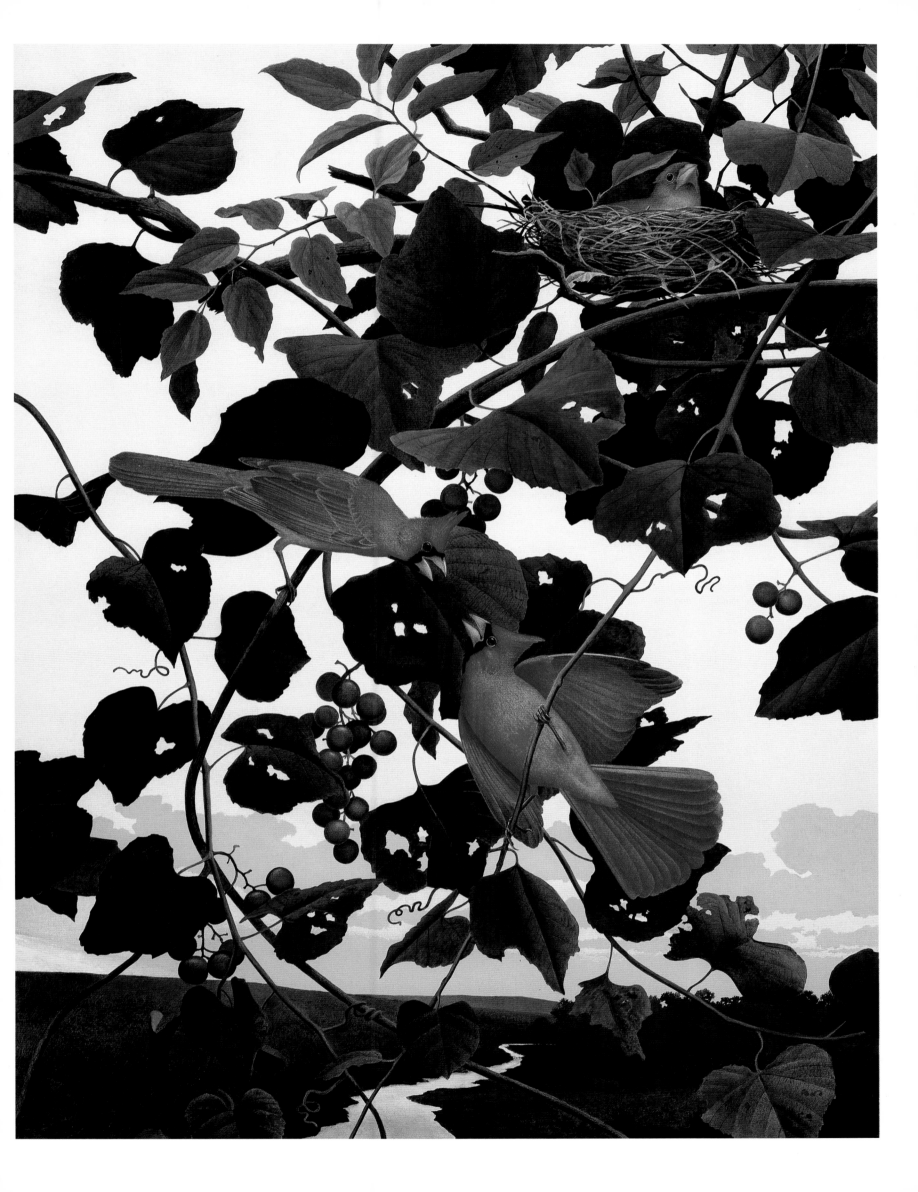

CATTLE EGRET

This bird, an immigrant from Africa, has been extending its range northward from South America for the last fifty years or so. It now inhabits a good half of our country, from the southern states and the Atlantic seaboard to areas in the far and middle west. Due to its surprising adaptability, it is one of the few birds actually on the increase around the world. This is in almost universal contrast to other bird species.

In expanding its range thousands of miles beyond its African homeland, this bird's rugged flexibility has made it a familiar sight on all the world's continents, save Antarctica. In Texas there are few fields east of the Cross Timbers country where these birds cannot be seen darting after insects and other small creatures stirred up by grazing livestock. Quite often they can be seen standing comfortably upon the backs of cattle in much the same way that they associate with cape buffalo and rhinos in their African homeland.

We selected the Cattle Egret for our book not only for the beauty of its breeding plumage but also for the opportunity it gave us to show the influence of Audubon's sense of line on our own styles of posing and drawing birds. Of all his qualities as an artist, it is Audubon's refinement of line that has mightily influenced us and that we want most to acknowledge in the presentation of this work. It is our wish, indeed our pleasure, to honor those people whose teachings and painting styles have had an impact upon us and our ways of seeing and feeling. If in our own way we can become a part of that artistic continuity that began with Mark Catesby and Alexander Wilson and John James Audubon, one of the primary aims of this book will have been realized.

We chose to represent this bird in its spring nuptial plumage when it has taken on its tawny orange-colored breeding feathers, and the colors of its bill, feet, and eyes have become a rich reddish hue. For the setting we have chosen a cypress swamp in East Texas, a place both mysterious and enchanting.

SGG

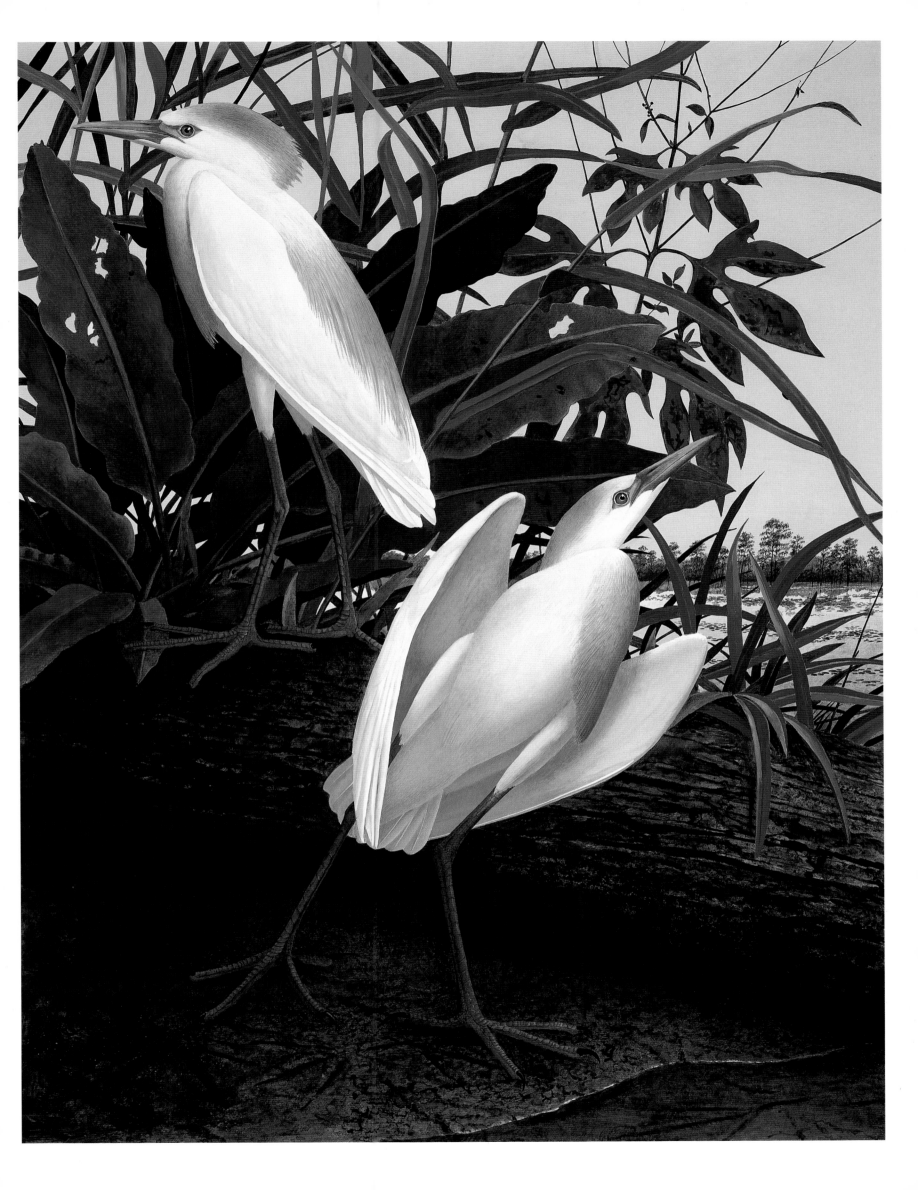

MERLIN

This small falcon is not common in our area of North Central Texas. In fact during all the years that I have been studying birds, both as hunter and bird-watcher, I have not seen more than a dozen or so. I tend to think of the Merlin or "pigeon hawk" as being primarily a bird of the northern United States, especially since it usually appears in our part of the country during the first cool months of autumn when it arrives with other migrating hawks. At a distance they are difficult to tell from the similar-sized American Kestrel or "sparrow hawk." The Merlin has a somewhat more stocky appearance. Both are insect feeders, though the Merlin has a greater appetite for small bird meat.

The falcons are probably the most handsome and admired of the world's birds of prey. They have been particularly prized over the last three thousand years for their hunting skills, their speed and agility, and their fearlessness in attacking prey superior to them in size. Unlike most other raptors, the falcons are spectacular aerial hunters. These skills made them highly valued as hunting pets by European rulers from at least the early Middle Ages until well past the Renaissance. They have a much earlier association with men in the lands of the Middle East, Arabia, and across most of Asia. In Europe the ownership of various kinds of hunting hawks and falcons was strictly regulated. Only an emperor could possess and hunt a Golden Eagle. A king could hunt with the Gyrfalcon. The Peregrine was reserved for princes and dukes. From there the size and quality of the hunting bird and the people who could own them descended down the social scale. The smallest, being the kestrel, was allowed to the lower ecclesiastical orders.

In my teenage years I too was bitten by the falconry bug. The first wild predatory birds that Scott and I raised were two diminutive but fearless Loggerhead Shrikes. They were brought to us late one spring by a schoolmate as little more than very young nestlings just beginning to fledge. Our sixth-grade teachers at Arlington Heights Elementary School were very understanding and permitted us to bring the birds to school, letting us feed them at appropriate times. Shrikes made wonderful pets. After

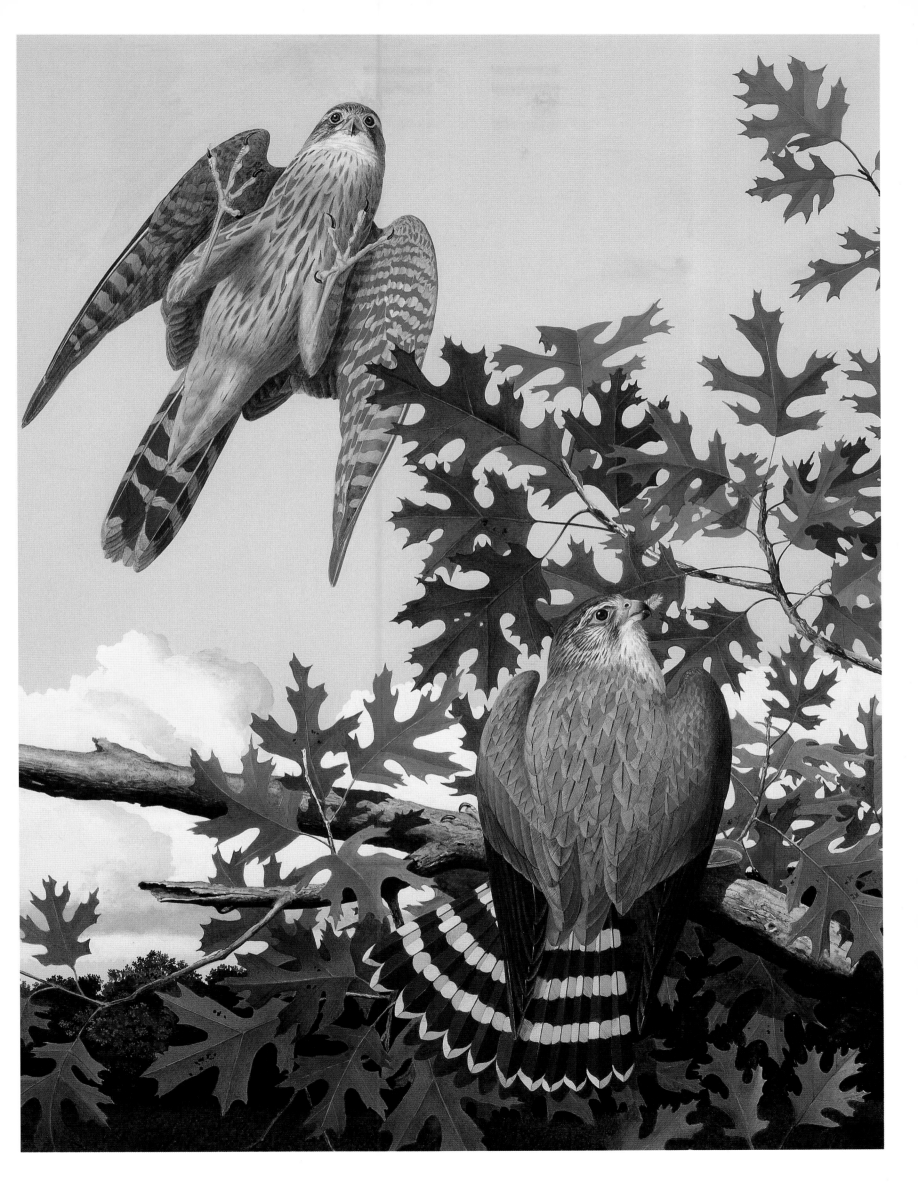

learning to fly, they spent most of their time sitting on curtain rods in our bedroom, making their peculiar loud rasping noises, and every now and then swooping down to land on our heads or to attack and kill any socks lying on the floor. They really seemed to enjoy wrestling with socks and often would fly back with them to the top of the curtains, stick them between the rod and the wall, and proceed to unweave them. Occasionally, if I forgot to close the bedroom door behind me, they would fly out into the rest of the house. More than once they were caught perched on the edge of my older brother Pete's aquarium eagerly eyeing the tropical fish. I can even remember that our maid was so absolutely terrified of them that our room remained even more unkempt than usual that spring and summer.

We finally had to let the shrikes go to restore domestic tranquility. I was depressed for weeks afterward, knowing that the liberated birds would never be able to fend for themselves. Sometimes they would return and sit on the Sewells' garage roof next door. Though they would take food from Scott's and my hands, they never seemed particularly hungry. This reassured me somewhat, but I still had my doubts. Then early one morning I heard a terrible screeching coming from our front porch. I rushed out to find one of our shrikes eagerly dispatching an English sparrow. But at my sudden appearance the shrike let its hapless victim go. From that moment on I knew that those birds were going to be OK.

In high school, at the same time my brother and I and friends were involved in raising rare pheasants, I had several hawk pets. My favorite was a huge Red-tailed Hawk I raised from a small chick given me by the director of the Fort Worth Zoo. I named it "Rufus." No more than a ball of white down when it was put into my charge, the red-tail grew so quickly that by the end of summer it had become obvious that Rufus was a female. In fact she was one of the largest Red-tailed Hawks that I had ever seen. Among hawk species, the female is almost always larger than the male.

Falconers use the term "eyas" to describe hawks that are taken as nestlings to be raised for hunting. They are easier to tame and to train for hunting with humans.

Unlike wild-caught adults, they are usually very vocal. I rarely hunted Rufus, though she proved an able pursuer of rabbits and cotton rats in the prairie fields west of town. I often would release her to range throughout the neighborhood. Sometimes, to my great dismay, she would be gone for days, but I always knew when she was back by the noises of angry mockingbirds and blue jays, whose fury would be aroused at the first sight of her. Faced with going away to college in the fall of 1961 and knowing that I would never be able to care for her again on a daily basis, I gave her to some acquaintances who were much more learned in the arts of falconry than was I. When I returned home for Christmas vacation I went to visit Rufus. My once friendly, noisy pet had become a sullen, dark-eyed and beautiful adult who would have attacked me if she had not been bound by her leather jesses.

In those high school years I had several other pet hawks, but only two did I keep very long. One was a beautiful little sparrow hawk, which I called "Nero" after Audubon's pet of the same species that he acquired near St. Francisville, Louisiana, and that roosted in the porch shutters of Oakley plantation when Audubon was a tutor there. The other bird was a Swainson's Hawk, a buteo or broadwinged bird similar to a red-tail but smaller. Both had been shot and brought to me by hunters who had read one of many articles about Rufus that had appeared in the local newspapers. Both birds recovered completely. The sparrow hawk became, I thought, quite tame. The Swainson's remained as wild and wonderfully defiant as the day he was first brought to me. I guess I expected some sort of gratitude for saving his life, but "haggards" or wild-caught adult birds are never easy to tame. Eventually I gave up and let the bird have its freedom. Not long after that my "faithful" sparrow hawk, Nero, was frightened from my gloved hand by Scott's sudden appearance at the back porch door where I was airing the bird. He flapped away with my jesses dangling from his yellow legs, and he never looked back.

Today I have neither the time nor the patience to try my hand again at falconry in spite of a lingering lust for it. But my experiences with hawks are among my fondest memories.

SWG

AMERICAN OYSTERCATCHER

No one can deny that the American Oystercatcher is an extremely handsome shorebird. Its striking appearance makes it look almost artificial, as if the bird had been carved out of wood and painted in bold acrylic patterns of black, brown, and white accented by bright yellow eyes with red eye rings and a chisel-shaped mandible of orange-red enamel. Perhaps because of their spectacularly noticeable appearance, oystercatchers are wary and seem always on their guard. Next to the Grey Junglefowl of central India, they are the most difficult birds that I have ever tried to stalk in daylight and study at close range. As a rule they appear to prefer to feed and rest out on sandbars and open beaches where any creatures approaching by land or sky can easily be detected.

I remember an incident back in the 1950s, in the bird-collecting days of my errant youth, when I once sighted a lone oystercatcher sunning on a sandbar at Lake Benbrook, which was still out in the country a few miles west of Fort Worth. I remember how excited I was at seeing this elegant visitor, an event quite rare in our part of the world. I was about twelve at the time, and my father had just given me a twelve-gauge Winchester automatic shotgun, which greatly increased the distance at which I might procure specimens for my taxidermy collection. At that time I was an extremely determined, patient, and able bird stalker who would spare no effort and would take all the time necessary, hours if need be, to approach within fatal distance of the most wary prey, if rare enough. Such single-mindedness often led to the exasperation of my hunting companions, who usually abandoned me in the field to do my own thing. They would be found later sitting in the car back at the main gate or at the ranch house waiting to see what on earth had so distracted me.

With that rare and alert oystercatcher, however, no amount of patient application of stalking skills would suffice. I could swear it had radar. I crawled several hundred yards on my belly, carefully keeping a wispy screen of weeds between it and me, but to no avail. It was downright spooky how extremely sensitive it was to seemingly insignificant signs, like the flushing of a single field sparrow or a moment of too much quiet. It was not until years later, when Scott and I were guests of the Bart Browns, Sr., at Aransas Pass in 1966, that I again saw oystercatchers in their more familiar surroundings. The Browns hired a boat guide for a memorable day of fishing and bird spotting, which gave Scott and me an unrivaled opportunity to observe from seaward all kinds of coastal avians on nearby islands, on sandbars, in distant shallow marshes, and in the Gulf skies overhead. Plovers, skimmers, terns of different plumages, gulls, herons, and spoonbills were abundant there. Later we saw many small gatherings of oystercatchers on shallow offshore islands of mostly oyster shells. Our boat was no different from the many other craft cruising by, but the moment our pilot began to steer closer for a better glimpse, the birds began to make their nervous, high-pitched cries of "wheep, wheep" and as if on cue suddenly took flight.

It was on this trip, surrounded by so much of the richness of Texas bird life and sharing it with the enthusiastic and bird-savvy Browns, that Scott and I first began to fantasize about one day doing a special book on the birds of Texas. We have shown a pair of oystercatchers at rest on a quiet sandy stretch of coastal beach. Behind them a thunderstorm rises high over the Gulf, the upper clouds reflecting the bright, late afternoon sunlight. Even at repose these eaters of oysters are always on the alert.

SWG

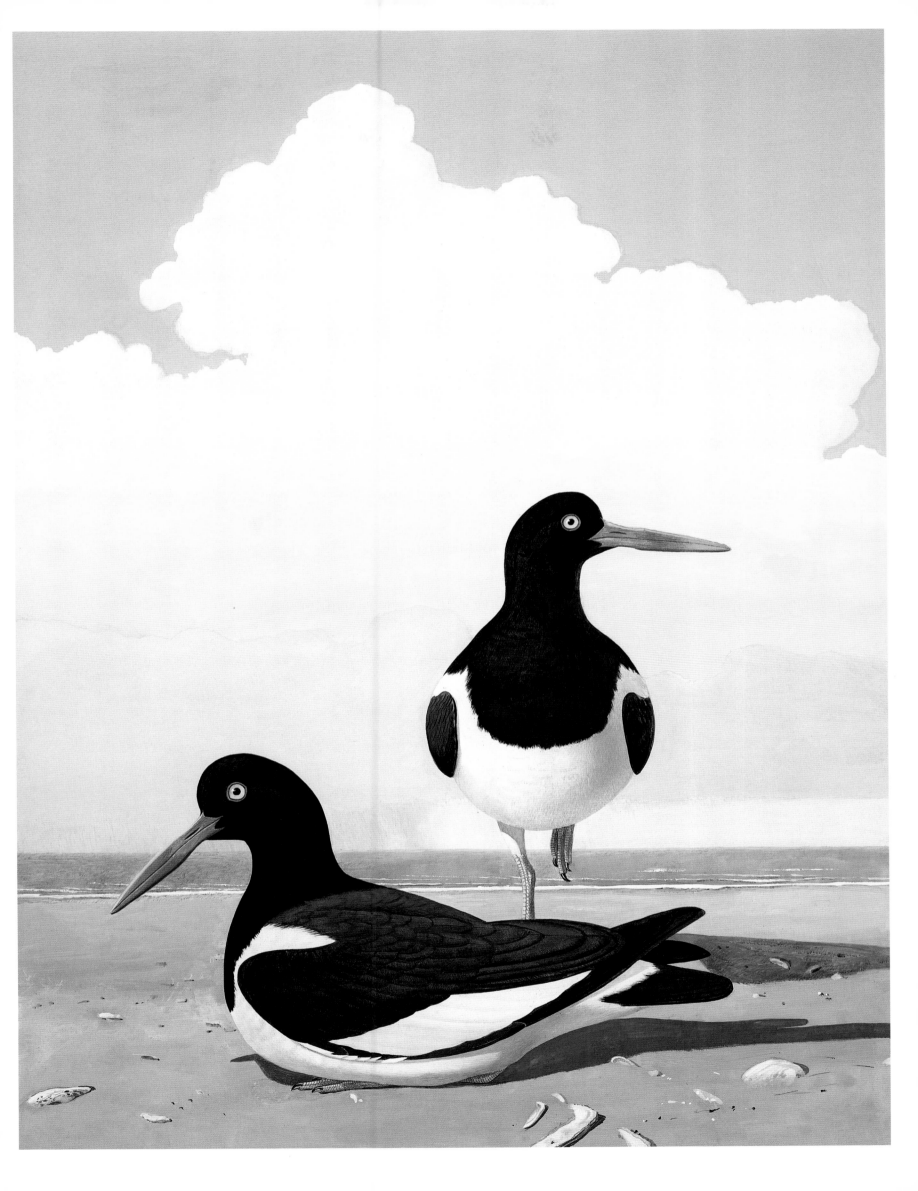

WILD TURKEY

We agree with Dr. Benjamin Franklin, who wanted the Wild Turkey to be this country's national symbol instead of the Bald Eagle. Indeed one would be hard pressed to find a bird more thoroughly American or more representative of the natural wildness and bounty of this land when it was new to the Europeans. To ensure a steadier supply of meat, the high indigenous cultures of Meso-America and the North American Southwest had almost completely domesticated turkeys by the time our white ancestors arrived. Their feathers were important status adornments and, combined with rabbit fur, were even woven into warm blankets. I don't know if the turkey was ever domesticated in New England by the original native inhabitants, but our tradition has it that turkey flesh may have meant the difference between death and survival to those English lawyers, deacons, and shopkeepers who set foot on our rocky coast trusting in God's providence rather than their nonexistent agricultural skills.

The turkey lost out to the eagle, of course, not only because of the latter's noble appearance, but also for its association in the Old and New Worlds with the worship of solar deities who presided over the power of the state. In ancient Mexico and probably elsewhere in the Americas, the turkey was also associated with divine power and in my mind had a better claim for worship, being the animal form of some procreative gods and gods of the hearth (its fiery plumage recalling glowing embers). But the architects of our republic were for the most part readers of Greek and Roman classics when they laid the foundations of our government, and I suppose it is understandable that they chose, among other borrowings, this emblem for the new state. It really does not matter that the eagle is both thief and scavenger; simply nothing surpasses it for sheer good looks.

As background to our plate of the Wild Turkey, I chose a beautiful stretch of Texas terrain just north and west of Austin where the land gives hints of the approaching Hill Country. This young tom, startled by something outside the picture plane, is about to take wing for the cedar breaks on the other side of the road. The road itself leads the eye to a distant and almost limitless Texas horizon.

S G G

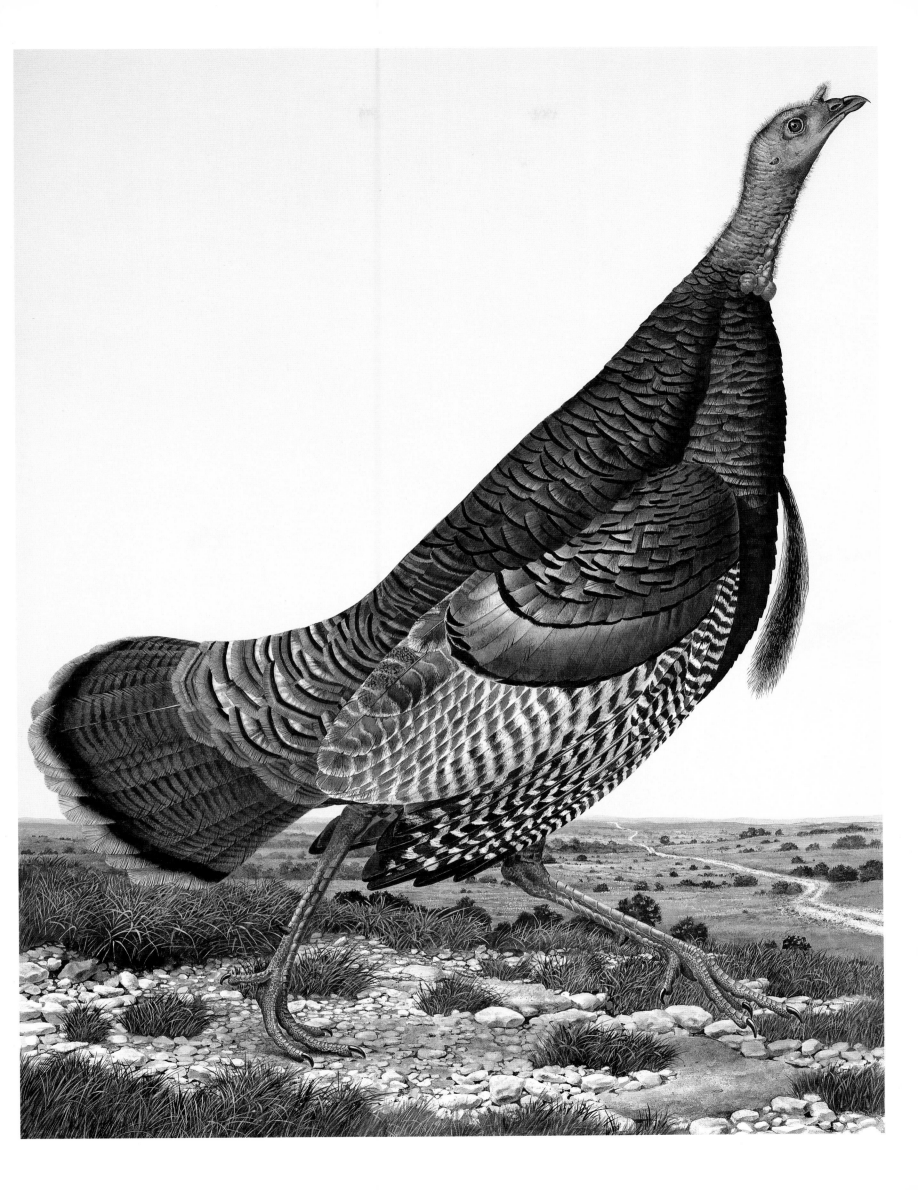

PURPLE GALLINULE

Many of our pictures originate as concepts long before we actually have specimens available or the backgrounds figured out. In our quest for variety we have been determined to avoid that look of sameness so common in many of the wildlife books we have in our collection. From the beginning we have wanted to do a book that would interest *us,* hoping that in so doing it would interest others as well.

With the Purple Gallinule we had the complete idea at least two years before we had all of the subject matter necessary to paint it. In finding the alligator's skull (something one does not come upon all that easily), we were uncommonly lucky. A small museum at the Aransas National Wildlife Refuge had precisely what we needed. The ubiquitous water hyacinth was easily obtained, and as for the bird itself, a common resident in that part of the state, we were fortunate in our many close observations and photo opportunities.

This painting is intended to convey an undercurrent of irony and even of black humor. The Purple Gallinule, so often a welcome tidbit in this formidable reptile's diet, has now in a way got the tables turned. The skull is a haven for many small marsh creatures, gallinule food. I wonder, as it inches down this boney piece of shoreline, whether in some small portion of its gallinule cortex there is not at least a glimmer of recognition. The bird appears curious, but in a few moments it will be elsewhere, perhaps striding lily pads of nearby ponds, this time under the scrutiny of another pair of unblinking eyes—two small presences risen from the dark and quiet waters.

SGG

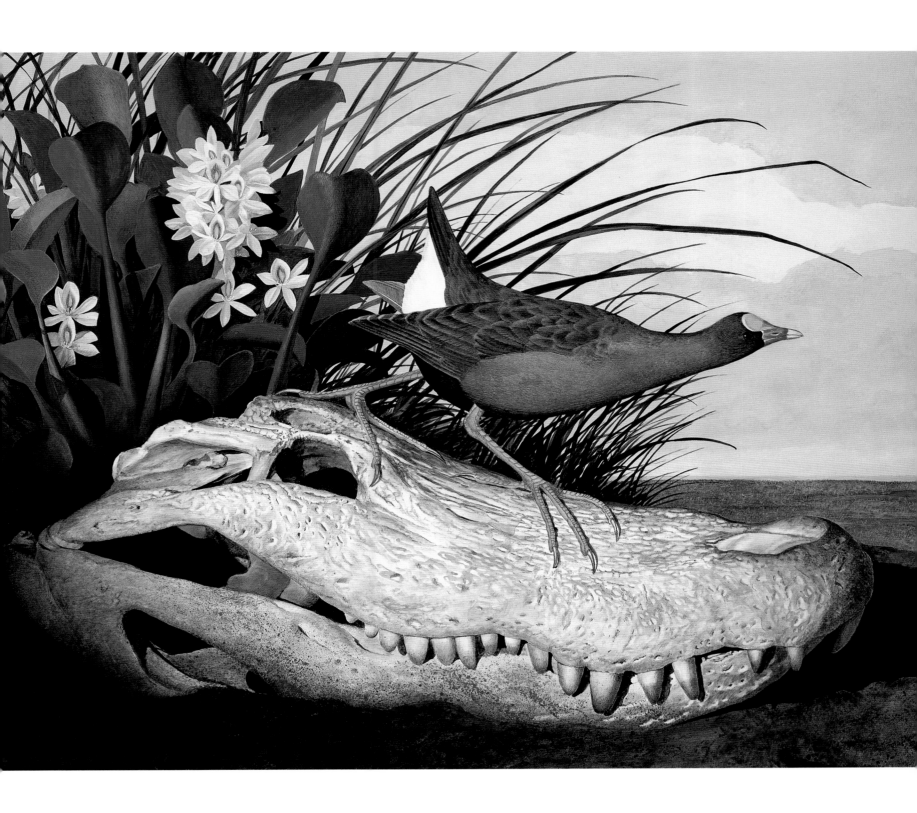

BURROWING OWL

This small owl was once a familiar sight in open fields and virgin prairies all over Texas. Its decreasing numbers are the direct result of the destruction of its habitat by the plow, the improvident use of insecticides, and indiscriminate shooting by varmint hunters. These birds are easily recognized from other owls by their unusually long legs. They are not strong flyers and are most often seen on the ground standing near the entrances to their nests, which are made in the abandoned burrows of prairie dogs, ground squirrels, skunks, badgers, armadillos, and other digging creatures. The owls are frequently seen nesting in colonies with adults and fledged young standing by their burrows, their heads bobbing up and down and from side to side as they focus their eyes on potential intruders. If threatened, they immediately retreat down their holes and will often make a noise that sounds exactly like the rattling of a rattlesnake, a common neighbor in such owl places. They do more daylight feeding than is common among most owls. Their food consists mainly of grasshoppers and other insects, a diet augmented by small snakes, mice, unlucky young prairie dogs, and small birds.

We have depicted a pair of Burrowing Owls confronting the tail end of an armadillo, which is busily digging away at an abandoned hole. Owl eyes are transfixed by the animal's armored snakelike tail. Archaeologists are often grateful for digging animals, being digging animals themselves. Rabbits, armadillos, prairie dogs, and even ants unearth bits of ancient evidence of past cultures. In this picture bits of broken china, small bones, and worked flint, including arrowheads, have been brought to the surface. There is a minié ball near the tunnel opening. Rarely do you get a whole history at one tiny site, so that in a way our picture is a visual allegory of our pioneer past.

As a rule, Scott and I prefer to conceal symbolic references or storytelling elements in our paintings. We have indulged ourselves somewhat in this book, and especially in this painting, in order to pay homage to a very important period in Texas's past, from 1850 to 1880, when the first major wave of settlers moved westward beyond the line of protective forts at the edge of the Cross Timbers country of Central and North Central Texas. Many of these people came incredibly ill equipped to face the dangers of life on the prairies. And a hard life it was! Droughts, blizzards, dust storms, insect invasions, poor soil, no doctors, few schools or churches in towns and none beyond, and of course American Indians. The annual raids of lean red men on horses were more than many people could take. When Texas entered the Civil War in 1861 so many white male protectors went off to fight that wives and children and old people were made more vulnerable than ever to fatal attacks by Kiowa and Comanche. Swooping down from Oklahoma, they brought so much death and destruction in the war years that some believe the country never regained its former population density in relation to the rest of the state.

And yet somehow enough of these pioneers held on to their homes and survived the hardships of those early days—as well as later dust bowls and bank failures—to create a hardy breed of West Texans who even today exhibit character traits that seem uniquely their own. As a rule they are a vigorous and independent people who place high value on honesty and good humor. As John Steinbeck would say, they endure.

SWG

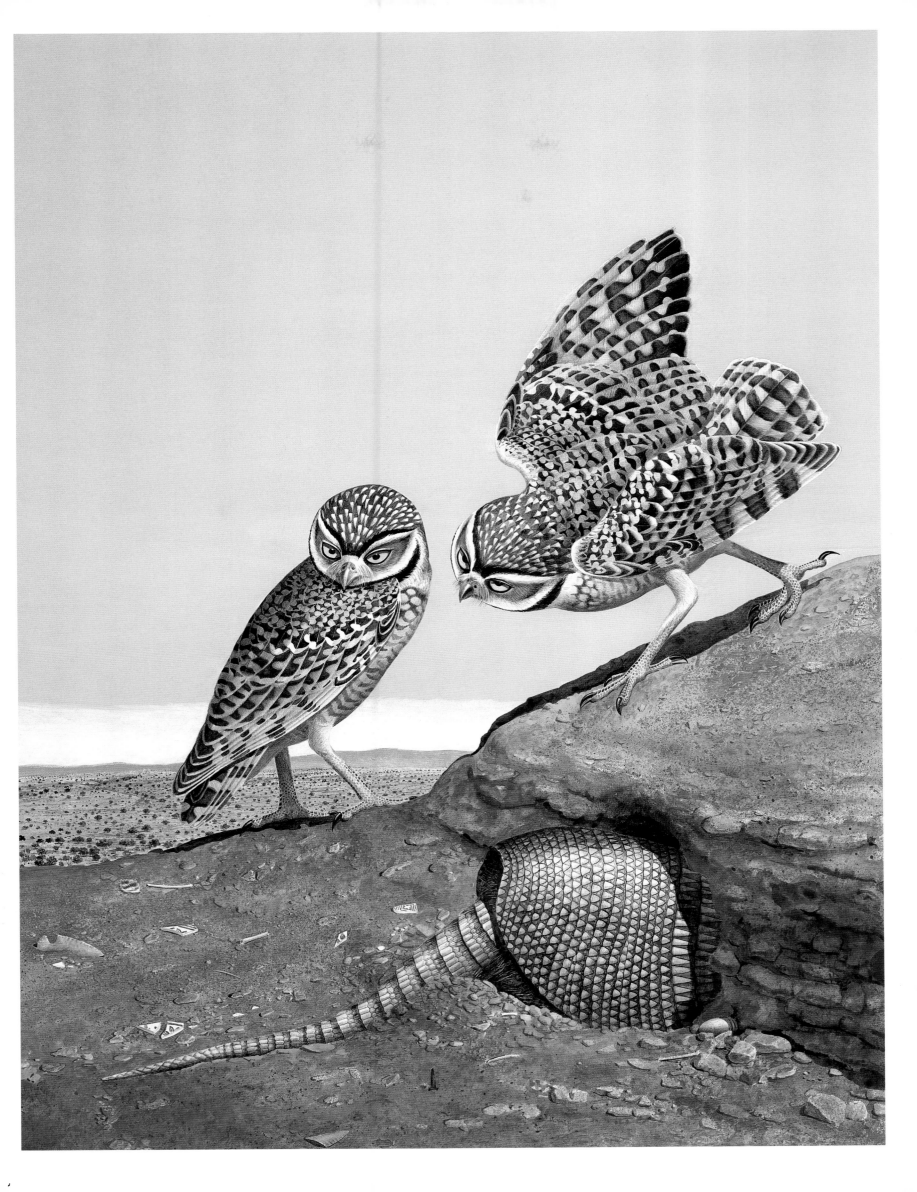

AMERICAN WOODCOCK

On the day before Thanksgiving 1999, I flew to Houston to join Caroline "Cina" Forgason and her husband Mark for a weekend hunt and holiday dinner at the Norias division of her family's famous King Ranch. Cina picked me up at the airport while Mark ran some errands in downtown Houston. We were to rendezvous at Mark's family ranch west of the city before heading south to the King Ranch in the notorious holiday traffic. After picking me up, Cina deposited me at the Museum of Fine Arts, Houston and immediately went back to the airport to pick up her Washington friend Nini Ferguson, a beautiful lady with the whitest teeth I ever saw.

Cina and Nini met me outside the art museum, and we drove over to the nearby museum of natural science to see Scott's recently installed thirty-seven-foot-long mural of the Aztec Templo Mayor, which was a part of the museum's impressive new pre-Columbian art display.

While we were enjoying this, Cina got a call on her cell phone. It was Mark. He told her about the oddest event that had just occurred. Accompanied by his Labrador, "Vel," he had stopped by an optometrist's shop in the middle of downtown Houston. He let the dog out into the parking lot while he went into the store, and as he walked inside he saw his dog running around the back corner of the building as if it had seen an alley cat. When Mark came back out a few minutes later, there was his dog sitting at the front door, wagging its tail and with a bird in its mouth!

"I think it's some kind of plover or snipe. Maybe even a woodcock," Mark said.

I asked Cina to inquire if the bird was still alive.

"Yes, but pretty roughed up. I'm taking it out to the ranch so you can see it when you come to pick me up."

It was almost sunset when we finally got to Mark's parents' place, a beautiful ranch surrounded by thick stands of pines. After our brief hellos, Mark retrieved a red plastic egg box. There huddled in a corner was an adult American Woodcock, eyes wide open and terrified, but nonetheless not looking too frazzled.

Mark and his mother and father are hands-on ranchers with a mild almost Old South way about them. But

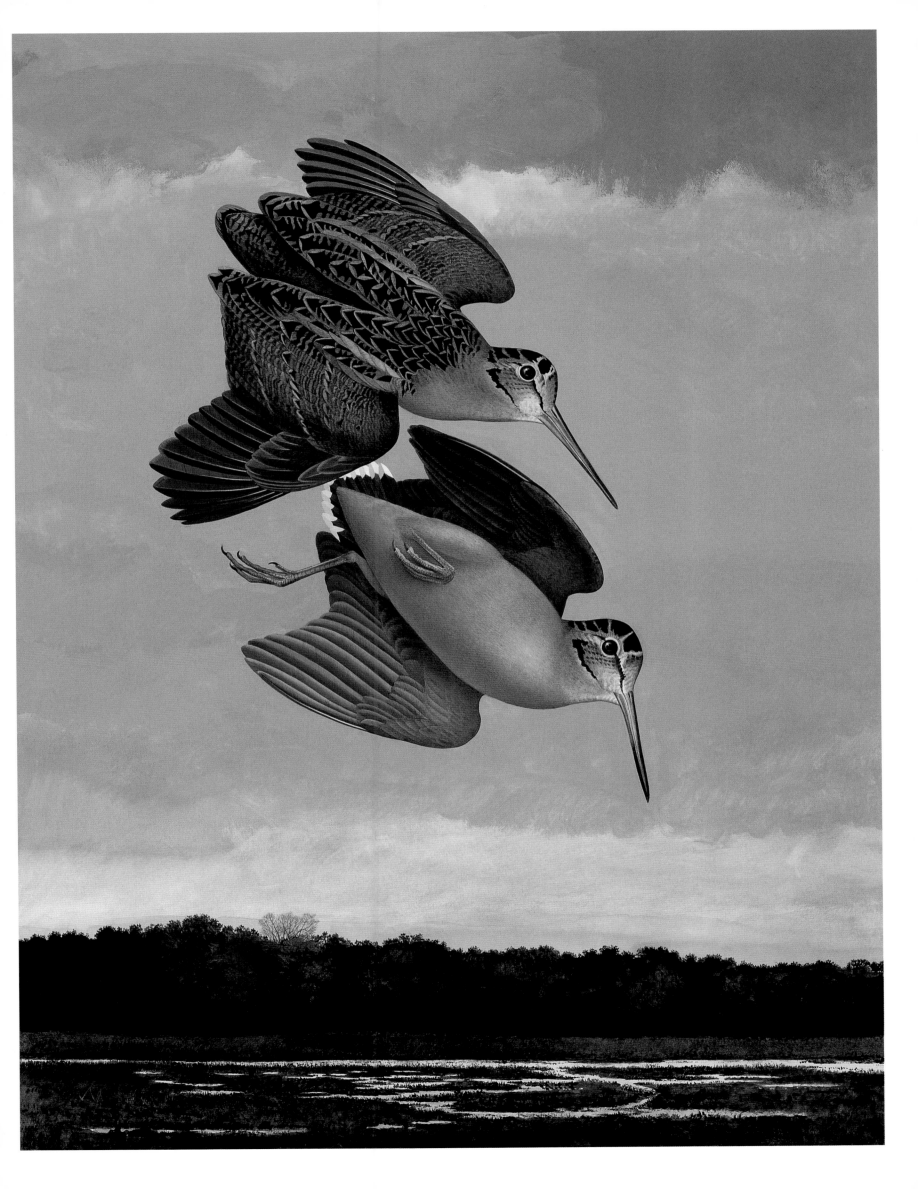

clearly they were excited about their new prisoner and the fact that it had been retrieved in the middle of all the asphalt and cement of downtown Houston! We all speculated that it must have been flying through town to some distant swamp and had hit a window. It was not the first bird brought to me that had suffered that fate. But a woodcock in downtown Houston?

It was an oddity to be sure. Mark's parents wanted to keep the bird to show it to friends and relatives later that evening or the next day. I didn't think it would live that long and said so. I asked if I could examine the woodcock outside of its improvised cage.

It put up no resistance when I reached into the box and picked it up. It showed some signs of having been mouthed by Mark's Labrador, but upon close examination seemed to have no broken bones, no signs of blood. Only an incredibly fast-beating heart and beautiful eyes that never blinked.

"I think this bird is OK," I said. "It would probably survive if we let it go."

Dr. and Mrs. Forgason looked somewhat disappointed. They gently hinted that they would like to keep it at least for a little while. They graciously relented, however, when I told them that the bird might die of shock that night. Mark agreed.

I wanted to see how well it might fly on its own so I did not gently toss it up into the air. I merely opened my hand. The woodcock flew out of my hand like it had been shot out of a cannon. It winged straight away into the nearby pines. No zig-zagging like its cousin, the snipe, but a direct and unaltering straight line to the woods. I was delighted. So were Cina, Nini, and Mark. Mark's mom and dad were, I think, somewhat disappointed. When I returned to Fort Worth, I sent them one of our folio prints of the woodcocks to replace the live one they had lost.

In the painting, we wanted to show the birds' beautifully camouflaged plumage, a marvelous combination of warm and cool colors, of light and dark tones that bespeak the autumn colors of forest and earth. We isolated the birds somewhat by contrasting them with their background, choosing a scene quiet, somber, and reflective against which we could place these sparks of wildness in a sort of living, swift-moving still life.

The earth here at the Trinity River bottoms near our home is wet, dark, and primordial, saturated by long, quiet autumnal rains that presage winter. Soon the birds will be feeding on the nearby mud flats with bills probing moist earth for hidden worms and such. Although American Woodcocks are solitary by nature and hardly ever found in pairs, we took some artistic license in this painting in order to give the reader a view of both the upper and under sides of this bird. We constantly marvel at the sheer beauty of its coloring, back and breast, and could not resist the temptation of showing both.

SWG

ACORN WOODPECKER

On our journey around the state with Travis Beck in May of 1981, we had the opportunity of seeing many species of birds that were new to us, especially in those parts of South and West Texas near the Mexican border. Some were very localized, like the Colima Warbler and the Magnificent Hummingbird, then called Rivoli's Hummingbird. Others, like the Green Jay, the Great Kiskadee, and the Altamira Oriole (known then as Lichtenstein's Oriole), were more common within their range but still exotic to us, offering the same thrill as if we had seen something really quite special. The Acorn Woodpecker of the Big Bend was for Stuart and me certainly one of these, though veteran birders there irritated us by referring to it as a "trash bird." We nevertheless took an immediate liking to this strikingly beautiful little woodpecker with its almost clownish markings. We studied it closely at every opportunity. When we returned home from that expedition, the Acorn Woodpecker was the first "exotic" that we drew and painted.

We have always had a fondness for woodpeckers of all kinds. They are all elegant, eccentric creatures with more than their share of wildness. I could paint a whole book devoted to nothing but woodpeckers, and that would suit me just fine. In our picture of these birds we have shown two males and a female on a dying sycamore tree, though as a rule they prefer the oaks and pines that grow in the mountains in greater abundance. Almost every time we saw them they were in groups of three or four, always on the move, always noisy. They have an interesting habit of stuffing acorns for future use into hundreds of holes which they chisel up and down tree trunks. Trash birds.

SGG

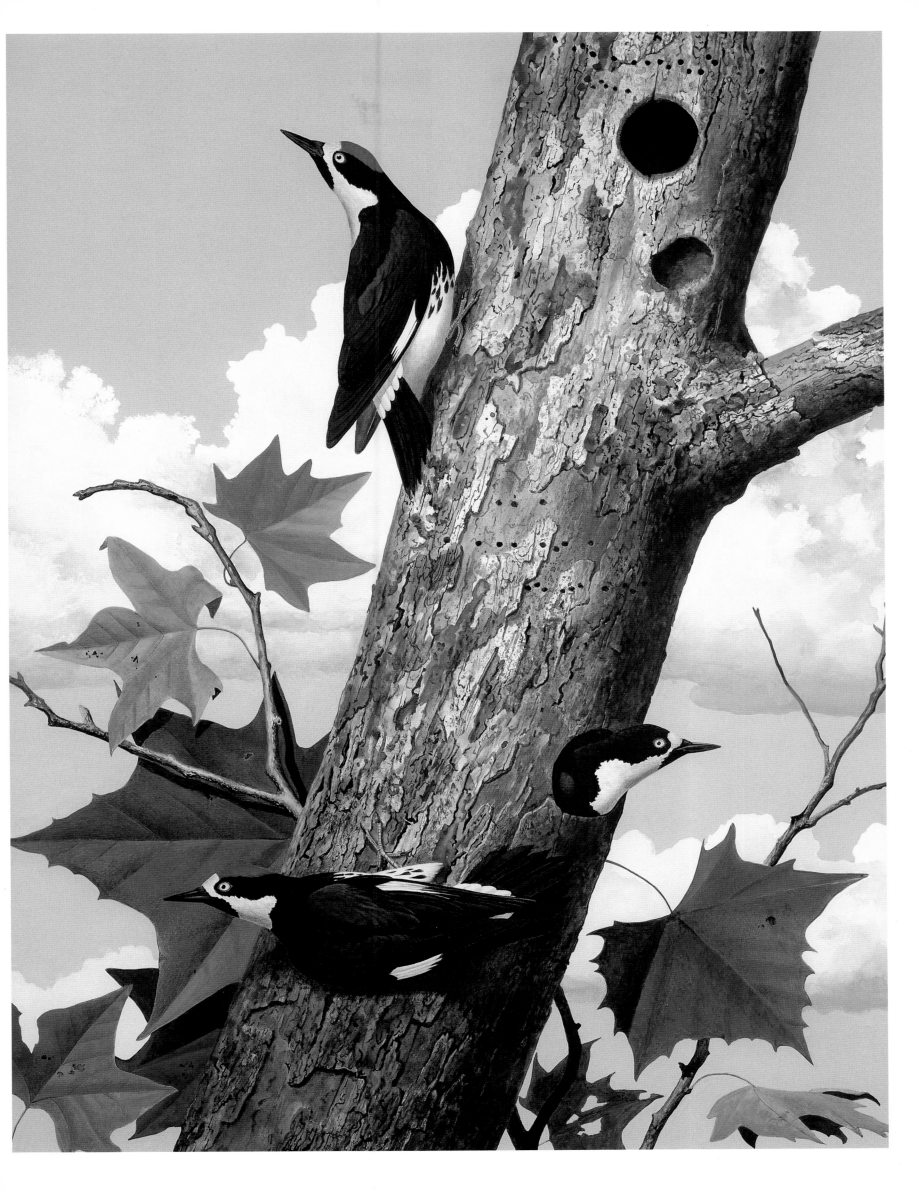

ROSEATE SPOONBILL

This is hurricane weather. The atmosphere is heavy with an ominous sense of impending change. Seabirds and shorebirds make their feeding flights closer to land, while others begin to leave the smaller, less protected islands altogether for the safety of the mainland. As the barometer falls the tides begin to rise. The heavy, humid air absorbs sounds like a blotter, creating a stillness, an eerie silence that seems to cast a spell over the land and its nervous inhabitants. Coastal homes and businesses are boarded up, windows taped, doors locked, and beaches abandoned without hesitation by those who have been through this before.

A single spoonbill from one of the outer islands braces itself on an anchored piece of driftwood to survey the Gulf horizon and its strange, changing sky. Soon it will follow an ancient instinct to join the other flocks of shore dwellers for the flight inland to sanctuary, while all along the coast others still watch and wait.

SGG

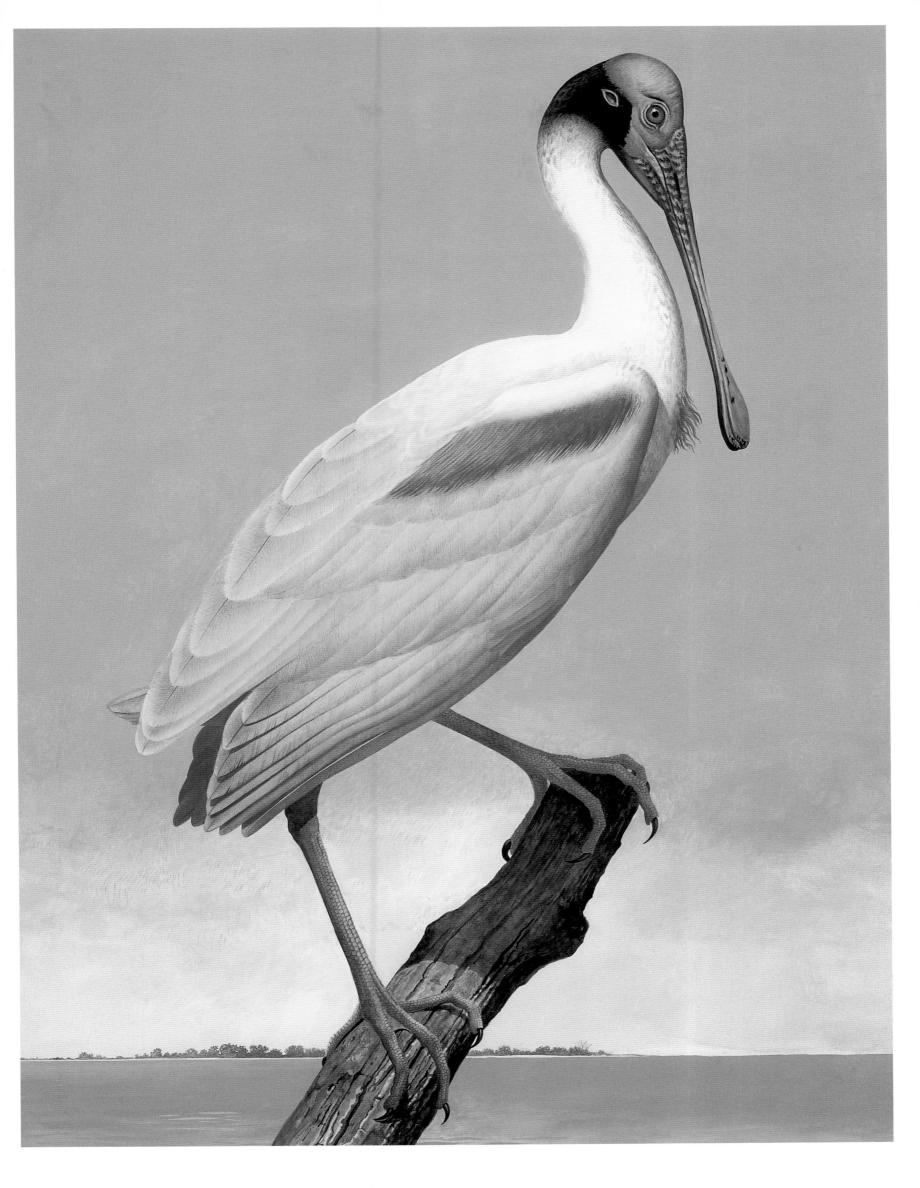

HOUSE WREN

In my painting of the House Wrens I have had the double opportunity of painting one of my favorite birds and also indulging my passion for still life. Years ago I witnessed just such a scene as pictured here—a mated pair of wrens examining some boots for a possible nesting place. They won't use this site with its easy access to predators, but they do nest in the most unlikely places. They will even, without qualms, invade nesting sites already occupied by other birds, often throwing out the previous occupants—nest, eggs or babies, and all—and moving right in. When the nesting urge is on them their curiosity is boundless. No nesting possibility is likely to go unexplored. They will even set up housekeeping in the pockets of shirts or pants left too long on the clothesline. The boots are mine. I sketched them at a beautiful weekend retreat in East Texas that Stuart and I enjoyed with friends John and Sally Truelson, their son, Palmer, and a nearby woods filled with wrens. Each morning, I was awakened by their scoldings, and the first thoughts in my mind as I lay in bed were of the pair I had seen years before sizing up some boots.

SGG

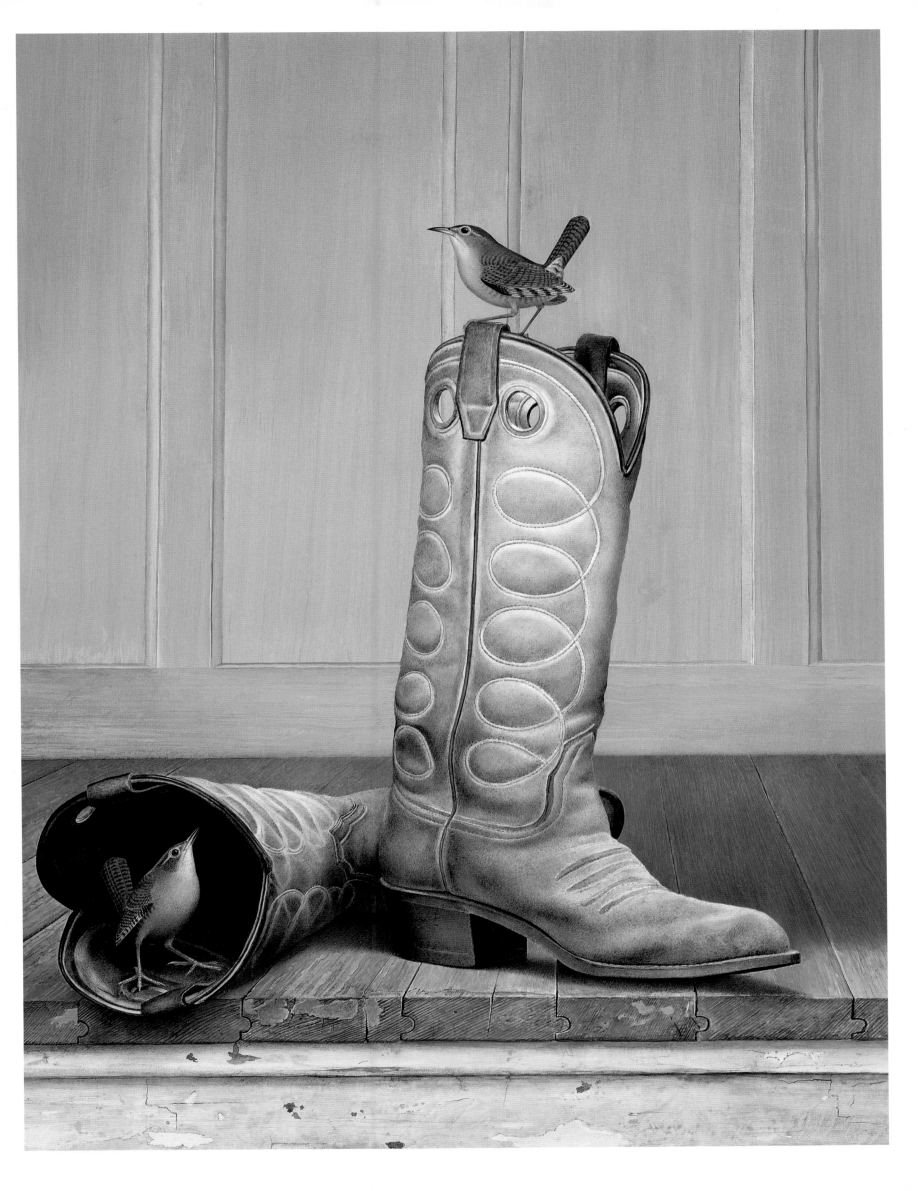

SHARP-SHINNED HAWK

For several days it has rained steadily, the early summer woods gloomy and silent, the low-lying fields sodden and filling with shallow pools. During the night the skies have begun to clear, and as the sun rises, the storm front has moved on to the east. The woods are full of singing, with that clarity and fullness of voice that birds display after a storm. Cardinals, mockingbirds, meadowlarks, crows, jays, buntings, tanagers, and sparrows declare their territories with calls and sweet melodies in the rain-cleaned air. But in the skies above, keen eyes are surveying these woods and fields and the edges of the rain pools. Gliding, rising, gliding and descending, winging through the trees, out over the fields and into the woods again with balance and exquisite purpose, the sharp-shins are on the hunt again.

SGG

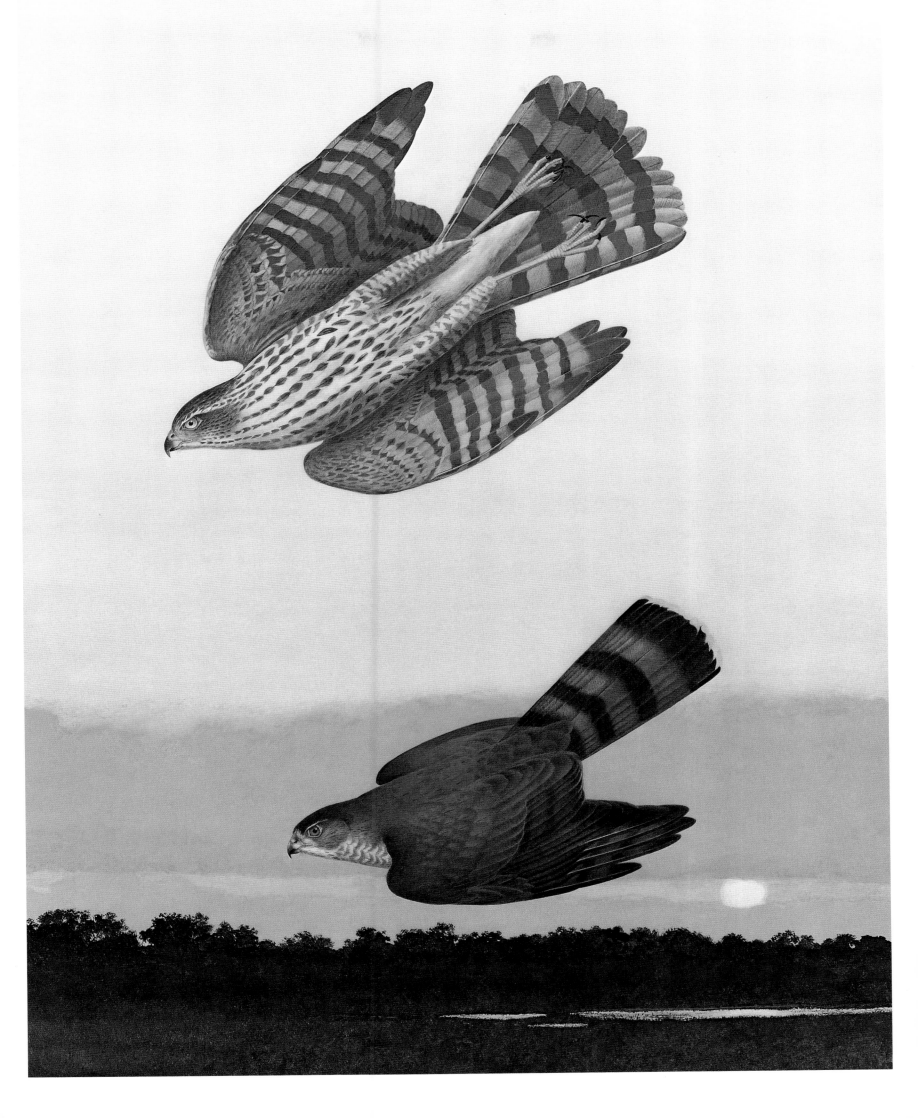

SNOW GOOSE

My only experience with the Snow Goose has been as a hunter. I have never traveled to the Arctic regions where this beautiful bird breeds, raises its young, and lives a relatively unmolested natural existence. Goose hunting is an adventure that every young waterfowl hunter will probably want to experience at least once. I have been on several hunts, all in the famous Eagle Lake area near Houston, labeled with typical Texan hyperbole "the goose hunting capital of the world."

I would like to tell of my first encounter with wild "snows" as a hunter. Although I did follow this hunt with other forays after geese, I now know that I shall never hunt them again. To be quite frank, the experience, thrilling enough as blood sports and the noisy and profligate expenditure of shot and shell are concerned, left a dissatisfying taste in my mouth. There are a couple of reasons for this. On my first morning in the field, it soon became apparent that the main sport of hunting geese consisted of getting these wary birds close enough to shoot. Once within range even a mediocre shot could hit one with relative ease. But once hit, they are so difficult to kill that the annual toll of wounded birds must be terrible. Also, because you are invariably hunting in a group, all of whom seem to be shooting at the same bird, the relationship between hunter and kill is obscured. But, if you like to hunt, goose hunting is a truly exciting adventure to experience at least once. If you do not approve of hunting, perhaps you should avoid the rest of this narrative.

My initiation into the Eagle Lake tradition began before four o'clock in the morning, when my companions and I forced ourselves out of bed, dressed, and hurried through the fog over to the local diner to meet our guide and to have breakfast with a hundred other sleepy-eyed and probably hungover fellow hunters—stockbrokers, bankers, doctors, accountants, and perhaps an artist or two. Punctuality was demanded. If we had been late, we would have simply been left behind. In less than an hour we were following our guide's truck along a dark, narrow, black-topped country road, totally disoriented as one road turned off to another out onto land whose flatness did not vary. Eventually our leader brought us to a dirt road

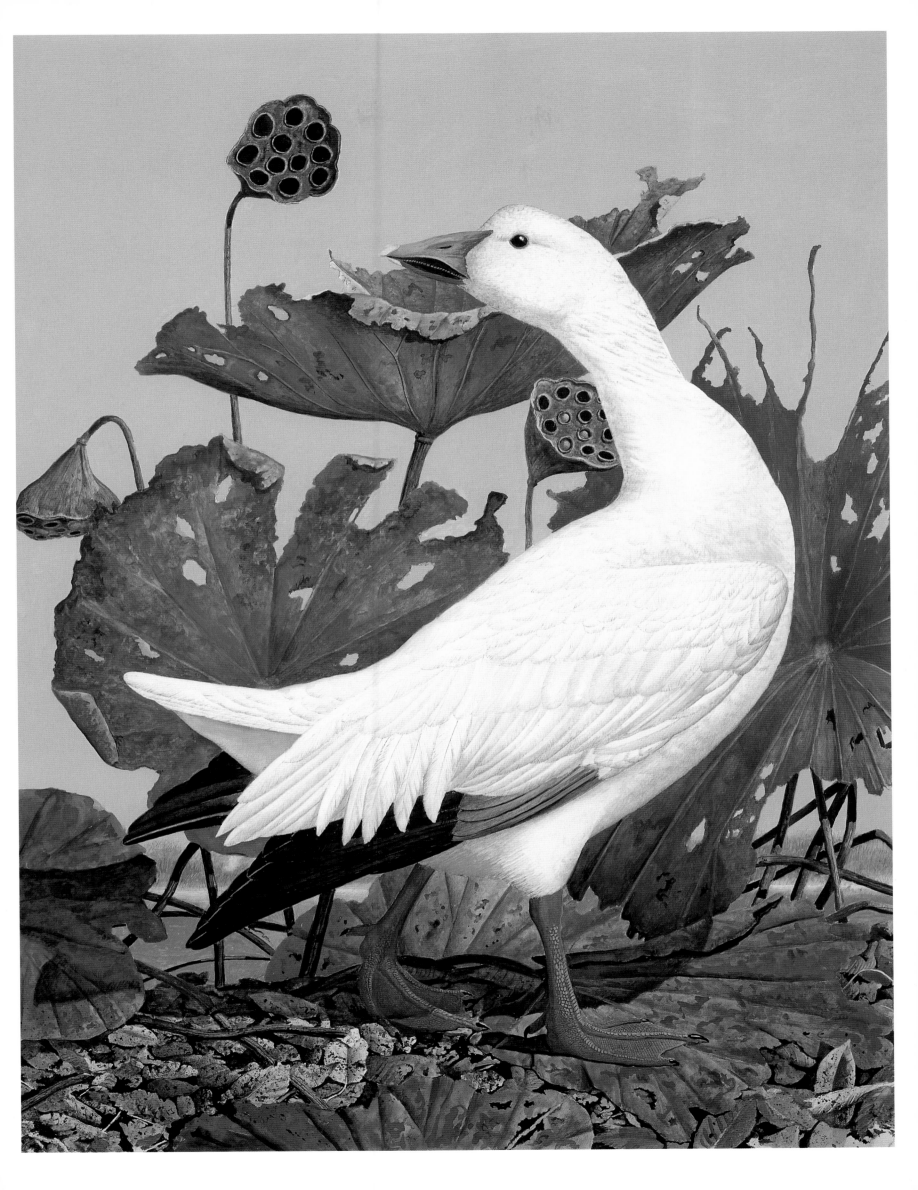

which took us a mile or so into a vast field before stopping. We pulled up behind him.

I had not met our guide at breakfast but had returned to our motel room to get my gear ready. He loomed in our headlights, a really big man, with a rather large beer belly stuck in waist-high rubber waders. Over his hunting coat he wore a loosely draped, white, robelike cotton duster with hood attached. By his side wagging its tail with some effort was an old black Labrador with grizzled muzzle.

As our party of seven disembarked from our lavish Winnebago, the guide was already pulling huge bags out of his pickup. These contained hundreds of white, plastic drop cloths, each about three feet square, our decoys. We would scatter them about our shooting site in great semicircles, each plastic sheet propped upon the remaining rice stubble to create the effect of a feeding flock of Snow Geese. Each of us was handed a white robe so that when we were finally dressed and ready to go, we stood there in the headlights, guns in the crooks of our arms, looking uncomfortably like a Ku Klux Klan lynching party.

Our guide—boss, rather—then loaded us with the huge but relatively light decoy bags, and in no time we were following far behind his flashlight out into the middle of a flat, soggy, mud-soaked rice field that sucked at our rubber waders with every step and smelled pungently of goose droppings. Far off, where we were told was a lake, thousands upon thousands of geese were calling, their high-pitched cries growing more and more agitated as the dawn horizon began to faintly lighten. By the time I caught up with our guide, he had put his flashlight on the ground as a beacon to exhausted stragglers, myself among them, and had already scattered what seemed like hundreds of white decoys in wide arcs around us. He tersely issued orders for us to start scattering our own cloths, designating areas and correcting us when we strayed. He kept telling us to hurry. The geese would soon be taking off from the lake, flying out to the fields to feed whether we were ready or not. We obeyed without question and did our work quickly and in absolute silence. In the gathering light my friends in their white tunics and our sergeant major had almost disappeared among the decoys. It was all disorienting. Our spread of decoys, I swear, seemed at least two hundred yards or more across. As a duck hunter, I was used to having the decoy spread much smaller and closer in.

I had just finished placing my last plastic sheet on a patch of rice stalks when the guide whistled and motioned us to gather around him. He quickly assigned positions

among the decoys and warned us with many blasphemies to keep our hoods over our heads. Under no circumstances were we to look up even if the geese sounded like they were directly over us. And absolutely no one was to shoot until he gave the word. I took my place near the inner perimeter of our spread, flanked by two gunners about ten yards on either side. Our guide took his place with his old Labrador twenty yards behind us. By their calling you could tell that scattered flocks of geese were now beginning to leave the lake. The sounds were getting louder as we hunkered down, arranged our open boxes of shells for quick and ready access, loaded, and waited.

We didn't have to wait long. In front of us and almost overhead stretched a low cloud or some fog, which in the growing light hid much of the blueing sky above us and all of the lake beyond. Suddenly our guide whispered, "Keep your heads down. Don't look up." He began to use his wooden goose call, making a high-pitched "ee-ee, ee-ee, ee-ee." The geese answered back. A sudden surge of adrenalin made me forget my fatigue and the smell of goose. The birds sounded as if they were directly out in front of us and coming closer. The urge to look up was overwhelming. Our guide called again. Again the birds answered. This time I just knew they were right over our heads. I could hear their wings. It sounded as if they were going to land right on top of us! The guide said nothing. As a veteran duck hunter, I thought I knew when incoming birds sounded in range. I turned ever so slowly to look up toward the sound of wings. I didn't see a thing. I heard a voice behind me, "I said keep your heads down, they're spooked." I felt instantly ashamed. Was I the only one who had weakened? He then said it didn't make much difference, the birds were too high and way out of range. That was a relief! I had learned a lesson. Incoming geese are never as close as you want to think.

The sounds of hovering birds were all around us now, though I had yet to see one of them. Our guide began to call again, that same high-pitched, very, to me, ungoose-like "ee-ee, ee-ee, ee-ee." This time, I thought, I am not going to look up even if a damned goose lands right on top of me. Snows somewhere on our perimeter answered. The guide returned their calls and the geese answered again.

"Boys, they're right out in front of you, but don't shoot till I say."

From my position I could actually look out somewhat without raising my head. Emerging from the fog bank directly in front were a dozen birds not yet setting their

wings for landing. These Snow Geese are the first wild geese that I have ever confronted as a hunter! My heart is pounding. God, they are close. But the guide says nothing. He keeps on calling. The geese always answering. I think, how strange to persist in calling when the birds out there have obviously seen our spread and are about to come in. A good duck hunter would never do this. But I am learning, finally, that geese aren't ducks. The birds now seemed clearly within twelve-gauge shotgun range, so close that my hood blocked sight of them. Still, there was no command to fire. Was our guide looking at the same birds I was looking at? The urge to throw back my hood, look up, and fire was overwhelming, but I didn't move.

Suddenly I heard the words, "OK, boys, take 'em!" The shooting started before I could throw my hood back, and for an instant I didn't know where the birds were. They ought to have been slightly behind me. I turned and swung my gun but then saw that the geese were directly overhead, and higher, much higher, than I thought. I picked one out and fired. I hit it. I fired again and connected again, but I could tell that someone else had shot the same bird. The goose folded its wings and dropped, striking the mud with a loud, padded thump. I heard the thudding sounds of other geese falling around me. Then the shooting stopped, and the survivors disappeared back into the fog.

We had shot five birds. For all the magnum firepower of seven men and all the shots expended we had killed only two outright. The black Lab was breathlessly pursuing one fallen goose while a hunter down our line was running after another. It was all over so quickly. Our guide took the dying cripples, wrung their necks, and dropped them by his side. "Get back to your stations," he whispered.

This procedure set the pattern for the rest of the hunt. By ten o'clock in the morning most of us had killed our limits. Shooting after twelve o'clock was not allowed so that the birds could settle down and have a chance to feed. One final trial awaited us, however—carrying our game and bags of decoys back to our vehicles. We had walked much farther out into the rice fields than I remembered, about a mile or so, and carrying all those dead geese back in the mud! They got heavier with every step. When I finally reached the Winnebago I was quivering like a bowl of jelly and was sore for days afterward.

In this painting, I have shown a handsome adult Snow Goose near a pond just as a distant fog is lifting. Behind the bird, tinged with frost burn, are the leaves and seed pods of some ornamental lotus plants, which grow down by the Trinity River not far from where I live. I don't hunt very much these days. I know that I can never explain to avid non-hunters how I can love birds and kill them, too, without apology. Nor can I convince the real anti-hunters that their simple presence on this planet (and mine as well) and the new mouths they peacefully bring into the world and all that goes with meeting their needs and comforts have done more to threaten wild things than shot and shell will likely ever do. Most hunters know this because they are connected to wild things in a way that the vast majority of non-hunting dwellers of cities and frequenters of shopping centers will never be. They have witnessed firsthand the ravages that the everyday demands of city people, in always increasing numbers, have wrought upon the ancient habitat of fish and fowl, destroying vastly greater numbers and with greater speed by robbing them of places to replenish and sustain their numbers. If nature could choose between the sword or the plowshare, I believe it would take its chances with the sword every time.

SWG

SCALED QUAIL

It is early morning in the Trans-Pecos country, dry and cold. The sun is rising and fills a distant valley, bringing light and warmth to the desert. On higher ground the covey stirs on the still-shadowed side of the hill. Now in single file they begin their descent toward feeding grounds below. Often called "blue quail" or, because of their white crests, "cotton tops," this desert bird inhabits an area from the Trans-Pecos grasslands to the brush and cactus country of South Texas and all along the Rio Grande Valley to the Gulf. It is also found in considerable numbers west of the Cross Timbers country and throughout the Panhandle. It can live on land having almost no water, getting its necessary moisture from the vegetation and insects that form its diet. It ranges far out into the driest country, enduring great extremes of temperature and actually thriving there.

I remember a trip I took with good friend Dutch Phillips out to his family's ranch in Borden County in West Texas one bitterly cold, late December weekend in 1962. The conditions were so rough that I find it difficult to describe them except to say that it was cold, bitterly cold, windy and dusty, and cold. Oh, was I ill-prepared for it! And when we ran out of food that holiday weekend with no means of getting more (Snyder, the nearest town, being more than thirty miles away on ice-covered roads, and the stores being closed anyway), we had to resort to living off the land.

Now, all that I had brought to hunt with was a smooth-bore, single-barrel flintlock musket with powder horn and shot-filled pouch, and to these were added an empty belly and a grim determination to bag something edible. I double-loaded the gun, and after being driven to a prairie tank and left alone, I found what seemed like a good spot for an ambush, sat down out of the wind, and waited. The surrounding country that blustery day had a certain bleak poetry about it. I felt like Audubon out on the prairies of the upper Missouri, actually more like Robert Rodgers's starving Rangers on their desperate retreat from St. Francis during the French and Indian War.

It was not long before a good-sized covey of cotton tops in groups of two and three began to emerge from the brush, hurrying down the bank to the frozen water's edge close by. I don't know if they sensed my presence, but they immediately scurried back into the brush again. I knew they remained near. I could hear but not see them. They were so perfectly camouflaged. I checked my flint and priming pan, full-cocked the gun, got up, and started toward the clump of brush. It was then I discovered that Scaled Quail are practically impossible to flush, especially without a dog. Nor will they stand motionless, relying on their protective coloring like bobwhites. They moved just ahead of me, keeping enough brush between them and me for protection. Now and then a bird or two would emerge from the weeds before disappearing again. I started after them, trotting first, then at a run. Not having any qualms about sportsmanship considering our present condition and my hunger, I kept my eyes as best I could on the birds until they entered a clearing open enough for me to take a shot. As luck would have it, they bunched together for an instant. Still running, I raised my flintlock and fired. I hardly felt the kick of the double load of black powder and shot as the explosion echoed off the nearby hills. A huge cloud of white smoke and dust obscured everything in front of me, but the icy wind quickly blew it away. As the smoke cleared, I could see that I had hit the mark—nine birds with one shot! Even with the roar of my primitive weapon, the survivors flew only a short distance before landing at a run and making their escape.

Later when I returned in triumph to the ranch house, we cooked the birds up with some beans into something resembling a makeshift cassoulet. None of us were any great shakes at cooking, yet somehow we pulled off a tolerable dish. Benjamin Franklin was right though. Hunger does make the best sauce. At any rate, this was my first encounter with the beautiful Scaled Quail. I have never hunted them since and am content to leave it that way.

SGG

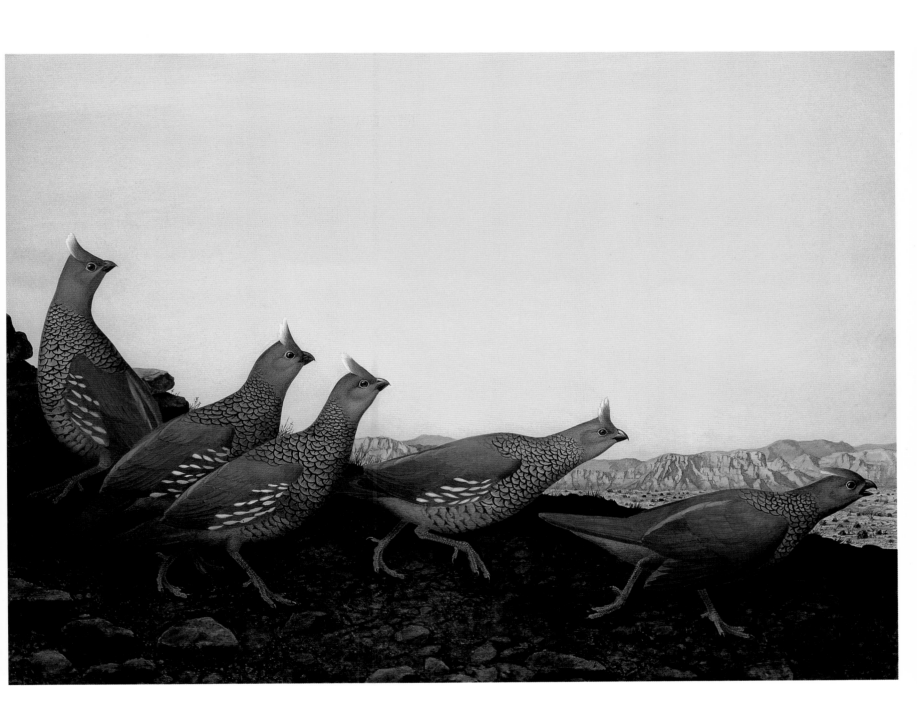

BLACK-CROWNED NIGHT-HERON

Camping at night on the Brazos River was one of the highlights of our growing-up years, that time when the urge for independence and the thrill of discovery ran as strong undercurrents in our lives. The river itself became a different world with the setting sun. The day creatures made way for those of the evening. The day people left, and only the easy laughter of a few fisher folk with Coleman lanterns working the banks or checking on trotlines in the early evening hours betrayed any human presence at all, and they too were gone by midnight.

It was then that the senses became more acute, and we became aware of the river sounds. Frogs, Chuck-will's-widows and whippoorwills, crickets, katydids, owls, the sounds of distant truck horns, or the occasional jet airplane passing somewhere overhead—all of this under a starry sky of crystalline brilliance, far from the city's glow. As the night wore on into the cooler hours of the morning the river noises became fewer, the crickets slowed their cadence, and conversations in low tones grew fainter until only the crumbling of a fire log broke the peace of sleep.

It was this time of night, or should I say this time of morning, that we chose as the mood for our painting of the Black-crowned Night-Heron. High above the river Brazos it climbs a branch, pausing to survey the valley below. Here and there a light comes on in a distant farmhouse as some early riser starts his day. A cowbell sounds somewhere downstream. The bird ruffles and smoothes its feathers. In a moment or two it will be on the far bank of the river, patrolling the shore under a bright and lowering moon.

SGG

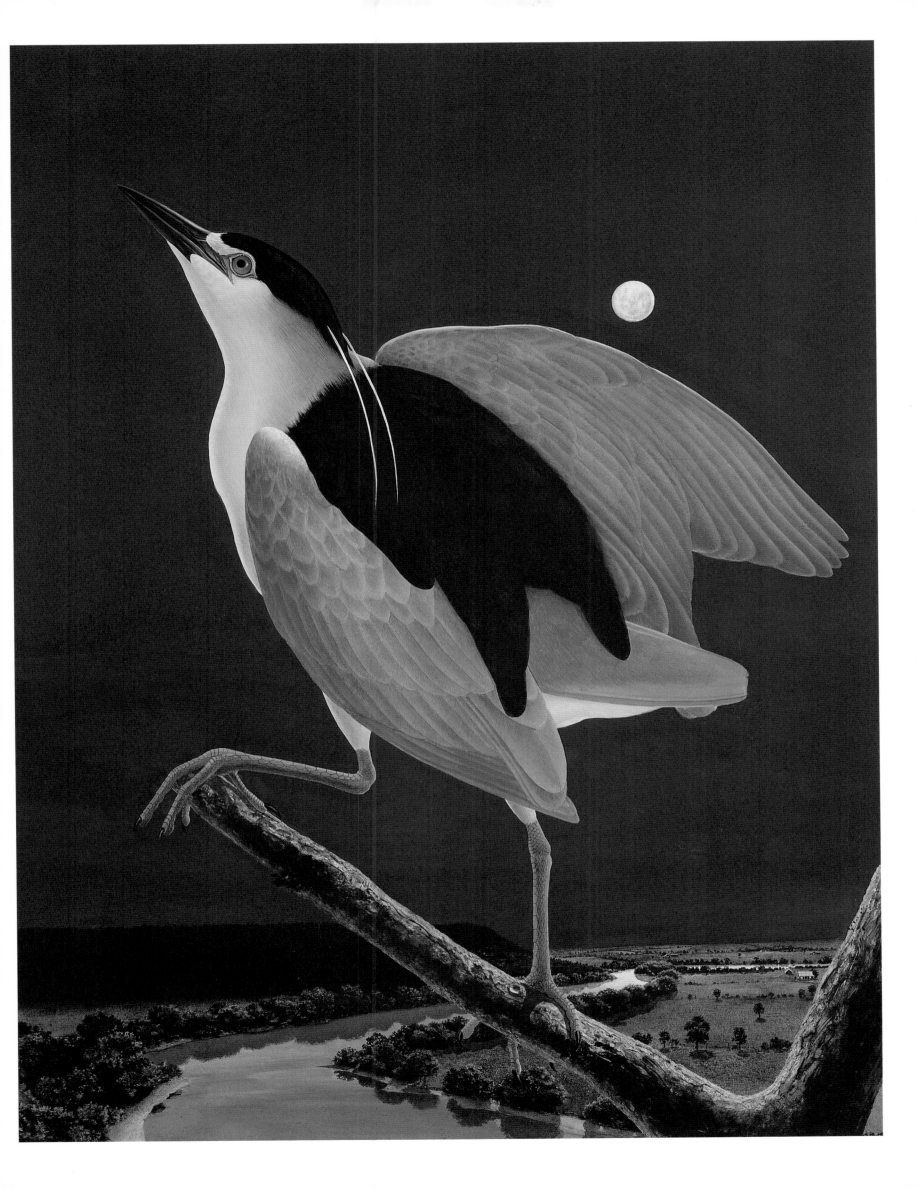

BARN SWALLOW

Stuart and I have, as long as I can remember, been great admirers of Oriental art. The delicate and jewellike colors of Persian and Indian miniatures and the sensitive relationship between subject matter and setting so beautifully expressed in Chinese and Japanese painting prompted us to seek a subject in which we might not only pay homage to these influences but also add to the variety and scope of this book.

On one of our spring trips to the Gulf Coast and its environs, we had the good fortune to come upon the perfect subject, some Barn Swallows drinking water on the wing from a lotus pond. Both the swallow and the lotus are powerful symbols. Not only in Eastern thought but in many other cultures the swallow is associated with the cycles of spring and fall, which are marked by its arrival and departure in the course of annual migrations. Some peoples actually believed that the swallow buried itself in mud during the cold months to hibernate in a kind of little death. Its reemergence in spring was in a sense a resurrection. Thus the swallow became a powerful symbol of life and death and rebirth. And, like angels or spirits, it partakes of the element of air, denoting height and therefore loftiness of spirit which in the process of cyclical regeneration ascends toward its perfection.

The lotus is a closely related symbol associated with the coming together of heaven and earth and the evolution of the human spirit. It originates as a seed deposited in the primordial mud of pond bottoms. It germinates and rises through the water to emerge into air and light where it bursts into a purified bloom. This echoes the growth of the soul toward enlightenment.

The Barn Swallow is the only deeply fork-tailed swallow in this country and as such is closely related to its Oriental cousin, so often represented in paintings from China and Japan. In keeping with the Far Eastern approach to this subject, the horizon line of the pond has been eliminated to create a spiritual, undefined sense of space. We kept the colors as pure as our style of realism would allow, but they are meant to reflect the vivid hues of Rajput and Mhughal Indian miniatures. The sharp contrasts of sunlight and shade were passed over in preference for the even tones of a cloudy day, which help to emphasize the flatness of colors as in traditional Indian paintings. It is important to realize that it is not at all necessary for anyone to read the symbolism of this picture, but rather to let it operate in a quiet, subliminal way as another level of feeling. What we have presented here is basically a picture of spring with some of the sensations that season evokes in us, while at the same time acknowledging the rich and influential sources from which it came.

SGG

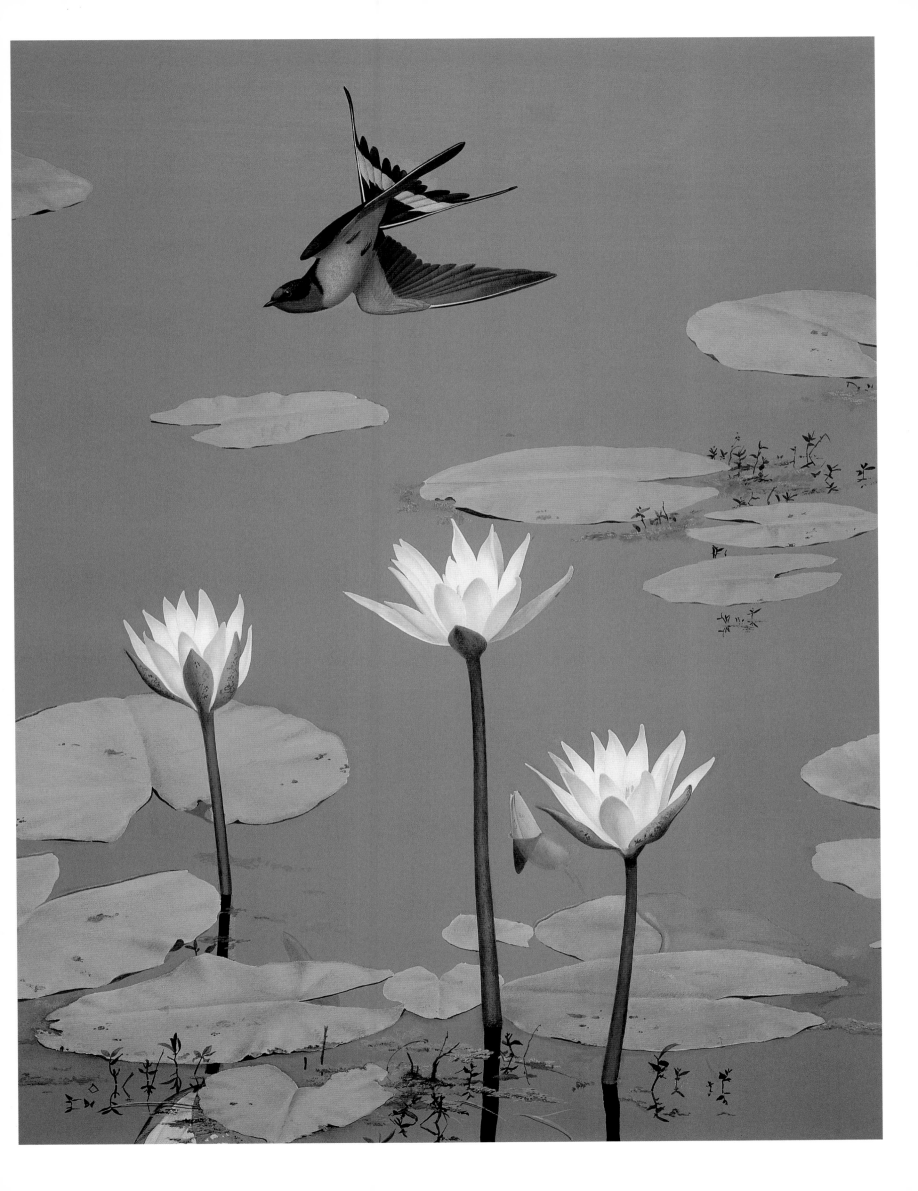

RED-SHOULDERED HAWK

One of the most treasured possessions that Scott and I have is a manuscript that Audubon wrote in Edinburgh, Scotland, in the winter of 1830, as one of his commentaries for the first volume of his famous *Ornithological Biography* to be published the following year. It is the first draft of his observations on the Red-shouldered Hawk, a species he portrayed three times in *Birds of America*. He painted the bird on plate 71 in its immature phase, which he thought was another species that he called the "winter hawk." He also depicted it attacking a covey of bobwhite quail, then called the Virginia partridge, in plate 396, certainly one of his most dramatic compositions. The third version was plate 56, showing a pair of adults which he knew and studied in Louisiana in the early 1820s. This plate has always been one of our favorites, and is regarded as one of Audubon's finest works.

Audubon found the writing of commentaries to be an extremely difficult and onerous task, made more so because he believed that he couldn't write "a decent sentence in English and hardly a more tolerable one in French." Considering the heavy burdens of raising money to pay his printer, Robert Havell, and Havell's workshop of fifty colorists and engravers, and then seeking new subscribers and collecting from tardy ones, the fact that Audubon could do any writing at all is a testament to his boundless energy.

We may be thankful for his close collaboration with a thirty-four-year-old Scotsman named William MacGillivray, who patiently edited the bird artist's rambling prose. He did a masterful job and in so doing helped the "American Woodsman" to create one of the most important monuments of nineteenth-century American literature. It was the standard reference on American birds for nearly a century and proved far more financially successful than his double elephant folio. Ultimately, *Ornithological Biography* was much more instrumental than the paintings in establishing his fame and reputation.

Unfortunately, much of Audubon's personality was obscured or glossed over by MacGillivray's editing, and rarely have examples of the biographies been published as he originally wrote them. For this reason, we are in-

cluding here a facsimile reproduction of the first page of our Audubon manuscript. We are also printing his comments in their entirety, with all of Audubon's original misspellings and eccentric punctuation left intact. It offers a wonderful view of the artist and the way he thought. It will also give the reader a great appreciation for MacGillivray's editing skills.

Though, as I have mentioned, Audubon incorrectly considered the immature phase of the Red-shouldered Hawk to be a separate species, most of his statements still hold true for this bird. It is with great satisfaction and pride that Scott and I have the opportunity to let John James Audubon himself write the commentary to our own plate of the Red-shouldered Hawk.

RED SHOULDERED HAWK
BY JOHN J. AUDUBON

*Although we are Informed that **the Skin** of this Species has been described for a great lapse of Years in Europe, we are in the Same breath told that nothing is Known of the Life & Habits of the Individual or the body of which it once was worn new, clean & glossy—No Kind Reader; The defaced coat only of this bird has been transmitted abroad; and like that belonging to many equally interesting Species of the feathered tribe has been exposed for Sale in distant market with as little concern respecting the Life of the Individual to whom it once belonged, as any of the thread bare vestments we see offered for sale by any of the old clothes vendors of St Gile's London!—even Mr Alexander Wilson himself Knew nothing respecting the habits of this Species and as other Authors ranking equally high with that pleasing writer, have unwittingly confused it with another Species Known in the United States by The Name of The Winter Hawk it is with some satisfaction that I find myself in a great degree competent to give an account of The diferences of **Habits** existing between These Species.—*

*The "**Red Shouldered Hawk**" or as I would prefer calling it The **Red-breasted Hawk** although dispersed over the greater portions of the United States, is rarely observed in the Middle*

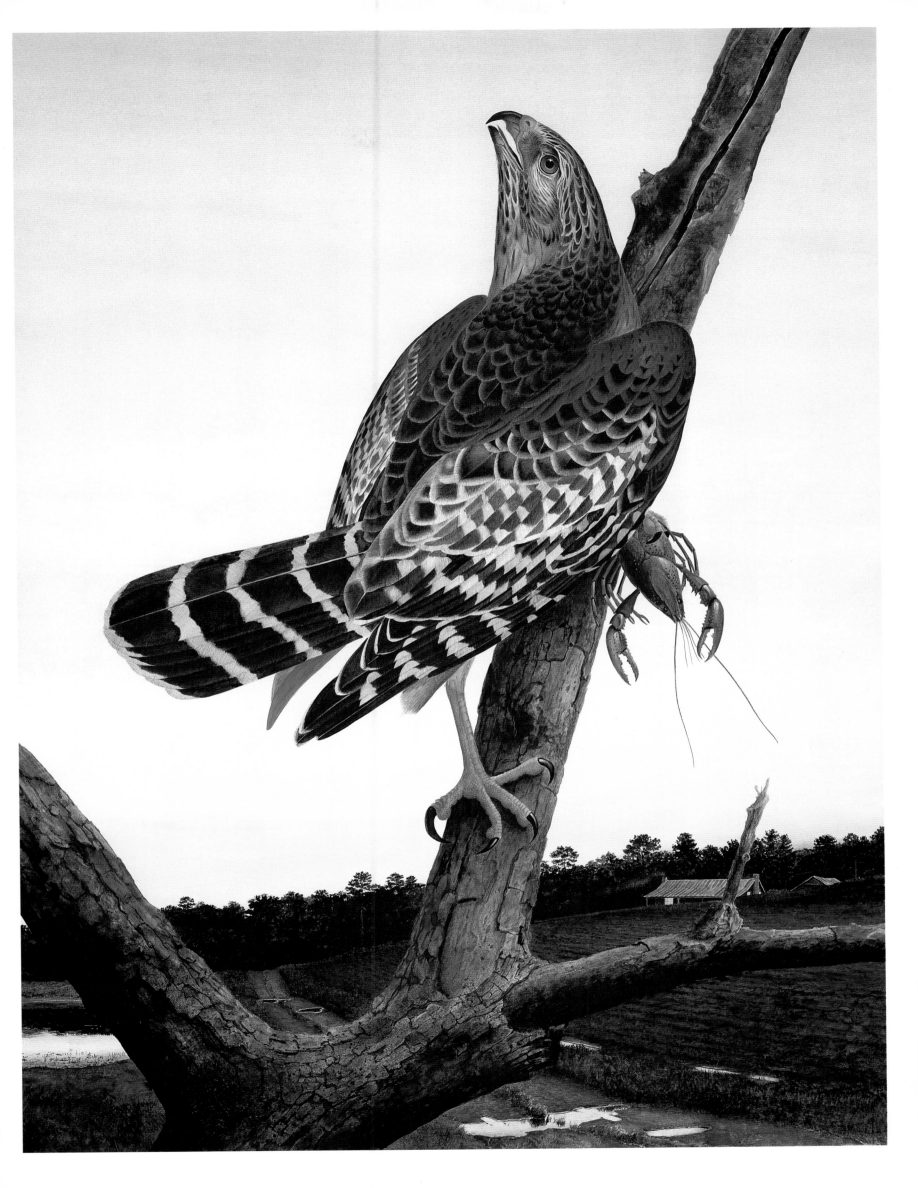

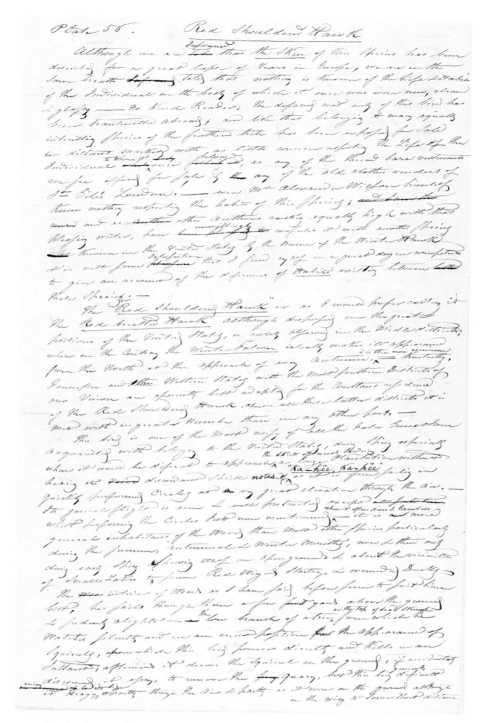

Facsimile page from Audubon's draft manuscript "Red Shouldered Hawk" for
Ornithological Biography. *Collection of the authors.*

districts, when on the Contrary the **Winter Falcon** *initially makes it appearance from the North at the approach of every Autumn & is then more common—Kentucky, Tennessee and other Western States with the Most southern districts of our Union are apparently best adapted for the constant residence of The Red Shouldered Hawk. **as** in all these latter districts it is met with in greater numbers than in any other parts.—*

This bird is one of the Most noisy of all the Falco Genus I am Acquainted with belonging to the United States, during

Spring especially when it would be dificult to approach the skirts of woods bordering a large plantation without hearing its discordant Shrill notes of "Ka-hee, Ka-hee" as it is seen sailing in quickly performed circles at a very great elevation through the air.—Its general flight is even & well protracted except whilt performing the Circles just now mentioned When it often dives & Gambols—it is a more general inhabitant of the woods than most other species particularly during the Summer, Autumnal & Winter Months, now & then only

during the early Spring Shewing itself on open grounds & about the vicinities of Small Lakes to secure Red Winged Starlings & wounded Ducks.

The interior of Woods as I have said before seem to suit him best, he sails through them a few yards above the ground & suddenly alights on the low branch of a tree or the top of dead stumps from which he Watches silently, and in an erect position for the appearances of Squirrels, upon which this bird pounces directly and Kills in an Instant; afterward it devours The Squirrel on the ground, if accidently discovered it essays to remove The Quarry, but this being generally dificult owing to its size it draggs it partly through The Air & and partly as it were on the ground although on The Wing to Some short distance until he conceives himself out of sight of the Intruder after which it again continues to feed on The flesh of its prey—The eating of a Whole Squirrel which this bird often devours at one Meal so gorges it, that after this ample repast I have seen this Hawk foundering about incompetent to fly and with such an extraordinary proturance on its breast as appeared to be quite unatural and very far from the usual beautiful form of it body when observed before feeding,. thus to such excess.—On all occurances such as I described when the bird is so gorged it is approached with the greatest ease; when on the contrary if it is in want of food it requires extreme caution to come within shooting distance of it.

At The Approach of Spring This Hawk begins to paire, and Their evolutions through the Air are accompanied with many circlings & zig-zaging motions during which His cries are heard The whole day. The male is particularly noisy at this time, he gives chase to all other Hawks, returns to the branch on which its Mate has chanced to perch & Caresses her—about The first of March The Spot chosen for a nest is already fixed upon and The Fabric is about half finished.—The high top of a Tall beech tree appears to be preferred by this Hawk as I have Their Nest more usually placed on these trees than any other, not far in the Woods bordering plantations; the nest is seated in the fork of a large branch toward its extremity, is as large as a Common Crows nest, formed outwards of dry sticks & Spanish Moss & lined with dry grasses and fibrous roots of diferent sorts laid circularly, The female usually deposites 4 eggs sometimes 5—These are of a . . . [This sentence was left incomplete for a description to be added.]

On ascending to the nest which by the way is not always an easy Matter as our Beach trees are not only very smooth

but frequently without any bows for a considerable distance from the ground as well as of rather large diameter; The female bird if it be her that happens to be sitting flies off silently & alights on a near tree to watch The result of The event, but should The Male that supplies her with food & divides the task of Incubation be there or make its appearance it immediately sets up a hue & cry & dives toward The assaillant in such rapid & successive sallies as without fail to attack any one nearing their nest—Where on several occasions I have had the tree on which The nest was placed Cut down; I have observed a few days afterward The same paire build another Nest on a tree not far distant from The very Spot where the first one was.—

The Mutual attachment of The Male & female Red Shouldered Hawk is of equal duration with that of their lives, They hunt usually in paires during the whole Year and Although They build a New Nest every Spring They are fond of resorting to the same parts of the wood for that purpose.—I Knew The paire which are represented in The Plate for Three Years & and saw Their nest each Spring of These Years fixed within a few hundred yards of each preceding one.

The Young remain in the nest until fully fledged and are fed by The Parents for four weeks after They have taken to wing, but leave Them and begin to Shift for themselves in about a month when they disperse and hunt separately until the approach of the succeeding Spring when after pairing They are as constant to Their mates as Their own parents—The young birds acquire the rusty reddish colour of the feathers on the breast & on the shoulders before They leave the Nest. This deepens gradually at the approach of Autumn and the following Spring they compleatly resemble the Old Birds.—The Red Shouldered Hawk raises only one brood during The Year. Scarcely any diference in size exists between the sexes, The female being only rather the stoutest.—

This Hawk seldom attacks any description of Poultry, & yet frequently pounces on Partridges, Doves and Wild Pugeons as well as Red Winged Starlings & now & then very young Rabbits—on one or two occassions I have seen them make Their Appearance at the report of my Gun & and try to Rob me of Some Blue Winged Teals Shot in some Small ponds of Water.—I never have seen Them Chase Small birds than those above mentioned nor quadrupeds less in size than the **Cotton Rat** neither am I aware of Their ever eating Frogs which are the common food of The Winter Falcon an account of which you will find, Kind Reader, in the course of This First Volume of My Biographies of the Birds found in our United States.—

RED-BILLED PIGEON

Some years ago Randy Rogers, a hunting friend return-
ing from a hunt in Mexico, appeared on my doorstep
with one of these beautiful pigeons. Scott and I were well
into our book project by then. One of our chief aims had
always been to find several special species for our folio
that John James Audubon had not painted. I knew that
Red-billed Pigeons were, or at least had been, residents of
the Rio Grande Valley, but apart from that I was com-
pletely ignorant respecting their habits. I had never stud-
ied them in the field. I had never even seen one alive be-
fore. In fact the Red-billed Pigeon is one of the few birds
in *Of Birds and Texas* I have not personally observed and
studied in nature, but it was simply too beautiful *not* to
paint. Though I had watched and noted the habits of
Band-tailed Pigeons in New Mexico many years ago, it
was risky to assume that the ways of one pigeon species
would be like those of another.

Since I was determined to paint a picture of this bird,
I naturally turned to our library to acquaint myself with
details of its range and habits and to determine whether
or not the bird in my hand had any particular anomalies
that might set it apart from the rest of its kind. Our books
soon provided all the information that was possible with-
out the benefit of direct field experience.

Scott and I debated about whether or not to include a
bibliography in our book. How could we list the reading
of a lifetime? And yet much of the material in this book,
both the pictures and the text, has been the result of re-
search derived from our own extensive library, of which
our collection of ornithological books is a relatively small
part.

Two works have been of signal service over the years.
We are truly fortunate to own the four great double el-
ephant folio volumes of the Amsterdam edition of *Birds
of America*. The prints contained therein are stunning
works of art in themselves, reproducing as they do in life
size all of Audubon's birds to dazzle the eye. The books
have proved indispensable in providing much extremely
valuable data to aid us when, as has been true on many
occasions, we did not have access to the actual birds. Im-
portant particulars such as beaks, eye rings, claws, the

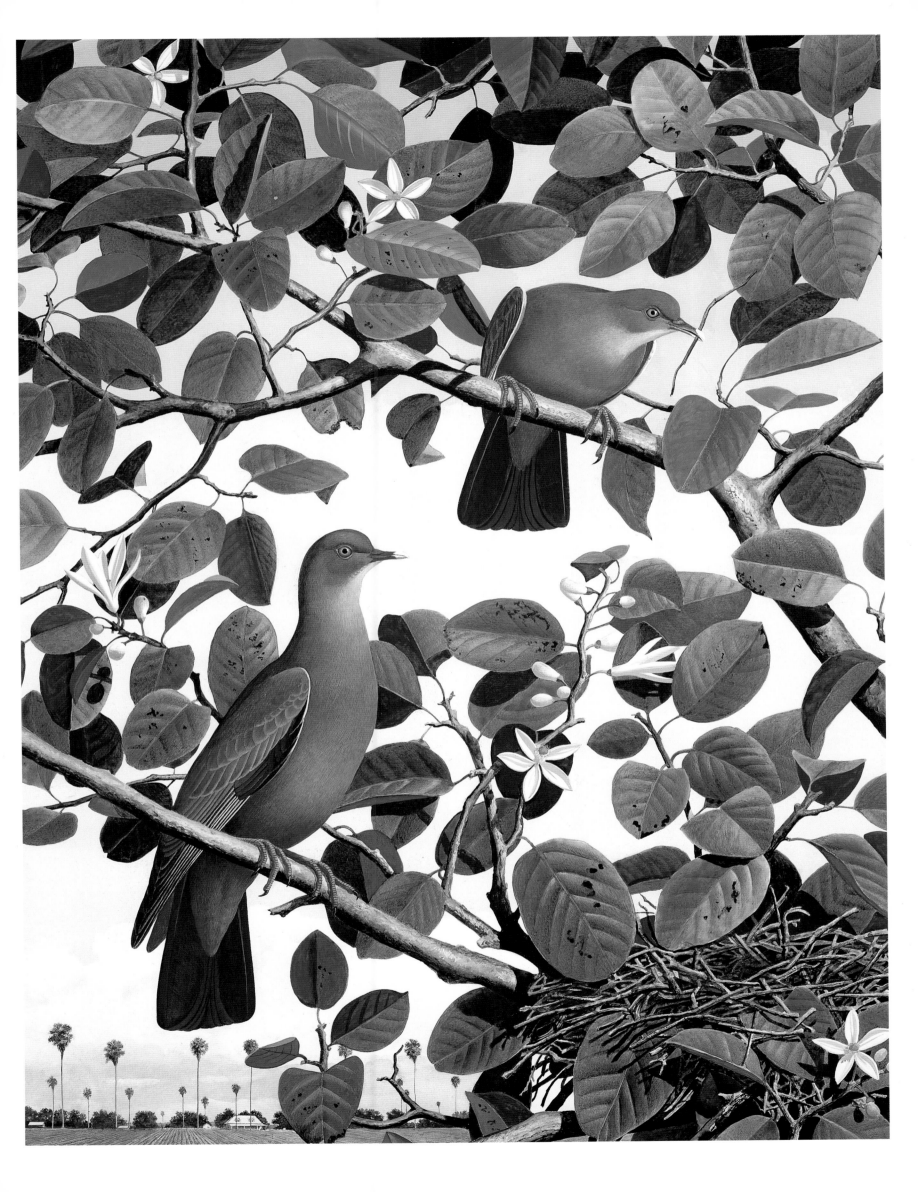

scale patterns of legs and feet, and the various configurations of feathering are all, for the most part, beautifully and clearly illustrated for easy reference. The importance of having this information easily at hand can not be over-estimated.

Another publication has been of equal or perhaps even greater help. It is the two-volume set by Harry C. Oberholser titled *The Bird Life of Texas,* edited by Edgar Kincaid and published by the University of Texas Press in 1974. Though the book has beautiful illustrations executed by Louis Agassiz Fuertes during his Texas travels at the turn of the twentieth century, it is Oberholser's bird biographies, intricate measurement data, and records of species distribution that have made this work of incalculable value to Scott and me. Both of our volumes are really quite worn from constant use, and frankly I do not know if our own book could have been completed without this indispensable reference.

There have been other books, of course, important scientific-artistic works by Fuertes, Sutton, Peterson, and others, and the many photographic field guides which are so popular today. Other useful sources have ranged as far afield as photographic guides for duck decoy carvers, Texas tourist books and magazines like *Texas Parks and Wildlife* and *Texas Highways,* and various monthly national birding magazines, the most prominent of them being the National Audubon Society's *Audubon* magazine.

My brother and I have shown a pair of Red-billed Pigeons building their nest in a blooming lemon tree in the Lower Rio Grande Valley at the tip of Texas. I am told that today they are extremely rare. I am also told that when they did nest in the area they preferred the thick cover offered by citrus orchards. After the season of breeding and raising their young, they assemble in flocks, which in days of old must have been considerable at least in their more common Mexican habitat. They are to be found, when stationary, on the high dead branches of the tallest trees, behaving like their band-tailed cousins of cooler climes.

There are few sights in my memory more thrilling than seeing a flock of Band-tailed Pigeons appear in the clear mountain sky as if out of nowhere and descend, rocket-like, into a stand of dead trees. They did it with a suddenness that always took me by surprise even when I was expecting them to come, which they did with such daily regularity that you could, as they say, set your watch by them.

SWG

BUFFLEHEAD

I painted this version of a pair of Buffleheads in 1976. It was the earliest bird picture in our book. Originally it was conceived as part of a series of bird drawings in graphite pencil that I did for the Junior League of Fort Worth between 1972 and 1984. The League reproduced the drawings in facsimile size to sell to their members and the general public to raise money for their many community activities. The fact that with an inch-wide border added on all sides the final prints came to have the measurements of an elephant folio was pure coincidence.

Buffleheads are diving ducks which as a rule prefer the deep water of ponds and lakes. They are common winter residents in Texas, and I have seen them in fair numbers on West Texas and Panhandle waters. They seem to be a pugnacious lot. I have seen male Buffleheads fight and chase each other long before the onset of the breeding season, which might explain such behavior. The name "bufflehead" is derived from their unusually long and fluffy head feathers, which reminded the early settlers and bird people of the woolly head of the American bison. Oddly enough, by pure coincidence the large grasses in the background, not yet touched by frost, are called buffalo grass.

<div align="right">SWG</div>

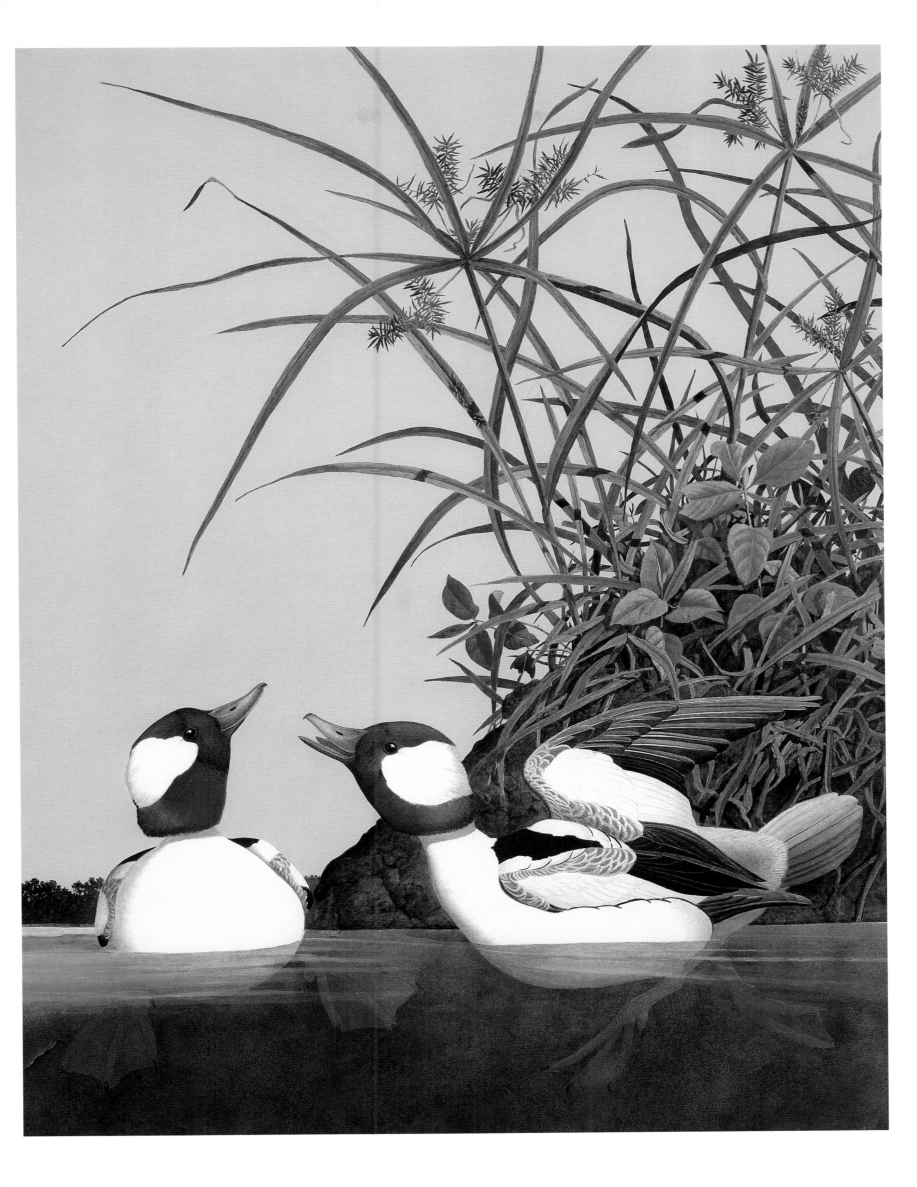

MOURNING DOVE

One should never plan a party, a wedding, an art open-ing, or an important event of any kind in Texas that re-quires sizable numbers of males in attendance on Sep-tember 1, for that is the opening day of dove season. Dove hunting is almost a ritual activity in this state. It makes little difference if you are a hunter or not. Chances are that on or during the weeks following the first day of September your life will be affected at least in some small measure by dove hunting. As I have gotten older, my tastes in hunting have changed considerably, along with a no-ticeable ebbing of zeal. Though over the years I have given up the pursuit of big game, including the hunting of deer or even varmints, I confess that I am likely to remain till the end of my days an unrepentant hunter of doves.

Dove hunting is as much a social activity as it is a sport. A sign of this is the happy inclusion of the fairer sex in group hunts. In fact, even non-sportive types of both sexes will accompany hunting parties to outlying ranches to enjoy socializing while their companions blast away around nearby stock tanks and sunflower fields.

Scott and I have depicted a Mourning Dove drinking water from a fossilized dinosaur track in the Paluxy River bottom near Glen Rose, not far from where I painted Limestone Ledge. The land around the town is one of the few areas in the United States where these tracks can be found. All of this country was once part of a great and shallow sea populated by creatures whose fossilized re-mains formed the very limestone that has made this area so well known. You can see the tracks of several kinds of dinosaurs ranging from the meat-eating theropods, the three-toed varieties, to the larger vegetarians like the duck-billed dinosaur and the great brontosaurus.

SWG

FLAMMULATED OWL

This tiny owl is an inhabitant of the Chisos Mountains in Big Bend National Park in the southwestern elbow of Texas near the Mexican border. When Travis Beck kidnapped Scott and me and took us there on a marathon expedition in May 1981, this bird was one of the most important species that he wished to add to his life checklist. To look for it we had to hike about seven thousand feet up a winding, narrow, and tortuous foot path over a mountain before descending to Boot Springs, a valley paradise not even hinted at from the arid side of the mountain where we had left our truck. That first fantastic view of Boot Springs became the background for our painting of the Zone-tailed Hawk in this book and was only possible after we had been shown what seemed like a secret canyon entrance right out of a 1940s Tarzan movie.

The epic river canyon spreading out before my unbelieving eyes was absolutely unspoiled and primordial, well worth the expense of shoe leather and sore feet. Not being a camper by nature or temperament, though I've done my share of it in Texas and faraway places where lions and tigers and one-horned Asian rhinos dwell, I didn't even mind that no campfires were permitted there. It had been bone-dry for a biblical forty days or more so that our food was going to be cold beans and Vienna sausage. One particularly annoying problem, however, was finding a level spot to pitch our pup tent. There weren't any. Finally Scott and I did find a place for tent pitching. It was ideal in every way except one; it was located right at the edge of a dry creek bed, a tributary originating on the wooded slope high above us. Travis was quick to point out that, should it rain, we might be in for a big surprise, but Scott and I were adamant. It never occurred to me that we could have arrived at the end of the valley's biblical drought.

Travis gave in good naturedly. He had got the usually sedentary Gentling twins this far, already much removed from the Aransas National Wildlife Refuge on the coast, which my brother and I had thought was our sole destination, though Travis had other plans. Thinking that we were going to be out of town for only one day, we had brought just the clothes on our backs and very little

146

money. Travis, an ex-Green Beret captain, on the other hand, had thought of everything—camping gear, food, three sleeping bags, three backpacks, bird books, a pair of binoculars for each of us—everything. He had used, no doubt, subterfuge to pry us out of Fort Worth, but he just knew that once we were on the road Scott and I would be grateful for the opportunity to visit areas that we had not studied before.

In order to get to Big Bend, we had followed a route from Port Aransas to Brownsville, then through the Rio Grande Valley to visit the Santa Ana National Wildlife Refuge and other points of interest along our way. We crossed the Pecos River above its confluence with the Rio Grande and had slowly driven down into the Big Bend country, where we left our vehicle behind in a parking lot and hiked up into the Chisos looking for birds. We finally arrived at Boot Springs in the late afternoon. The hiking was strenuous. Because of this and the dry weather there were not many people in the canyon, but every one of them was a bird person. Bird people are a special species of human being. They often seem to speak a different language. They certainly exhibit different rules of conduct. Their appearance is somewhat different from the rest of humanity though there are dramatically differing types even among bird people. In the Chisos Mountains Scott and I observed two basic categories—the civilians and the professionals.

Civilian birders come in all shapes and sizes and in all ages and probably are composed equally of women and men. For a long time bird people were labeled as eccentrics, but now it is fashionable to be interested in birds. With normal people, especially retirees with time on their hands, joining the ranks, this trend has proven to be no fad, like most American fads—a mile wide and an inch deep. Of the two main bird-watcher types, I frankly prefer the civilians. They often show an ease of mind, an almost innocent enthusiasm and love for birds that, in most instances, is free from pretense and technical irrelevancies. This does not mean that the civilians don't know their stuff. They do. And like amateurs in other fields they have contributed more than their share to our store of bird knowledge.

Professionals, on the other hand, especially the young ones, remind me of graduate students everywhere in that so many of them seem to lack a sense of humor, at least when they are in the field. They are the possessors of knowledge too arcane to share with the unprofessionals, and they tend to speak techno-babble or what art critic John Hughes once called "impacted duckspeak." There

are dramatic exceptions to this, I know, but average birders will understand what I'm saying. In my life I have been involved peripherally in two areas of science—ornithology and archaeology—both peopled with numbers of these humorless technocrats whose disdain for armchair enthusiasts, if not expressed outright, is always just below the surface. John James Audubon certainly experienced this as a self-educated naturalist without credentials when he tried to get the attention of the men of science and learning while debuting his bird paintings in Philadelphia.

One characteristic that *all* bird persons seem to have in common is a scrupulous sense of honesty. In this quality they do stand out from the rest of us, especially hunters. The sighting of rare bird species among them confers a special kind of status that elevates the sighter in the pecking order of those who seriously keep life lists of bird encounters. Seeking rare birds among those species that are localized in the Big Bend or that accidently and occasionally migrate from south of the border is one of the main reasons so many birders flock to the park.

The people sharing Boot Springs with us that May afternoon were bird persons of the professional kind, young graduate biologist types dressed appropriately in khaki shorts and khaki shirts with various colored patches sewn on for status or to indicate their affiliations with school or wildlife organizations. They wore tennis shoes or low-cut hiking boots, carried backpacks, and from their necks hung, of course, binoculars.

Three of them, two men and a woman, decided to make their camp not far from us, about fifty yards down the creek. They had brought bedding but no tent. They were pleasant enough to be with, and when we were finished setting up camp we wandered down to talk birds. Scott and I were still excited about seeing our first Acorn Woodpeckers, certainly one of the most striking members of that family. But our neighbors called them "trash birds." I had never heard that term before. No matter how beautiful, those woodpeckers were regarded by these professionals as trash simply because they were common. They had come for rarer sport: the Flammulated Owl, a species that was nowhere common in the park and definitely no trash bird.

The Flammulated Owl is somewhat smaller than the screech-owl. From a distance its gray coloring also resembles its larger cousin, but the feathered tufts of its "ears" are less prominent, and it has eyes that are a mysterious dark brown instead of yellow. Flammulated Owls live exclusively on insects, mostly moths and beetles, which

they often capture on the wing or glean at night from tree branches or occasionally the forest floor. By day they roost by scrunching up next to the trunk of a tree, usually a pine or mountain oak. With their subtle colors and markings they become literally a bump on a log and simply disappear. They would be altogether impossible to find were it not for their habit of hooting most of the night. The three ornithologists told us that the chances of finding one of these owls were fairly good, especially since the young woman could imitate their hooting perfectly. If we were quiet and obeyed their instructions, we could go along later that evening.

We knew that Travis was very excited by the prospect of adding this bird to his life list. Scott and I, being of a more sedentary nature, were more interested in making our camp comfortable as it began to get dark. We were exhausted, and, believe it or not, the oncoming darkness was partially caused by thickening clouds with hints of rain. By evening, as it began to sprinkle, we started to harbor forbidden thoughts of motel comforts.

It was dark and quite cold, and it had been raining for some time when the three bird people with flashlights in their hands showed up in our camp. Travis was ready to go flammulating, but Scott and I could not be lured from our pup tent. Neither of us relished the idea of getting wet in the mountains with no fire and no possibility of getting dry afterward. Travis, as tolerant as ever, only gave us a look of disappointment and reminded us that we were missing a capital opportunity to add this owl to our life list. We answered from our tent that we had no life list. The other three bird people simply looked on in silence.

Just then, almost as if on cue, on the far side of the densely wooded ridge at whose foot we were camped, came the distant call of a Flammulated Owl. "Hoot. Boo, boo, hoot." The woman birder instantly responded with an incredibly ventriloquistic hoot of her own. The owl answered. The three birders were quite excited, and Travis too. He asked us if we would change our minds and go along, but there was little passion in his request. He knew he couldn't stir us from our tent and our warm sleeping

bags. Besides, there were ominous sounds of distant thunder up on the mountain, and they were getting closer.

Off went Travis and the birders, answering the distant owl with their own hootings as they climbed out of sight, their flashlight beams disappearing in the dense growth above us. It was soon raining more heavily, and though we at least were relatively warm and dry, we could feel run-off water accumulating under the canvas flooring of our tent. The floor would be waterproof for a while, but there would be trouble if the rain continued for long.

Suddenly from a tree directly overhead came a soft "boo, boo, hoot." We threw the tent flap back and pointed our flashlight up into the pine branches. Perched there like a proverbial log bump was a small gray bird sitting quite still but blinking its large brown eyes in the glare of our flashlight. I turned my light off and pulled myself back into the tent. We hoped that the bird might remain long enough for Travis and company to see it on their return. Otherwise they would never believe that we had been so lucky.

In about a half an hour they got back to our camp. By then the rain had begun to taper off to a light mist, much to Scott's and my relief. We had not heard any hooting from owls or people for some time. When we emerged from our tent we could see that everybody had disappointed looks on their faces. A sense of humor would have served them well at this point, for the answering owl that they had gone out into the rainy darkness with such enthusiasm to find turned out to be a team of other birders who were also good at flammulated hooting. Though I had not heard our owl for some time, I held my finger over my lips and pointed my flashlight up into the pine tree right over us. There it was, sitting quite still, a ball of feathers not as large as my fist, looking down at us and possibly wondering what all the fuss was about.

We have shown this diminutive owl just after sunset and about to pursue a moth. The canyon below is vast and lonely and gives a hint of the untouched beauty to be experienced by those willing to make the effort to hike up into the Chisos Mountains.

s w g

GREAT-TAILED GRACKLE

The Great-tailed Grackle has become a common sight around Fort Worth, but I remember when it was not always so. It might be difficult for some to believe that I rarely saw these birds at all on the west side of town where I grew up in the 1950s. This close relative of the Boat-tailed Grackle is a tropical bird which in the last fifty to sixty years has spread across the state from its home in the warmer climes of South Texas and Mexico. At a distance, it differs in appearance from the less common boat-tail in that it is considerably larger and generally more purple in color. It is an unpopular bird here because of its noisiness and aggressive behavior and messy toilet habits.

Great-tailed Grackles range farther inland than do their smaller relatives and seem to me to prefer evergreen trees for making their nests and for roosting at all times of the year. I have most often seen them in cedar groves and evergreen oaks, and I have a private theory that these birds resort to evergreens because they are immigrants from tropical regions where most of the trees retain their leaves for the entire year and they have become genetically encoded to prefer these.

Though, as I have said, the Great-tailed Grackle is not a popular bird here, Scott and I have always thought that it is an exceptional species, gifted with more intelligence and certainly with more personality than most other Texas birds. We have depicted three glossy males and a brown female in a sweet gum tree as part of a flock descending on a harvested cornfield. The upper bird is shown in a pose that is characteristic of the males of this species when other rival males are present. This challenging or perhaps greeting posture is most evident as part of their spring mating behavior, but I have seen male great-tails perform it all times of the year. They are very inquisitive and will on occasion approach quite close to inspect you. But should you attempt to approach *them,* they become quite wary and will not allow you to venture near. I think we have caught in our painting a sense of this bird's remarkable personality, its boldness and intelligence, its cunning and wide-eyed alertness—and above all its sheer elegance.

One last note: We decided to include a painting of great-tails as tribute to our discovery in 1984 of the lost original Audubon painting of a pair of Boat-tailed Grackles that played such a remarkable part in John James Audubon's life and ours as well.

SWG

PYRRHULOXIA

So many of these paintings depict birds performing various kinds of activities. In our painting of the Turkey Vulture, for instance, the bird is opening its wings to take off and soar upward in the air currents rising over the Brazos River. Our picture of the Great-tailed Grackles shows these vigorous birds speeding through a sweet gum tree on their way to a harvested cornfield. In most of the other pictures in this book, birds confront their rivals, hunt for food, or are in brief, passing flights through the picture plane.

With the Pyrrhuloxias, a close cousin of the cardinal, we have done a painting which shows birds at rest. In fact, we have combined all the elements here to reinforce a feeling of peace and repose and a sense of time suspended. It is always a pleasure to do a quiet work of this kind, not only because it adds a needed element of contrast to the more dramatic subjects, but also because we are basically painters of quiet subjects. The rocky terrain against which these birds are posed is part of the western edge of the Edwards Plateau. It is a quiet place, a place removed, offering a view that encourages a moment of silence and contemplation.

The simple poses of the Pyrrhuloxias reinforce the feeling that here nature, at least for the moment, is clean and untrammeled, detached and serene. The only movement is that which is implied in the stem of the flowering red yucca which is bending under the weight of the birds. Nothing intrudes to break the silence of this scene, and the picture's cool tonality and mood also reflects an absence of urgency. We hope that it provides the viewer with a moment to pause and reflect.

<div align="right">SGG</div>

EASTERN TOWHEE

The towhee evokes associations that extend all the way back to the beginning of my interest in birds. The very colors of these sparrows seem somehow so American to me, perhaps because of their earthy simplicity and quiet elegance or maybe because my first serious interest in American history began about the same time as my enthusiasm for birds and the work of John James Audubon and his life and times.

Not far from our home and below the bluff on which we lived as children, and in fact still live, was a beautiful and relatively unspoiled area of woodland where many childhood dramas were played out. By coincidence this was John Graves's childhood roaming country a generation before us. It was there that a fascinating world of nature awaited our curious eyes. It was a good school where we could come on autumn afternoons and sit motionless in the thick undergrowth beneath the great trees and wait for towhees. One fall, I was painting a picture of this bird, so every afternoon after school I would take my drawing equipment and go to the woods. After a time these birds as well as a host of White-throated, White-crowned, and Harris's Sparrows, juncos, and Fox Sparrows would show up to scratch in the dead leaves and flit among the brambles, often coming within two or three feet of me.

As shy as towhees usually are, these birds soon became used to my presence and went about their usual activities. They would only get nervous when I had to sharpen my pencil or make some other obvious movement. Even so, they were soon back at their business while I, only occasionally glancing at my paper, made sketch after sketch, sometimes doing one drawing on top of another to be deciphered later at home. In this way I came to know and admire this beautiful bird and admire, too, the setting, the time of day, and all the other peripheral impressions that are stored in a painter's memory.

In the work here we have shown the edge of a woods on a late autumn afternoon. A couple of pumpkins serve this pair of towhees as observation posts from which they fly now and then to scratch for seeds and insects among the dead leaves and to which they return to preen and observe, their keen ruby eyes always on the watch. The pose of the lower bird, the male, echoes Alexander Wilson's drawing of this species, which appeared in his *American Ornithology* (1808–1814), the first great book of birds published in this country. This color plate is our tribute to that gentle Scotsman.

SGG

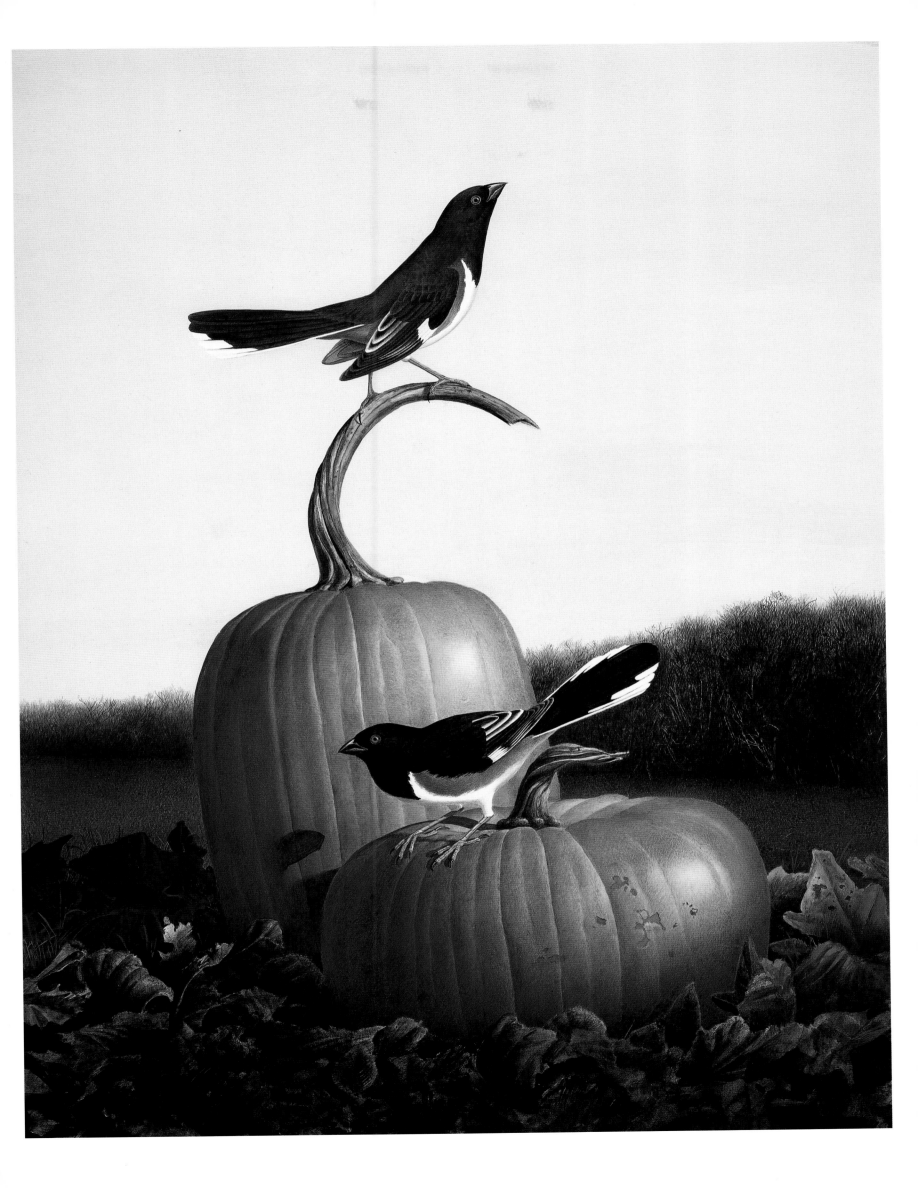

PURPLE MARTIN

The Purple Martin is certainly one of our most popular birds. A beautiful and large swallow, it is extremely gregarious, like most of its kind, and prefers to nest in large colonies, now entirely in structures provided by people. Its close association with human habitations must have a very long history in America, for early settlers learned from Native Americans how to attract martins by hanging large gourds cut with nesting holes in trees or specially constructed racks near the house and barnyard. One of the main reasons for maintaining a resident flock of martins, other than the simple pleasure of having them around, is that they consume countless thousands of mosquitos, flies, and other insects.

Today people in both town and country often go to considerable expense to have large "apartment houses" built to accommodate these birds. Conditions must be just right to lure martins, and I am not sure why they will pick one house and not another equally (to me) appealing one. Sometimes they will wait for years before moving in.

That Purple Martins return very early from their wintering grounds in South America probably helps them establish their claims to birdhouses before the breeding urge affects other local species like starlings and English sparrows. It is not uncommon to see martins in the skies overhead as soon in the new year as late January or early February. If care is taken to guard the nesting house from unwanted interlopers then martins most likely will return year after year to enhance your garden and your life.

Martins usually catch their prey on the wing, but I have seen them briefly alight on trees to pick insects off leaf tips or the ends of branches. On occasion I have seen them feeding on the ground. They often congregate in flocks of fifteen to twenty birds, especially when the young have learned to fly, and it is not unusual to see both adults and juveniles perched together in rows on telephone wires while other birds sweep over nearby treetops after bugs and spiders. It is also a delight to watch them skim deftly over the surface of local ponds for a drink or dip for an instant in the water for a quick bath on the wing.

You may wonder how Scott and I chose the birds for this book, since there are no terns here or seagulls; no crows, jays, or magpies; no tanagers, no cranes or thrushes, though we have favorites among them all. The idea for the painting itself dictated our choice of bird subjects first and foremost, and that required that both bird and background and dramatic moment come together as an artistic concept. It has been difficult for those people who like to mentally put things into clearly defined categories to understand that *Of Birds and Texas* is really a book about birds and not a bird book.

SWG

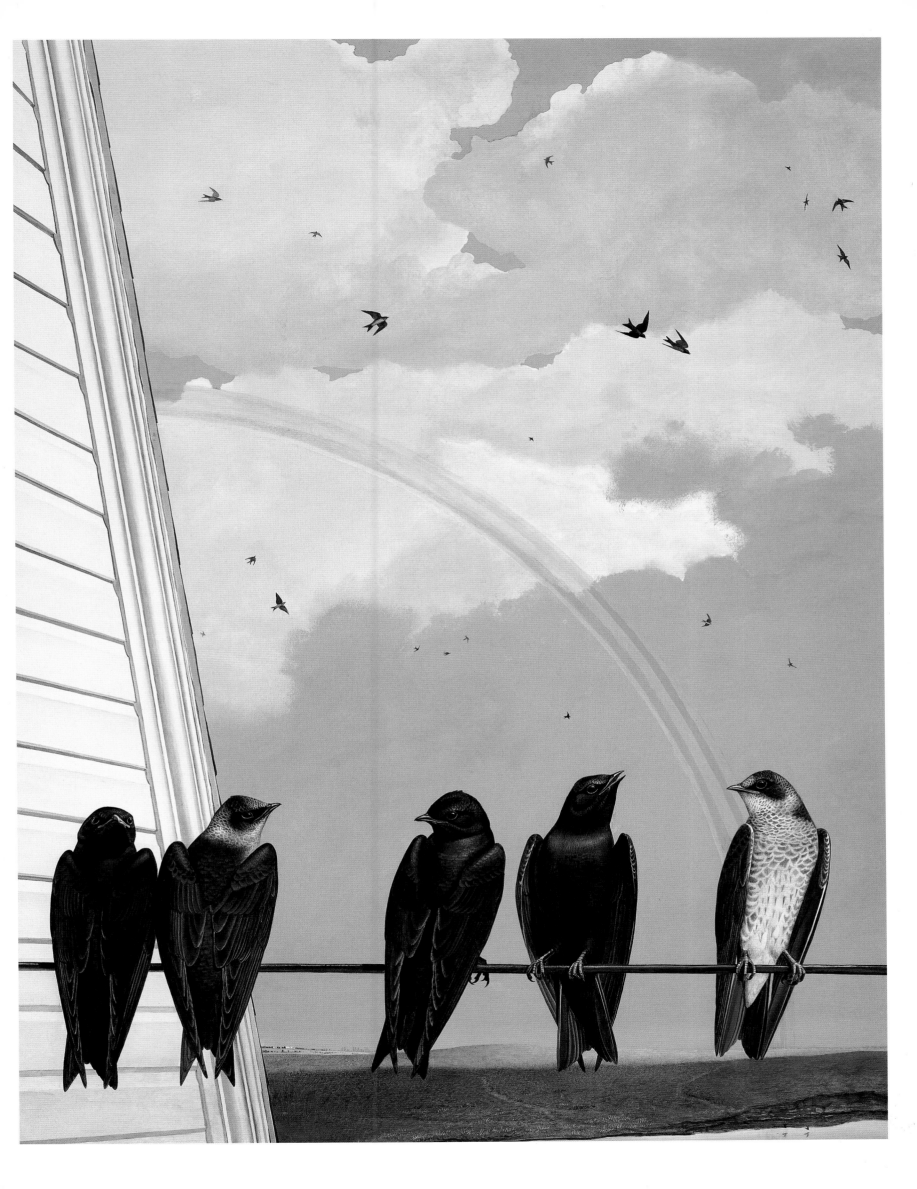

CRESTED CARACARA

I'm sure that there are a lot of Texans out there who have no idea that our forefathers first declared independence from Mexico in 1835 in the small town of Goliad. This place with its famous mission occupies a somewhat ambiguous position in Texas history, for not only were the first seeds of independence planted here, but it was also nearby that Colonel James W. Fannin and almost four hundred men were captured and later massacred by Mexican soldiers in March of 1836.

This tragedy shared several points in common with the disaster at the Alamo, but the two events are viewed quite differently today. Both engagements were fought for territory considered strategically worthless by the best military minds. The two Texan armies had been ordered by General Sam Houston to abandon their positions, destroy their mission fortresses, and join his command as quickly as possible, avoiding all contact with Mexican troops. Both Texan armies became hopelessly trapped by the enemy and subsequently met their deaths. The men serving under Fannin at Goliad and Colonel William B. Travis at the Alamo were brave by any standards, but they were poorly trained and, unfortunately, poorly led. Because most of the 183 Alamo defenders died fighting in a battle that cost the Mexican army hundreds of casualties, possibly hindering it from making a clean sweep up through the coastal settlements to crush Houston's feeble army, Texans have apotheosized the defeat at the Alamo into at least a moral victory. On the other hand, it has been impossible to transform Fannin's surrender and massacre into an equally symbolic triumph, so this important event has been overshadowed by what happened at San Antonio.

Probably the only benefit the Texans gained from these two tragic encounters was that Santa Anna, flush with victory, became so convinced of ultimate triumph in pursuing Houston's retreating army that he divided his own troops in the face of the enemy and let his guard down. This carelessness brought about his surprise defeat at San Jacinto at the hands of an inferior force of rebels filled with a desperate resolve to avenge the atrocities of San Antonio and Goliad. Had the generalissimo kept his army intact and alert, his superb cavalry units alone could have destroyed any Texan army on the open field.

The Texans were undisciplined, badly officered, divided in their aims, and so poorly supplied with artillery and ammunition that they would not have stood a chance in a direct face-off with Mexican forces. It can be truly said that Santa Anna grabbed defeat from the jaws of victory. That he was captured and made hostage by Houston was the main reason why the Texan army was not further attacked and sorely tested by the remaining Mexican troops under the very able command of General Filisola.

Because of the inglorious defeat of Fannin at Goliad, this place has not had, until relatively recently, as much attention paid to its preservation as the shrine of the Alamo. I can remember when Scott and I first visited Goliad in the 1960s; it still seemed like such a sad place, with a tragic aura about it, immediate and tangible. I have never felt that way about the Alamo, a site much restored and sitting on an island in the midst of downtown San Antonio traffic.

The coastal plains around Goliad are Crested Caracara country. This member of the falcon family is both a predator and a scavenger. Many scholars believe that the caracara was the fabled "eagle" of Aztec myth perched on a nopal cactus with a serpent in its beak. Whether eagle or caracara, this image is the symbol of both ancient and modern Mexico and undoubtedly flew on the flags of victory raised over the Alamo and Goliad.

We have shown two caracaras who have just discovered a Texas tortoise and are trying to breach its shell. In the background is the Goliad mission; Fannin and his men were held prisoners in its chapel before their executions. If any painting was created with the Texas Sesquicentennial in mind, it was this one. You could even say that while we pay tribute here to our love of Texas history and Texas birds, there are hints of other deep interests— our long-held fascination with pre-Columbian and colonial Mexican history, and the work of John James Audubon, who visited Texas only once, in 1837.

SWG

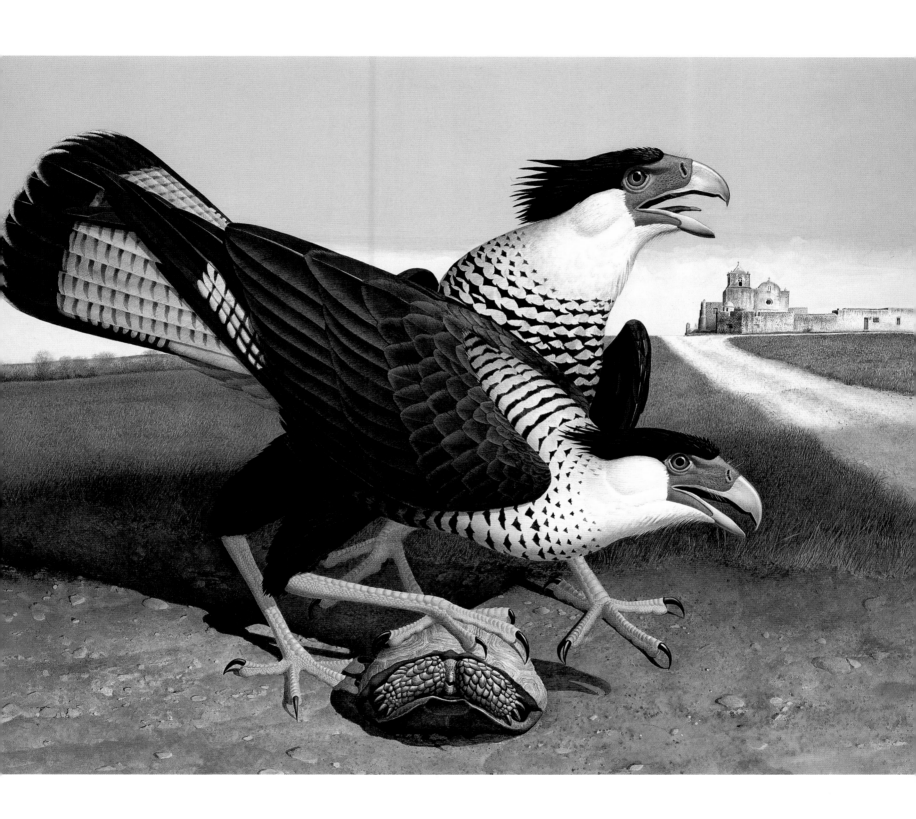

NORTHERN MOCKINGBIRD

John James Audubon thought the mockingbird might make a good symbol as our national bird, not only because of the polyglot nature of its song but also because of the fearlessness with which it defends its territory and young against all threats. In our painting of this bird, certain overtones of territoriality permeate the scene. A fence encloses a backyard space. Beyond, other houses have their spaces and boundaries plotted, separated, and fixed. And above all this, a vast and starry sky.

The night is permeated with the scent of honeysuckle, sweet and heavy. Crickets sound the drowsy, slow, and constant cadence of the very early morning. The air is damp. The mockingbird sings and dances from its perch, its performance lovely and unworldly, reminiscent of that passage from Ottorino Respighi's *Pines of Rome* where, in the nocturne, a nightingale enters with its solo—singularly strange, dreamy, and remote.

Once, through an open window, I heard a mockingbird's night song. I half opened my eyes, looked outside into the night, and saw it dancing butterfly-like in the moonlight. I asked myself before returning to my pillow the question in the last line of Keats's "Ode to a Nightingale"—do I wake or sleep?

SGG

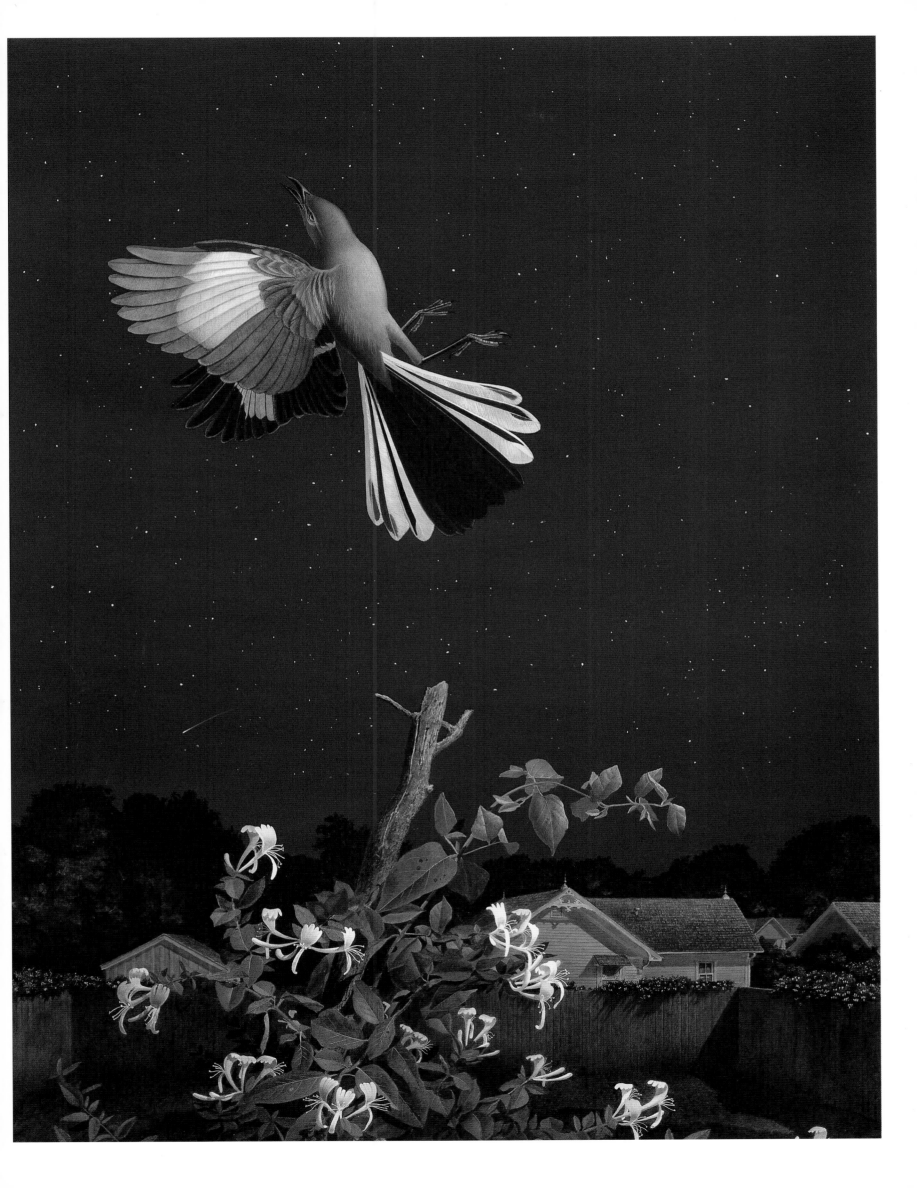

NORTHERN BOBWHITE

Many years ago I went hunting with old friend Richard Moncrief at his farm a few miles west of Fort Worth. With us was another good friend, Henry Hopkins, then director of the Fort Worth Museum of Modern Art. All three of us were experienced quail hunters and used to working with dogs. Dick provided two fine pointers, residents of the land where we were to hunt. We casually worked our way across an open field and then along the edge of a wood, bagging birds along the way without much effort. We flushed a number of coveys as we began to hunt our way along a narrow creek bordered on both sides by woods. Henry and Dick were on the other side of the creek, but the dogs were with me, searching the terrain only a few yards in front of me. It is a good dog that stays close to a hunter! We could tell that they had picked up the scent of birds as they moved back and forth criss-crossing the same trail. All three of us just stood where we were and watched in admiration as the two dogs searched the ground. There is nothing more beautiful to a quail hunter's eye than to see a brace of pointers hunting together in perfect coordination.

The odd thing was that the dogs were working their way closer and closer to the very spot where I was standing. To my surprise both dogs stopped just a foot or so away and simultaneously came to a firm point right off the tip of my boot. I mean right off the very tip! I looked down to inspect the ground. The grass was only about six inches high, and there were just a few dead leaves to partially obscure the ground. There simply was no bird. Still, the dogs remained firmly on their point.

Dick and Henry were watching with interest. I declared that it must be a false point, that the dogs were probably picking up the scent of quail blood from my boot. Dick answered, saying that his dogs rarely if ever made a false point. It was a boast that I had heard many a hunting dog owner make, and I told him so. But Dick persisted. In

fact he bet me five dollars that a bobwhite was right in front of me, and I simply could not see it. Before I accepted his challenge I looked again, this time scrutinizing the ground very closely. There just wasn't any bird.

I took Moncrief up on his bet, and as I slowly lifted my foot to step forward the quail flushed with such an explosive burst of flight that it totally rattled me. I fired. I was so startled, though, that I missed the bird completely. In a fraction of a second I lost my composure, the quail, and my five dollars. This bobwhite had only been about four inches from my foot. There was enough daylight to see quite well. The dogs had faithfully pointed out the spot to me, and I had plenty of time to inspect the ground.

The camouflage of bobwhites is so good that they are simply impossible to see. When they roost they will do so together in circles or semicircles depending on the number of birds and the roosting ground. There may be several birds concentrated in one spot and still they are almost impossible to see. They roost in this way because if they should be surprised by a predator they can flush in all directions and with such a noise that all but the most intent of hunters are easily confused. I might add that I have seen bobwhites roosting together in relatively open country and at midday.

This plate of Northern Bobwhites was one of the black-and-white drawings that I did for the Junior League in the mid 1970s and later colored by hand, much in the same way that Robert Havell's colorists painted the black-and-white aquatint prints of Audubon's birds after they were pulled from their copper plates. I have shown a covey of birds roosting on the side of a hill away from the winter wind. They have just heard a suspicious sound, perhaps a snapping twig or a dried leaf crunching under foot or paw. They are suddenly alert and in an instant ready to flush forth in all directions with a loud whirring of wings.

SWG

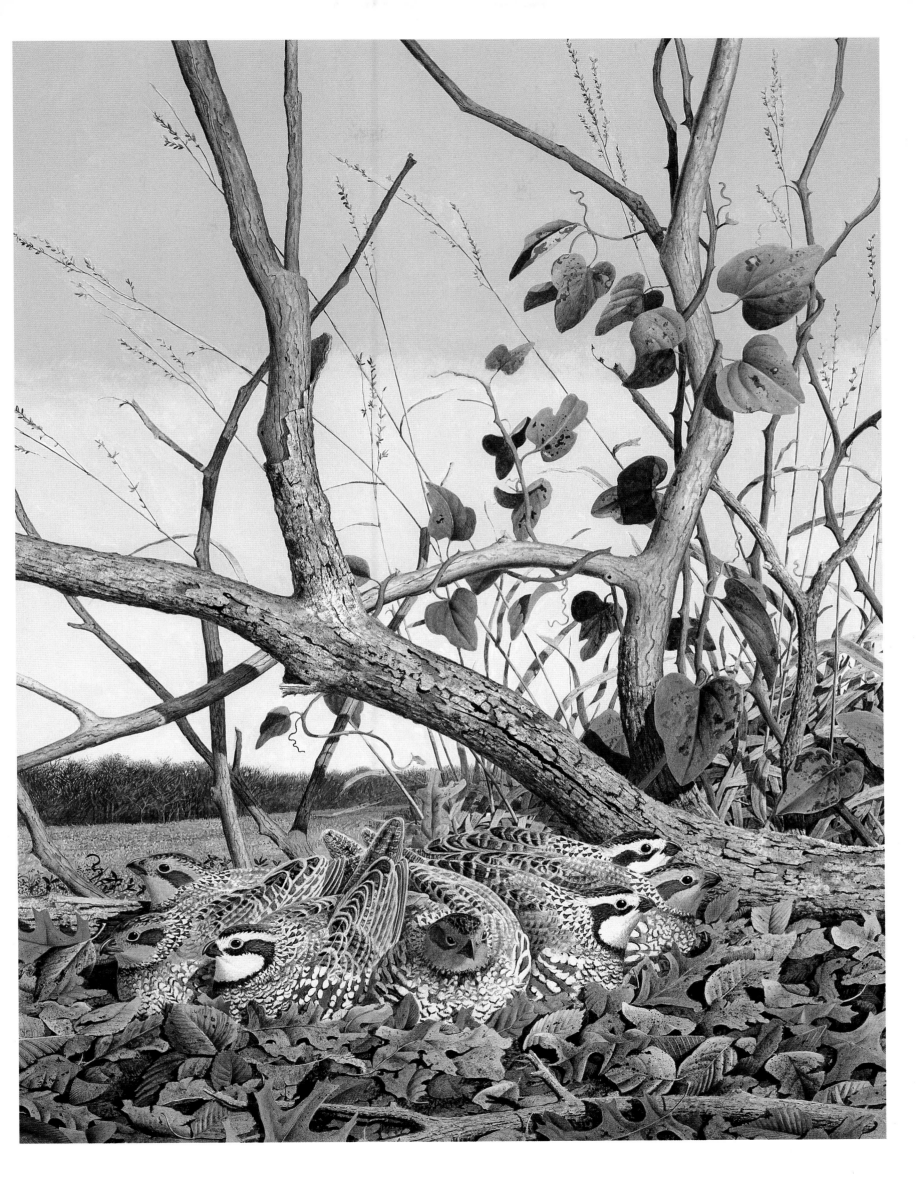

SIX MIGRATING WARBLER SPECIES

The month of August is usually a rather dead month in Texas. Those who do not take vacations to cooler places are driven inside for the relief of shade and air conditioning. There is a stillness about the month as if everyone pauses to rest physically and psychologically for the coming stress of autumn activities beginning in September. But as quiet as August usually is, it nevertheless promises a certain measure of excitement for bird people, for in the last two weeks or so of the month the first autumn warbler migrants begin to arrive in Texas. At this time in the old days, the trees in our neighborhood of west Fort Worth used to be alive with warblers of many kinds. Their numbers, however, seem to have steadily diminished over the years for reasons of habitat loss, strange toxins and animal waste and chemical fertilizer runoffs, and even cowbird parasitism. But come that time of year, I perk up my ears for the sounds of their bills snapping after insects in high branches.

Scott and I have greatly enjoyed several of Audubon's paintings in which he portrayed a number of bird species on a single page. He made no attempt to make a naturalistic picture of such scenes. He was under great pressure because of publishing costs and complaints from subscribers, many of whom had waited eleven years for Audubon, his printer Robert Havell, and Havell's workshop to complete the entire set of 435 bird prints. For economy he simply had to group a number of birds together.

In the course of producing our folio, Scott and I had many opportunities to appreciate the pressures under which Audubon labored, and it was really quite amazing how closely our publishing experiences paralleled his. We could have gone on to paint another forty birds and still not covered all the species that we wanted to represent, but there was a point where, like Audubon, we were forced to stop because of costs. As we reached the end of the project we regretted that we had not done more paintings of smaller birds. We yielded to this temptation by doing this picture of several warbler species in homage to our enjoyment of similar plates in *Birds of America*.

In 1999, Vera and Bob Thornton published *Chasing Warblers*, a book about their quest to photograph all fifty-two species of wood warblers that nest in the United States. The Thorntons, whom I met when Scott and I were in the last throes of publishing our folio, are a perfect example of why—in spite of what I might have hinted to the contrary—you cannot really profile bird persons as a type. To look at them you would think they epitomize upper class yuppie Dallas perfectly; they are a handsome couple right out of *Vanity Fair*. Yet it took a single-minded determination and much dirty work to track down and photograph all our U.S. warblers. And what photos they are! Many of the warbler attitudes they captured on film uncannily echo some of Audubon's most audacious, and most criticized, bird poses, proving again that Audubon was a far more astute observer than modern bird painters generally credit him.

Here we have included the Yellow Warbler, Northern Parula, Blackburnian Warbler, American Redstart, Magnolia Warbler, and Black-and-white Warbler. I added as a joke a seventh, the Goldencheeked Warbler, which I thought was a year-around resident of the cedar country near where John Graves lives. It was a joke that backfired. A savvy ninety-year-old bird lady in San Antonio pointed out to me in mid-lecture that they migrate to Central America. Oddly enough, though this picture was not really meant to be naturalistic, I have indeed seen as many as five different kinds of warblers at one time in a tree, and that tree has usually been a cedar elm, as in our picture, whose many small leaves hide thousands of tiny insects.

SWG

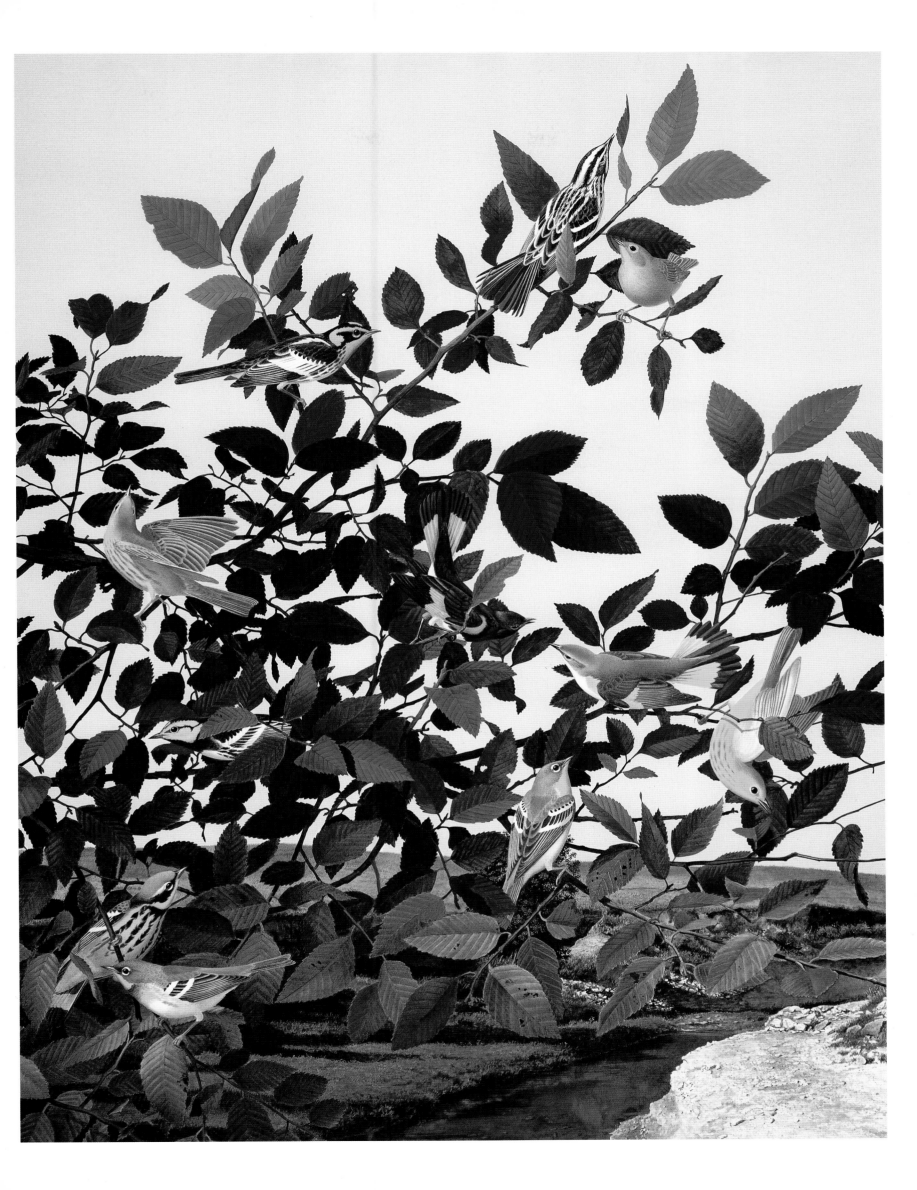

CANVASBACK

When I think of Canvasbacks I can't help but ruminate about the many duck hunts of my youth and the friends, some no longer living, who shared a brotherhood of mutual interest and a closeness that adult life rarely allows. Bill Utley, Charles Priddy, Don Burford, Tom Loffland, Dutch Phillips, John Truelson, Tom McCoy— each name recalls a different story. The survivors have in some cases followed diverging paths, but when we meet from time to time, the passage of years is simply swept away. When I hunt, which is rarer these days, I do so with friends made as an adult and with women, too, like Nancy Ferguson, a crack shot. It is a real but different kind of pleasure with occasional moments of youthful exuberance. And when I hunt with men like Doug More and Bill Meadows and others today, I often share the chase with their teenage sons as well, whose enthusiasm is infectious. Young Walker Meadows has often been my eyes and ears as these senses have suffered the wear and tear of years painting in the field under a bright Texas sun and shooting without ear plugs.

In 1998, I hunted with Harry Tennison on the opening day of dove season. Harry, who wrote the foreword to *Of Birds and Texas,* was seventy-nine years old and walking with a cane after knee surgery, and it just happened to be the anniversary of his wife Gloria's death. With Harry there, and Doug and Bill and their sons as well, I realized that here were three generations of hunters who have shared some very important moments in my life.

Harry and I were left alone at the edge of a newly plowed wheat field. Poor Harry, I thought. On a cane and by himself. If by chance he were lucky enough to hit anything, I knew that he wouldn't be able to retrieve it. So I thought I'd sit with him for a while to keep him company instead of hunting at my assigned spot a hundred yards or so away.

As I placed my hunting stool next to where Harry was already sitting I heard the familiar whistling of dove wings. Harry looked over my shoulder and with great ease and deliberation raised his new Italian over and under and shot the bird dead. It fell about twenty yards away, and I

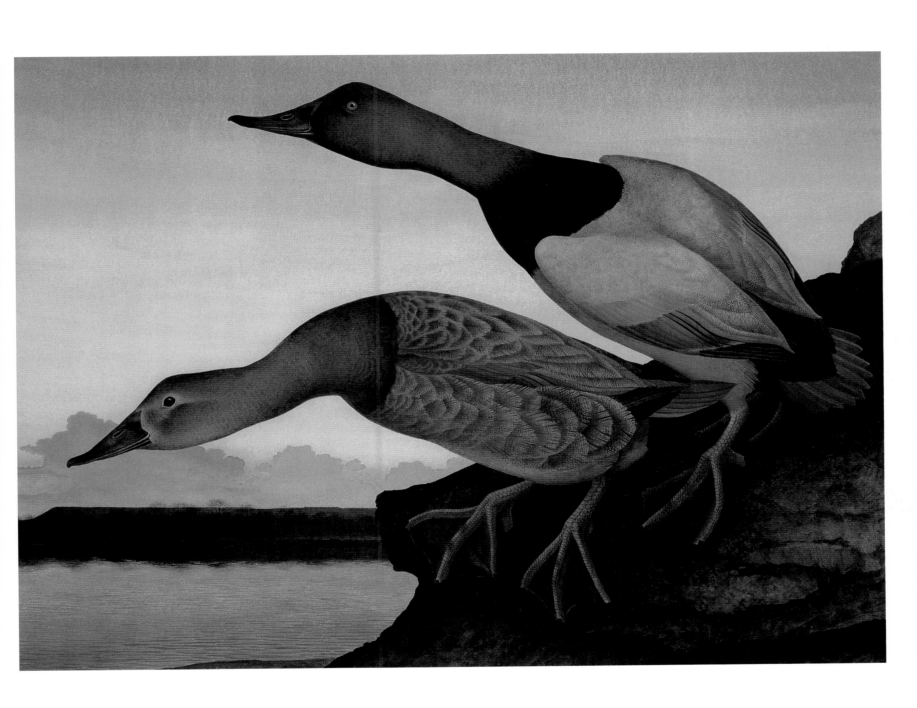

ran out and retrieved it. It was 106 degrees in the shade so I returned panting and sweating. At least old Harry had gotten one bird. I had no sooner sat down and loaded my gun than another dove flew by. I barely had my finger on the trigger when Harry fired. The bird plummeted into the wheat field. I was still panting from the first dove as Harry directed me to the exact spot where his dove had fallen. As I was walking back with dove in hand two more doves flew by. Harry fired, Pop! Pop! Both birds dropped out of the sky, stone dead. By the time I retrieved those, I was completely exhausted.

I did manage to get some shots in. And I hit some too. But my shooting was considerably affected by my constant heavy breathing, and Harry never seemed to miss. He had me crawling over the nearby fence so many times that I finally told him to shoot only at birds in front of him. By that time, though, Harry had just about shot his limit. That afternoon really raised his spirits. All of us got our limits. Harry called me the best bird dog he had ever had, and he couldn't wait to go hunting again.

Some of the best times I have had in the field were when I didn't shoot and simply watched. One of these times had to do with Canvasbacks. There is something very special about these birds. They are excellent swimmers and divers and usually prefer deep waters, where they feed at considerable depths of often several hundred feet. In flight they are swift and powerful. But, quite frankly, they are trusting to the point of being stupid. Because it was so easy to lure them into gun range, especially with decoys, hunting so depleted their numbers that they have only recently been on the increase. The restoration of some of their former nesting habitat has probably contributed more than anything to their return, but placing them off limits to hunters has also helped. Often, when Canvasbacks were still legal game, my friends and I would hold our fire in favor of more sportive shooting.

I remember one particularly beautiful November day at Lake Cisco, about one hundred miles west of Fort Worth. It was ten o'clock in the morning, which is always a slow time for duck hunting. My friend Tom McCoy and I were standing in the blind, not at all trying to hide ourselves. In fact we were talking out loud, cracking jokes, and laughing so loudly that we could easily be heard on

the other side of the lake on the still morning air. Suddenly a small flock of about fifteen Canvasbacks seemed to appear out of nowhere, winging with great speed past the front of our blind and again out of sight.

We hadn't shot our limits, but Tom and I decided to let the ducks come in and land unmolested, if I could call them back. I brought my duck call to my lips and with it made a few raspy Canvasback noises. In a moment the birds were out in front of us again with their wings set for landing. There being no wind, the water was still and glassy. The flock landed right in the middle of our spread of decoys, just about twenty yards away. We remained perfectly motionless, not touching our guns, which were leaning against the wall of the blind.

The birds soon settled down. They were not the least concerned or apparently aware that they had just landed among a group of plastic dummies. Soon they began to swim closer to the shore. Our blind was so situated that its front wall was actually at the water's edge. The ducks were soon diving for food among the underwater plants. Before long several of the Canvasbacks were feeding at the shoreline directly below, not two feet away!

Watching these beautiful wild things was the most enjoyable part of that hunting trip. Indeed, it is my only memory of it. I especially enjoyed watching the ducks flip over on their backs with their large webbed feet making feeble paddling motions in the air as the birds groomed their belly feathers with their long, arched bills. Eventually they grew restless, paddled out beyond our decoys, and took to wing, literally running across the smooth surface of the water until they were airborne. We never touched our guns. Nor did we shoot at any Canvasbacks that day though we did have several opportunities. We even returned home that night quite content without our limits.

Scott and I have depicted a pair of Canvasbacks at dawn on an island in a large and isolated stock tank on Dutch Phillips's old family ranch in West Texas. They are alarmed but move slowly down the embankment to the water. These deep-water birds are skillful swimmers, but they are awkward on land. Nevertheless, I saw them often in the old days resting in great numbers on islands and sandbars safely removed from the main shoreline.

SWG

MAGNIFICENT HUMMINGBIRD

This elegant hummer is one of those infrequent visitors from Mexico which sometimes can be found in the high forested ranges of the Chisos and Davis Mountains and is regarded by birders as a very special addition to their life lists. Unfortunately, neither Scott nor I have ever observed one of these birds alive, though we did see a single male specimen stuffed on display at the National Museum of Natural History in Washington, D.C., and we have seen films of them. A book by Crawford Greenewalt has a superb photograph of this bird, which allowed us to paint it based on it and other good photos and the precise measurements found in Harry Oberholser's book on Texas birds.

This bird and the Blue-throated Hummingbird are the two largest hummingbird species to inhabit Texas. Both are approximately five inches in length. In working out our ideas and composition for this plate, we decided to base our painting on our first sighting of a blue-throated hummer, which we had at Boot Springs in Big Bend National Park one stormy May afternoon on our memorable trip with Travis Beck in 1981. Travis, Scott, and I had been hiking over much of the area near the springs for nearly two days without spotting any hummingbirds, even though we had been told they were there. We finally sat down under some pine trees to take a drink of water and rest our blistered feet. The air was quite still, the skies heavily overcast and threatening a drought-lifting rain. Small shafts of light filtered down throughout the clouds, striking distant parts of the valley and lighting the small stand of pines where we were sitting.

Through the stillness came the familiar whirring sound of hummingbird wings. Suddenly, into a clearing in the pine branches above us darted a beautiful male bluethroat. It hovered for a moment, apparently aware of our presence but not unduly concerned, its tail swiveling back and forth to maintain its equilibrium. Then just as suddenly as it had come, the bird turned and in a flash of sapphire blue was gone.

SWG

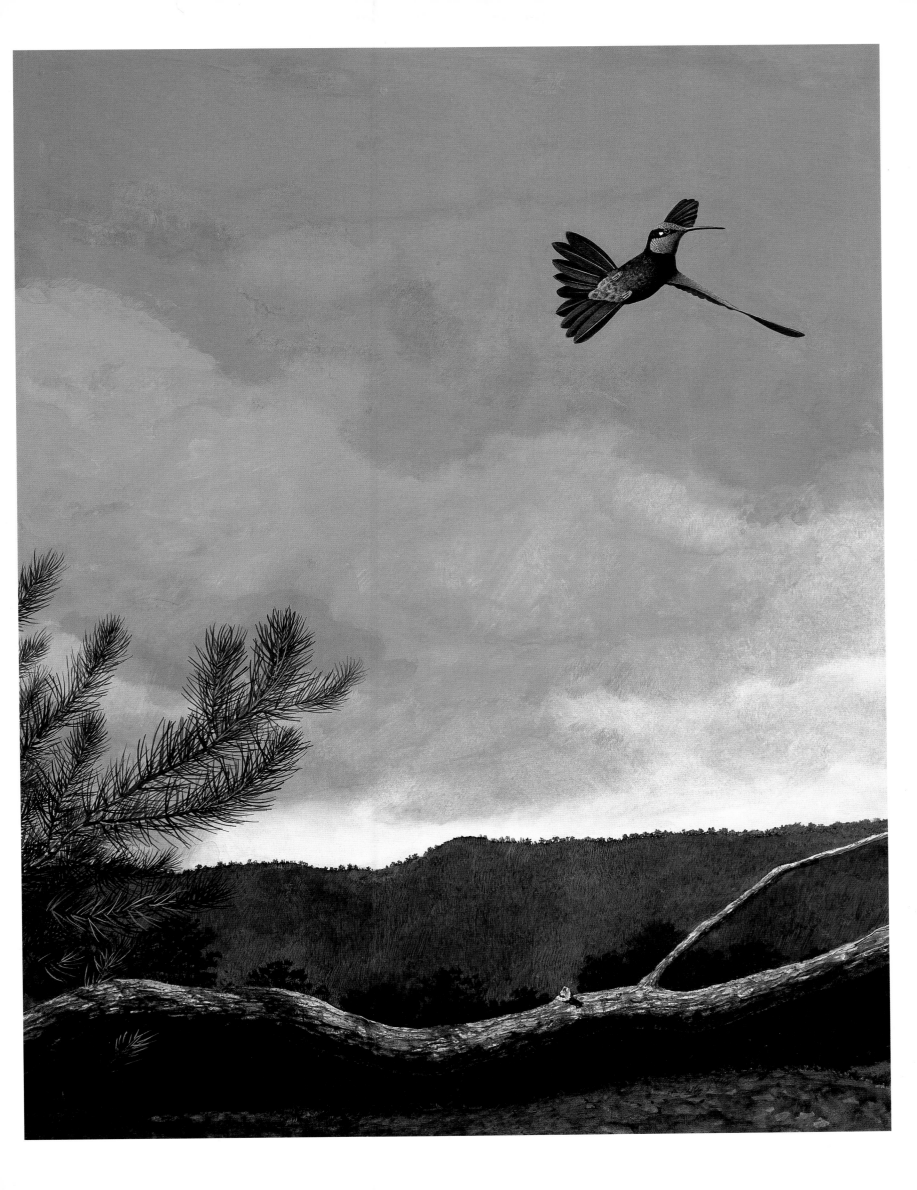

GREATER ROADRUNNER

Even though we live in a rather densely populated part of suburban west Fort Worth, we used to see red or gray foxes, armadillos, skunks, and raccoons on occasion in our front yards or even along some of our busiest streets. And sometimes vagrant roadrunners from the nearby Trinity River bottom. But that was years ago. Since then, due to all sorts of environmental factors, we never see them. In fact, until recently I hadn't seen a roadrunner for years.

So you can imagine my astonishment when, while I was working on this very painting and happened one morning to go out to the front sidewalk for the newspaper, I looked up, and there it was—not ten feet from me— yes, a roadrunner! It just stood there looking at me for what seemed the longest time and was not particularly shy at that. It eyed me for a while and then, leveling its body, ran around the corner of my house. I followed and saw it across the street. Arriving at the corner of a neighbor's house, it stopped and eyed me again for a moment before shooting around the corner. This coincidental encounter gave me a very good roadrunner view, which came in handy when I returned to my painting.

SGG

CLIFF SWALLOW

On hot summer days, Scott and I used to go with friends to the Brazos River to swim and mostly to lie around all afternoon on one of the many sandbars near the bridge at Dennis, Texas, a few miles west of Weatherford. We depicted this place in our plate of the Turkey Vulture. Sometimes we used to take enough gear to hike up river and camp out. The area was a birder's paradise. In the nearby woods were the usual cardinals, mockingbirds, and blue jays and such summer residents as Painted and Indigo Buntings, Summer Tanagers, Great Crested and Scissor-tailed Flycatchers, and occasionally even a Blue Grosbeak or Lesser Goldfinch. And, of course, on the river itself were kingfishers, herons, egrets of various kinds, and numerous small shorebirds.

One of the most interesting birds around the town of Dennis was the Cliff Swallow. They were seldom seen here until the old wooden and iron bridge was replaced by a structure of concrete. This new bridge provided a small colony of these swallows with solid walls and cover for their unusual nests, which are constructed entirely out of mud gathered in their bills from the riverbank and shaped into little pellets of adobe. These nests are clustered in colonies, and the skies around bridges and cliffs favored by these swallows are always filled with soaring and chirping birds chasing insects or gliding above the river's surface for a drink of water.

There are cliffs in our state which also bear some of the last few reminders that Texas was peopled by others before the coming of the colonists, especially that part encompassing the western range of Cliff Swallow territory, where many sites still display the remains of Native American picture "writing." About 80 percent are thought to be of prehistoric origin, and nobody knows exactly why they were made. Nature worship seems to be indicated by the frequent use of earth, sun, moon, rain, and mountain symbols. The presence of the Maltese cross and other quatrefoils, as well as the human hand, in all likelihood refers to the number 5, which symbolized the four cardinal directions plus the center, marking the painted site as sacred ground. Ancient human representations show hunters, warriors, and shamans performing rituals. At cliffs in Terrell County, an area visited by generations of Jumano, Comanche, and Apache peoples, are also paintings of more recent vintage depicting Christian priests, cowboys, horses, and other evidence of Europeans.

When Scott painted this picture, the mud swallow nests reminded him of the adobe dwellings of New Mexican pueblo people, and he wanted the painting to be a kind of microcosm of Texas history by combining a part of its ageless natural beauty with a hint of its ancient and historical human presence.

SWG

CHUCK-WILL'S-WIDOW

The spring storms in North Central Texas are often astonishingly violent. At this time of year, just when life seems to be luxuriating in renewal, the vernal forces of high and low air masses confront each other with often terrible results, producing flash floods and sudden destructive windstorms that can strike with little warning. Of all the kinds of bad weather that can plague this area, tornados are the most feared—and rightly so. Though we live in part of what is called "Tornado Alley," it is a fact that no place in the continental United States is immune to them, nor are they confined only to the spring months. Indeed, a particularly bad tornado was once recorded in Massachusetts during the month of December.

Because the plains of the middle west and southwest are the areas that come to mind when most people think of tornadoes, and since these storms are so much a part of Texas at this time of year, we thought it fitting to include a view of one in our book. The picture itself is based on the memory of an actual tornado that we witnessed just west of Fort Worth in May of 1967. The fact that we were in no actual danger did little to lessen our apprehension, but we did have the presence of mind to take detailed notes of the storm as it passed.

Recently, in March 2000, Fort Worth and our small studio in the cultural district had a truly frightening encounter with a tornado. It happened around 6:30 in the evening, when the funnel touched ground in a neighborhood only a few blocks away and then proceeded roughly in the direction of the studio. We were at home sitting in total darkness since our electricity had gone off. Outside, the skies were darker than usual but appeared no more menacing than any typical spring storm.

Ralph Carr, our Fort Worth dealer, was at the studio, however, doing some evening paperwork, and the storm rapidly bearing in his direction presented an entirely different picture. The studio building, though completely rebuilt in the early 1980s in preparation for our folio project, was only a small frame structure, no match for the 150-mile-an-hour winds this Force 2 tornado possessed. Worse, we had only recently assembled there all our original Aztec and Mixtec art, all Scott's Aztec mod-

els, all our paintings and drawings of Tenochtitlán—the product of twenty years of work.

Even Ralph, ever the optimist, could sense something ominous in the sudden, almost pitch-black darkness and in the sound of the approaching winds—like a huge jet engine, he later told me. He knew he had to do something and quickly.

Oddly enough, the studio had in its backyard something that had been an object of humor ever since we acquired the place in 1977. It was a 1950s-era bomb shelter. Years ago we had a door built to cover the shelter, which was so heavy it required two people to lift it. We hadn't been down inside for at least ten years and one could only imagine what might be living down there.

But now it was the only place of refuge. Already branches and other objects were flying through the air as Ralph slammed the back door of the studio and ran to the shelter. With the kind of adrenalin-spiked super strength that sometimes allows little old ladies to lift cars off hurt children, Ralph somehow pulled the shelter door open and descended just far enough down the steps to close the heavy door over him.

He stayed there crouched at the top of the steps, immersed in complete darkness with the storm roaring overhead, thinking about hordes of scorpions, centipedes, and brown recluse spiders. In a few minutes the sounds diminished and then subsided altogether. When Ralph finally decided it was safe to come out, he had no idea what he would find once he emerged. But the strength that had gained him entrance to the shelter now failed him, and he could not get the door open. He remained trapped for an hour before he finally managed to pry the door open wide enough to slither through.

As he emerged in the darkness, leaves and broken branches were everywhere but the studio still stood—minus a few shingles. Sirens were sounding throughout the city. Just a block away, several buildings had been completely leveled, trees were toppled, and the trees left standing were missing limbs and filled with debris. Downtown, major office buildings were windowless and power

lines were popping everywhere. Our dear friend Bill Bostelmann's new two-story flower shop and living quarters, with one of the best views of downtown, was destroyed almost to the bottom floor. When we were at last able to get past the police cordon to Bill's place, he was sitting forlornly on a naked stairway. But he was in good spirits. He was well insured at least. The first thing he said was that his copy of our big bird book had miraculously survived with just some small areas of water damage to the box. Both his delivery trucks had been carried off by the winds, but we laughed that the bird book must have been too heavy.

Thank God Ralph and Bill were safe and our studio, which contained the blood and sweat of so many years work on our Aztec project, was intact. But after having had such a close call and seeing our friends damaged, we'll never look at our painting of Chuck-will's-widow quite the same way again. And we don't think we'll make any more jokes about our bomb shelter either.

We chose the Chuck-will's-widow for this painting primarily because it felt right. It is a shy and gentle creature which, like its more common relative the nighthawk, feeds on the wing, scooping up insects with its incredibly wide mouth. It is frequently seen flying just ahead or in the wake of thunderstorms, feeding on the thousands of insects stirred up and sucked high into the air by violent updrafts.

This Chuck-will's-widow is at rest on the top of a fence post, partially concealed by an enveloping trumpet vine. Though it is in repose, its large dark eyes are alert for any change in the course of the distant storm. There is a stillness around the bird that belies the turbulence in the clouds overhead and the swirling cyclone on the distant horizon. Shafts of light appear and disappear in swift succession as gaps in the clouds pass beneath the sun to illuminate and shadow the landscape. The bird appears fragile in the face of such fury, but in an instant it will be bound for the shelter of some distant woods or perhaps fly out along the edge of the storm to find insects in the upward spiraling thermals.

SGG/SWG

ZONE-TAILED HAWK

Scott and I could easily say that without our friend Travis Beck this book in its present form and content simply would not exist. An East Texan from Mount Pleasant and a personal friend from college days at Tulane University, Travis is a combat veteran, an untiring hiker and birder, and a collector of rare books. He not only introduced us to birds in new parts of Texas by taking us there himself but also led the way for us into the world of book publishing by setting us up with all the various artisans who made our folio *Of Birds and Texas* possible.

Until he became aware of what we were attempting, we had worked on our book only when we could spare the time from making a living. Progress had been ever so slow when Travis arrived at our door, announced that we were going down to the Aransas National Wildlife Refuge for a day, possibly two, and then proceeded to take us on a nine-day odyssey to almost every part of Texas. To make our kidnapping tolerable, he paid our way, provided all the necessary supplies, made us the beneficiaries of his considerable knowledge of the country and its bird life, and even did our laundry.

While we were in Big Bend, we climbed up into the Chisos Mountains and cold-camped at Boot Springs— three of us in a small pup tent caught in a frightful lightning and thunderstorm. There we met other birders and saw for ourselves a few rare objects of their pursuits. One of these was the Zone-tailed Hawk.

In this painting we have shown the hawk against a distant view of Boot Springs not far from where we camped. The "boot" in the background is one of the most prominent monuments in the canyon. For the pose we decided on one that is a peculiar characteristic of this species. With wings spread, often with the primary feathers touching in a V-shape position, it plunges from great heights until it comes perilously close to the ground, a stunt it seems to indulge in out of sheer pleasure. Louis Agassiz Fuertes, the great naturalist and bird painter, illustrated a zone-tail in a similar pose when he visited Texas in 1901. Our painting is an homage to Fuertes and his work.

S W G

SCISSOR-TAILED FLYCATCHER

Bird people often refer to the Scissor-tailed Flycatcher as a "bellwether" bird—a bird that is always gone from this part of Texas with the first cool fronts and is always back with the first warm days of spring. It is this latter season which we have chosen as the setting for our painting, with two flycatchers doing what they seem to be doing most often—fighting! In fact all flycatchers are known for their quarrelsome natures, not even the smallest of their breed being an exception.

With this in mind, we decided to put them in a setting of utter tranquility, a landscape with the feeling of one of those sweet, quiet spring days when all seems right with the world, when the term "spring fever" truly applies, when one just wants to lie down in the cool shade and think long, idle thoughts—or no thoughts at all—beneath a canopy of great white clouds drifting overhead in soft majesty.

But back to the birds. These flycatchers will attack anything up to the size of an eagle. I have seen many a golfer who, having invaded the nesting territory of scissor-tails, received so many kamikaze assaults that they had to flee from the field. It is a truly beautiful and graceful creature in spite of its bullying ways. When perched, it sits very erect, exhibiting an alert and noble appearance. It is a great pleasure to watch its aerobatics in flight and to see those sudden flashes of vermilion and peach under its wings and on the sides of its breast and to watch the scissoring of its graceful tail.

I think this is the only picture in our book in which we have shown a field of wildflowers. Texas is justly famous for the number, variety, and beauty of these, but, of course, when one considers all the differing types of terrain and climates in this state, our bounty of wildflowers is no surprise. The country we have shown here is somewhere in North Central Texas, and prominent among the field blooms is our own state flower, the bluebonnet.

SGG

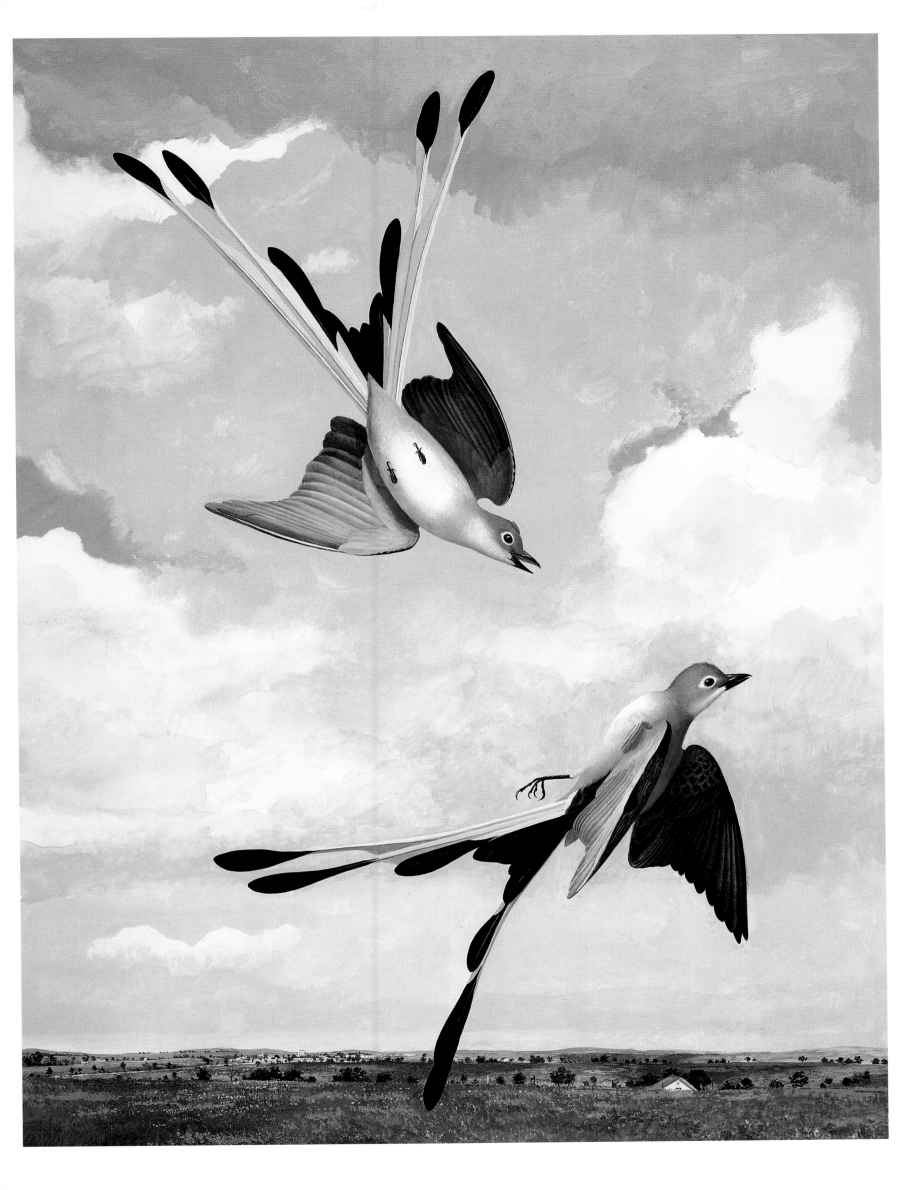

ALTAMIRA ORIOLE

When we traveled around the state on that marathon trip with Travis Beck, we had a fairly clear idea of some of the birds that we hoped to see. The Lichtenstein's (now called Altamira) Oriole ranked high on our list. At the Santa Ana National Wildlife Refuge we saw our quarry for the first time. It was an exciting encounter, kind of like seeing a bird movie star known only through book illustrations. Harry Oberholser in *The Bird Life of Texas* calls it a "showy" oriole.

We found them not at all shy, and we were able to get better-than-hoped-for observations of them at extremely close range without the aid of binoculars or a viewing scope. Their size—they are our largest oriole—their vigor, and the startling brilliance of their plumage made us want to paint them from the start. We were even able to get passable photos of them, not only at the refuge but also later during our journey up the Rio Grande Valley and across the Pecos River at the town of Langtry.

You can imagine, as history lovers, what a treat it was for my brother and me to unexpectedly come upon the town of Langtry, city of the infamous and almost mythical Judge Roy Bean. The town was mostly an abandoned oasis in the desert, the main oasis being the Jersey Lily—Judge Bean's legendary bar, billiard parlor, and court of law. There was no glitzy restoration here. Maintenance, of course. But what the visitor experienced must be something like the place as it once was. It was the same ramshackle building that we used to see on old Pearl Beer signs on the back walls of many a roadside diner or honky-tonk.

Adjacent to the Jersey Lily was a fine small museum, interesting, informative, and beautifully laid out with dioramas depicting life there in Bean's time. To the side of the museum was a nicely organized cactus garden, and it was here that we again met our oriole and again at quite close range. Its perch was the top of a yucca in superb full bloom. Its color against a cloudless blue sky was matchless. Stuart and I were tempted to paint them on just such a plant, but the yucca bloom was simply too big. Instead we have depicted two males and a female (the upper bird) in the eternal triangle of mating-time rivalry. We placed them in a semitropical setting against a Texas sky laced with typical summer clouds.

SGG

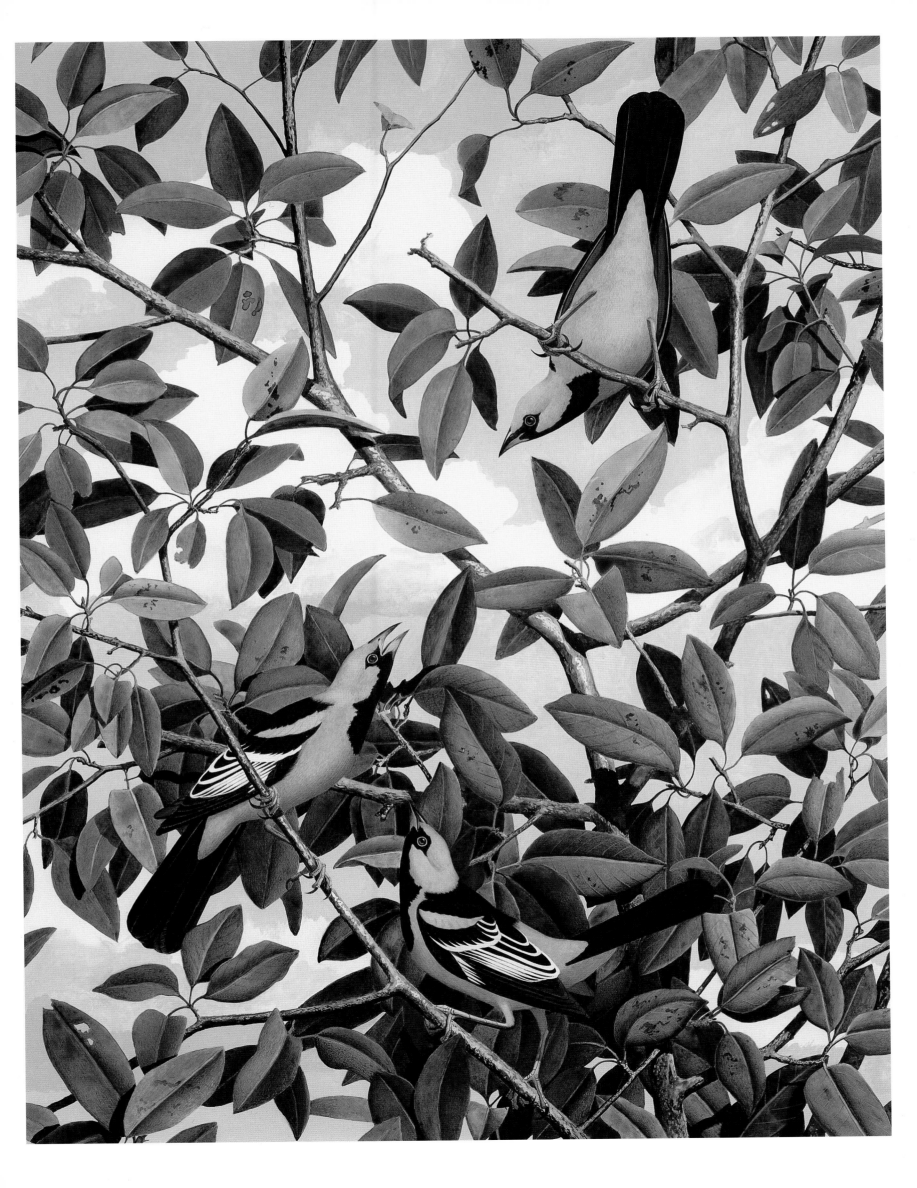

RING-NECKED PHEASANT

The Ring-necked Pheasant is an Asiatic bird imported into the United States toward the end of the nineteenth century. It is now well established in parts of the northern Panhandle in Texas. Scott and I included this bird in our collection not only because of its obvious beauty but also as a memento of a time when we had a very interesting collection of live ornamental pheasants. For about two and a half years, until going off to college put an end to it, Scott, Tom Loffland, Denny Woodson, Dutch Phillips, and I put most of our after-school energies into collecting and maintaining the inhabitants of a ramshackle assortment of bird pens which we constructed behind the Loffland house in Westover Hills on the west side of Fort Worth.

Westover had the distinction of being a separate township within the city limits of Fort Worth. It had its own mayor, police force, and fire department, and since it was an exclusive area with big estates, there was plenty of space with large lawns and fields and untouched wooded areas offering an excellent country atmosphere in which to construct and conceal our pheasant farm. I can still vividly recall the look on the face of Tom's father T. W., who was sometimes mayor of Westover, as he heard the news of our latest project. He threw his hands up in mock despair. He exclaimed that he never thought he would end up with a "chicken ranch" in his backyard. He would badger us about our sloppy carpentry and apparent lack of planning, but he secretly took keen interest in our enterprise. He proved a good ally on every occasion of calamity or economic shortfall, always being there to bail us out and to offer good advice. If our pheasant farm was a shared hobby, it was still hard work—and expensive. Tom, who became our self-appointed treasurer, was annoyingly efficient. He was constant and never let us escape our weekly dues obligations.

An added responsibility was thrust upon us each time it rained. No matter what we had planned for that day, we would have to stop everything and replace rain-soaked feed in each of the approximately twenty pens, an onerous task. In spite of this, our project ran well enough, and though Tom and Denny and Dutch were not really

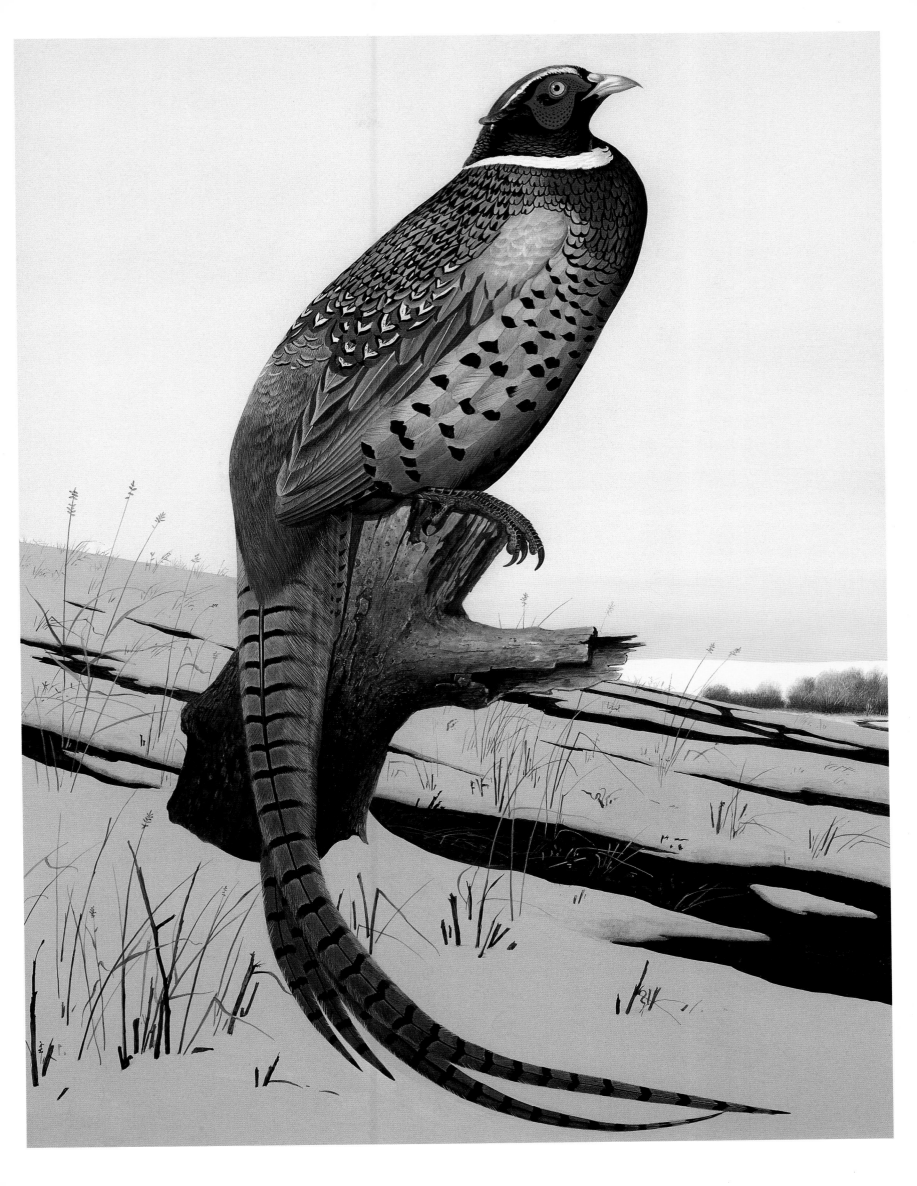

bird people, they seemed to enjoy the pheasants as much as Scott and I did.

At one time we had more than twelve different kinds of ornamental pheasants. Some were quite rare. We had one pair or more of Blue-eared Manchurians, Malayan-crested Firebacks, Swinehoes, Reeves, Blackneck Pheasants, Japanese Versicolors, Himalayan Impeyans, Cheers, Goldens, Lady Amhersts, Silvers, and Elliotts, as well as the common Ring-necked Pheasants. We also raised banties, bobwhite quail, and even a pair of Wood Ducks.

Since we were always short of money to procure necessities such as wood, wire, and gravel for the benefit of our growing bird collection, we were not above borrowing these materials from nearby Westover house constructions. We always needed more gravel to maintain proper drainage in our pheasant pens. Fortunately, there was a plentiful supply just a couple of houses away in Mr. and Mrs. Perry R. Bass's driveway. They certainly seemed to have far more than they needed, and early one Sunday morning, armed with two shovels and two wheelbarrows, we made our way down the street to the Basses' house.

We filled one wheelbarrow and had just begun on the other when without the slightest warning sound of an engine, a car appeared from around the corner and came to a sudden stop right by us. It happened so fast that we didn't have time to even think about running away. No such luck that it might have been some sort of early Sunday morning delivery or a servant. It was Mr. Bass at the wheel, his wife Nancy Lee on the seat beside him, and if I recall clearly in the backseat were all four boys, Sid, Ed, Bob, and little Lee. Down came the electric window on Nancy Lee's side, and Perry leaned over. Unfortunately, he recognized Tom, his neighbor's son, immediately. The rest of us just stood there dumb.

"What are you doing?" Bass said, acting as if he didn't know.

Tom did the talking. "We need some gravel for our pheasant farm, sir, and it looked like you had more than you needed."

"Pheasant farm? So that's what I've been hearing making so much noise every morning." (It was spring breeding time, when several of our species called loudly.)

"Yes, sir, that's what you've been hearing."

"Well, I guess you know that what you are doing is wrong, don't you?" Bass said. The boys in the backseat said nothing. Nancy Lee was quiet too.

"We're sorry, sir," said Tom.

"Well," said Bass, "you can have the two wheelbarrows full, but no more, OK?"

"Yes, sir, thank you, sir."

The electric window began to go back up, then stopped. Perry leaned over again and shouted out of the window, this time smiling. "I suppose you can't do anything about those damned pheasants calling at five o'clock in the morning, can you?"

"We'll try our best, sir."

The car sped off, leaving us with legs shaking, standing in a cloud of gravel dust.

The next afternoon while Tom and I were feeding our birds and cleaning their water bowls, a huge dump truck rumbled down the long driveway past the Loffland house and came to a stop at the steep stone stairway that descended to our pheasant farm. Tom and I hurried up to investigate the commotion.

The dump truck was loaded with gravel. A lot of gravel. It was clear that the driver had been given definite instructions. Right there by the stairs, with the loud grinding of gears and a straining engine, the back of the truck tilted to empty its load. Out spilled a mountain of pea gravel.

As soon as this was done the driver got out of the cab and without a word walked over to the gravel pile. He took out a small piece of paper with some writing on it. He took out a pencil too. He placed the note against the gravel and stuck the pencil through it. Again, without a word he gave us a two-fingered salute, got back into his truck, drove up around the curving drive, and was gone.

Tom and I walked over to the gravel pile. The note read, "This gravel ought to hold you awhile. Leave mine alone. Perry."

For this plate Scott and I depicted a male Ring-necked Pheasant resting quietly on a sawed-off tree stump. It is a bitterly cold winter morning as the sun begins to rise over the bleak Panhandle countryside. This bird is sitting on its heels, a peculiar posture that I often observed among caged birds when they were relaxed and sitting on top of the flat roofs of their nesting boxes. In cold weather they usually ruffle their feathers to trap and conserve warm air next to the body, but this bird has just heard a distant alarm of some kind, far off but menacing. Its body has become taut. In its eyes is the look of apprehension—cold and alert. In the wild these pheasants can never relax for very long.

SWG

SURF SCOTER

This handsome duck is a rare winter visitor to Texas. It is more commonly found along the shores of the northern Pacific, and from Alaskan waters inland across much of northwestern Canada. They are less common along the North Atlantic coast. We have chosen to end our volume with a view of this sea duck set against the open waters of the Gulf of Mexico. The sea in a way is all about journeys. We began this portfolio of birds with our painting of the Turkey Vulture high above the Brazos River, because it is one of the most common sights for Texas birdwatchers. It is a permanent resident, and like the river itself, it is an indigenous part of our state. In our vulture painting the river flows eastward and south toward our journey's end at the Gulf Coast with this Surf Scoter out to sea.

The land and the waters along the Texas coast are the destinations of hundreds of species of migratory birds, and the tropical and mountain country along the Rio Grande is visited by many exotics found nowhere else in the United States.

The Surf Scoter is not exactly an exotic species, but it is certainly not a common visitor. Like plovers, terns, cranes, and geese, it is a migrant from distant lands arriving with the first frosts to grace our state and add to its natural beauty. Now at its journey's end until spring, the scoter rests and feeds quietly in the surf to replenish the body fat lost on its long flight south. There are clouds on the horizon rolling in from the sea. Overhead and out of sight, thousands of smaller birds continue on their way, out across the open water, driven by instinct toward faraway and, for many, unknown lands. It is a part of an endless but reassuring cycle for those who love birds in Texas. The appearance, departure, and reappearance of these travelers help to define our lives and give them a much needed sense of rhythm too often obscured by the routines of modern life.

If it can be said that birds are nature's gift, then our state has been uncommonly blessed. Texans live in a state rich in history and cultural diversity, rich in natural resources and material wealth. Within our borders is one of the oldest continuously inhabited cities in the country

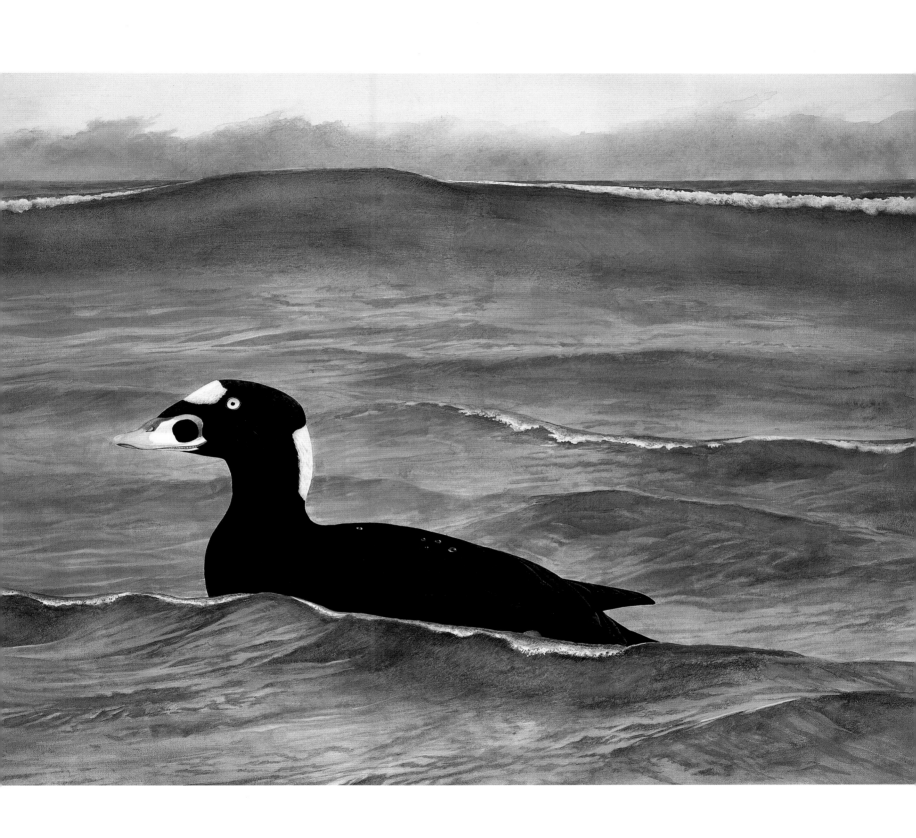

(El Paso), and yet we appear to have inherited only some of the problems and little of the pessimism that have plagued many of the settled areas of the North and Atlantic seaboard. We are not immune, of course. The pressures of increasing population and industrial growth, which to some is progress, may prove our undoing soon enough as the natural beauty that has drawn others hither is buried under concrete and asphalt. If we are to be proper stewards of our natural heritage and pass it on to future generations in as good or better shape than we found it, we must first appreciate what it is that we might be losing. Once gone, it will not be missed by those who follow.

John James Audubon, to his credit, was aware of this fact at a time when untouched land on this continent still existed in the millions and millions of acres. Then, there were virgin forests, prairies, and mountains which had scarcely felt the tread of European feet, but still Audubon was witness to the destructive hand of humanity. The pages of his journals and his *Ornithological Biography* are filled with observations and warnings about what was to come as people exploited the land for immediate profit without any regard for the future. Even *Birds of America,* his most eloquent visual testament to the vari-

ety and beauty of his adopted country's bird life, depicts species whose habitat was already being changed by the hunter, the woodsman's axe, the farmer's plow, and the inevitable encroachment of cities. Industrial progress and prosperous cities may have made most of us more comfortable and offered opportunities for growth and experience never before possible in simpler times, and as an avid recipient of such largess I am not ungrateful. But in the face of the vastness of human destiny in the centuries ahead—if there is a destiny—I cannot but wonder if for present profit and comforts we have not made a bargain with the devil. That when the bill finally comes due, it will be the price of our natural heritage and the natural beauties that still exist. There are those—and Scott and I are among them—who believe that if we lose our natural heritage, we lose our souls.

The bargain has been made. There is no going back. But if we look to the future and face all its dangers and opportunities with a determination not to turn our backs on our natural treasures, who knows what good may yet be done? Time and the seasons have determined the scoter's destination. I believe that we as a species have our fate for the most part in our own hands, but what we may do with it is, perhaps, the greatest question of all.

SWG

Remarques

A few subscribers to the elephant folio edition of *Of Birds and Texas* allowed us to use their money to finance the first stages of our publishing project. In return, we painted these special bird studies, called "remarques," on the title pages of their books and occasionally on a few separate sheets. Scott drew and painted all but three, the Rose-breasted Grosbeak, the Painted Bunting, and the Fox Sparrow. They are painted in a more personal bird painting style which actually evolved while we did our work for the folio.

LOGGERHEAD SHRIKE

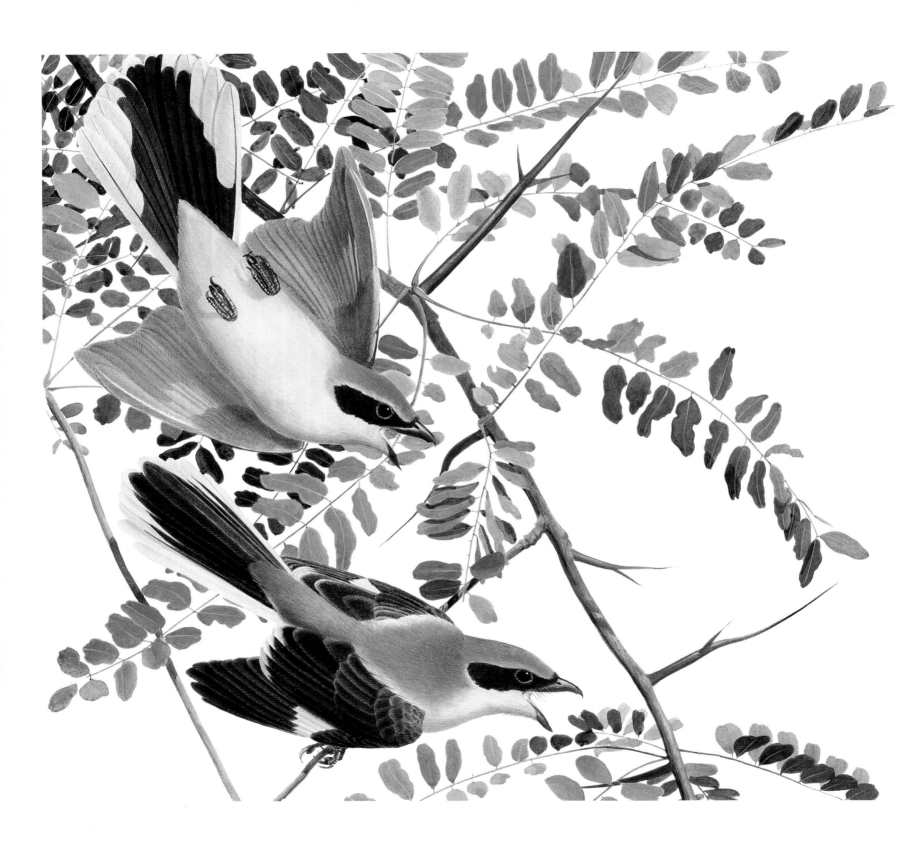

PROTHONOTARY WARBLER

BLACK-THROATED BLUE WARBLER

NORTHERN FLICKER

BLACK-BILLED MAGPIE

ROSE-BREASTED GROSBEAK

BALTIMORE ORIOLE

YELLOW-HEADED BLACKBIRD

YELLOW-THROATED WARBLER

BLACK-THROATED GREEN WARBLER

WHITE-WINGED DOVE

BLUE JAY

PRAIRIE FALCON

ELEGANT TROGON

CEDAR WAXWING

WOOD THRUSH

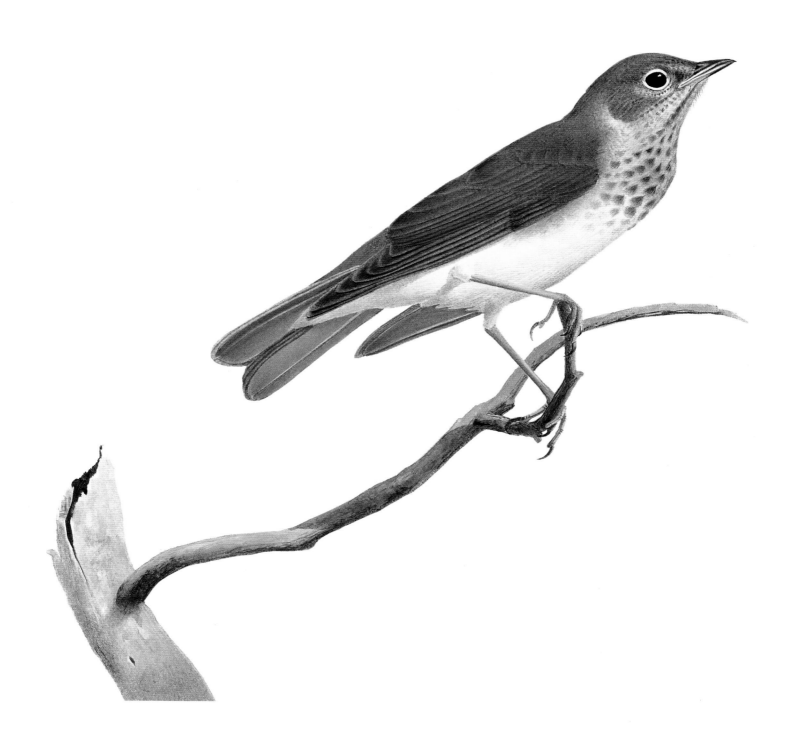

AMERICAN KESTREL

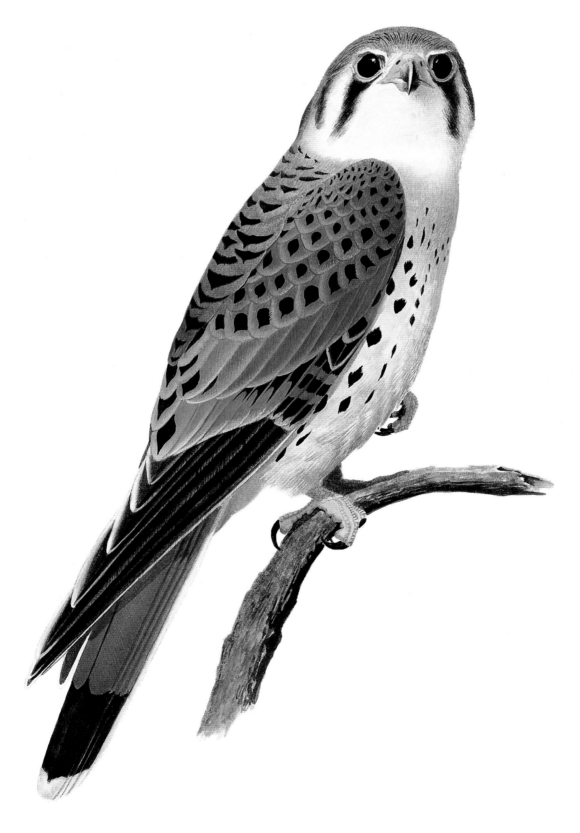

PRAIRIE WARBLER

RED-BREASTED NUTHATCH

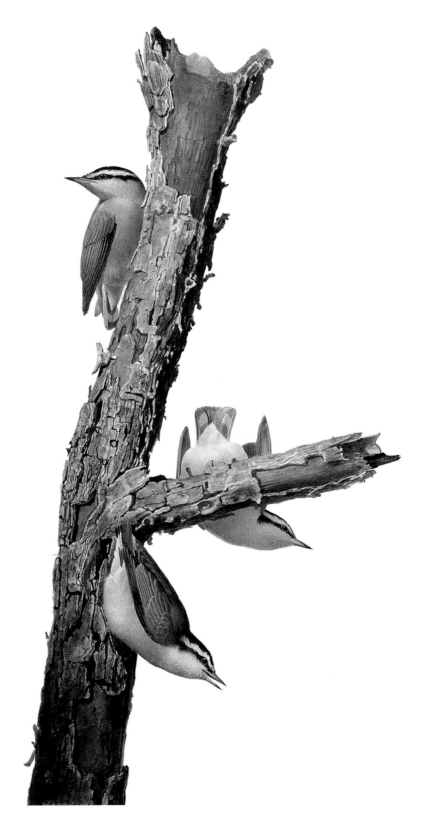

EASTERN SCREECH-OWL, GRAY MORPH

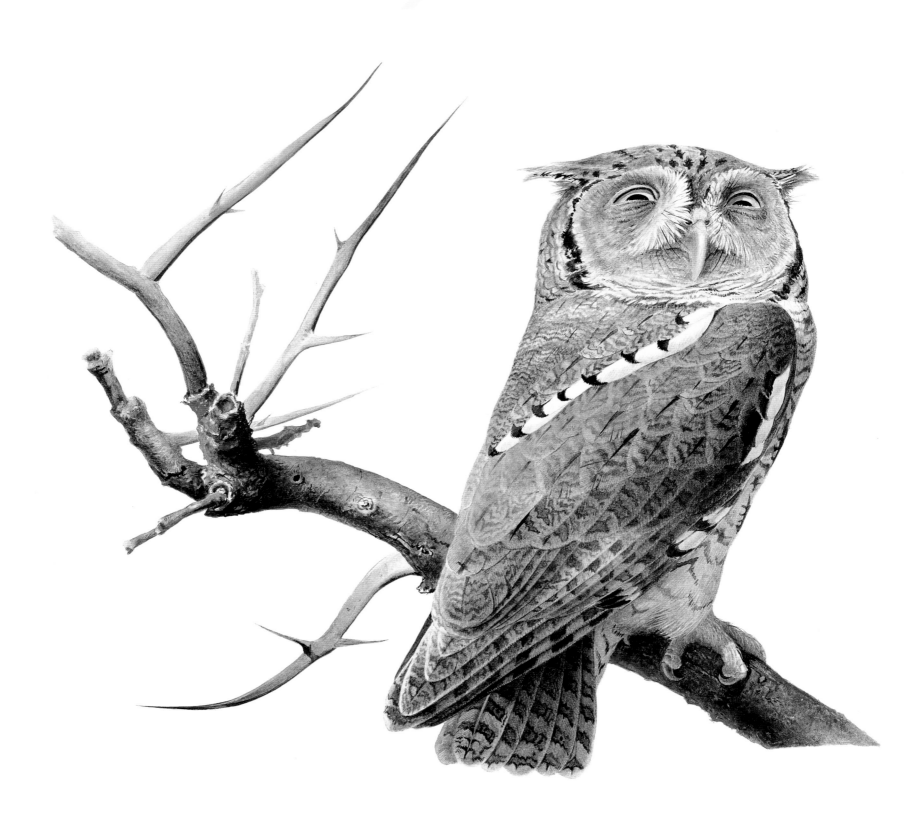

EASTERN SCREECH-OWL, RED MORPH

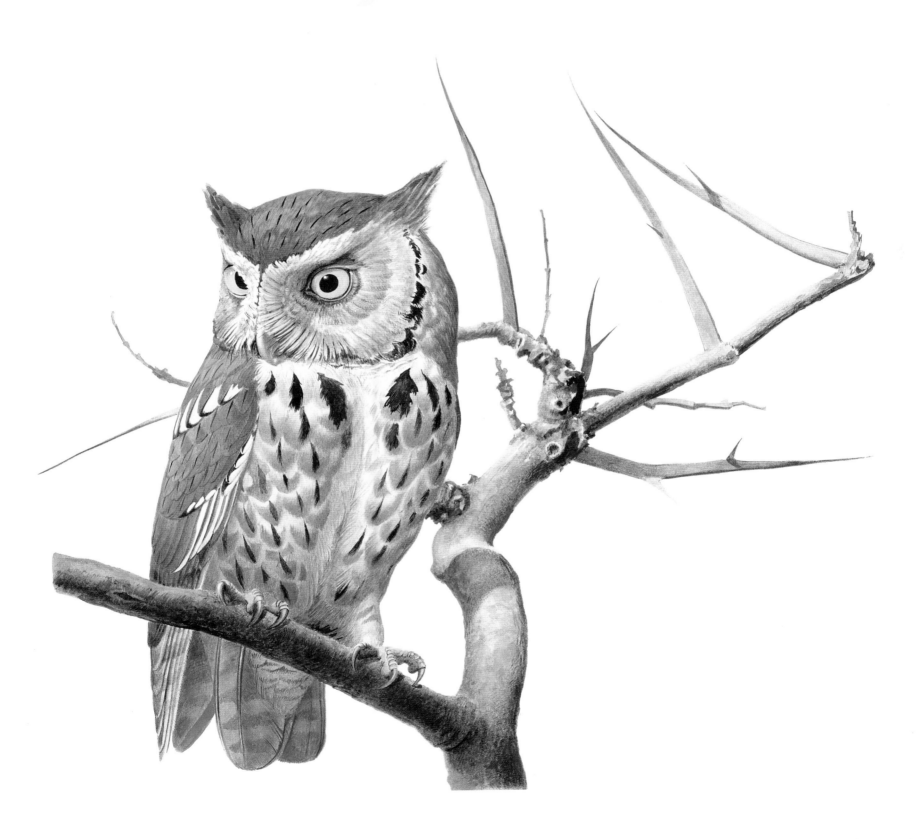

LOGGERHEAD SHRIKE

BROWN-HEADED COWBIRD

VIOLET-GREEN SWALLOW

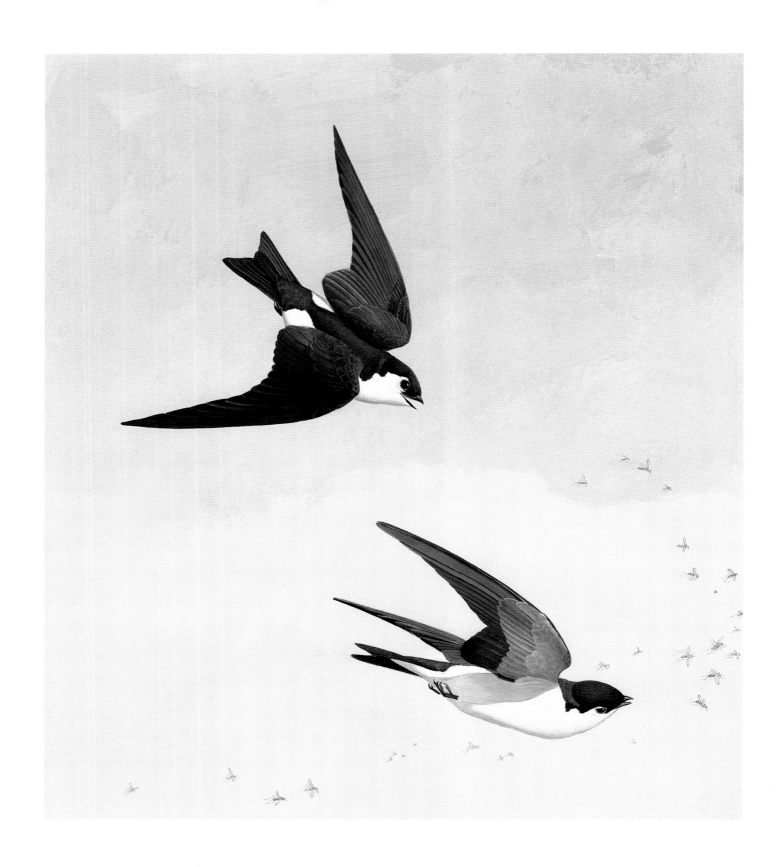

BELTED KINGFISHER

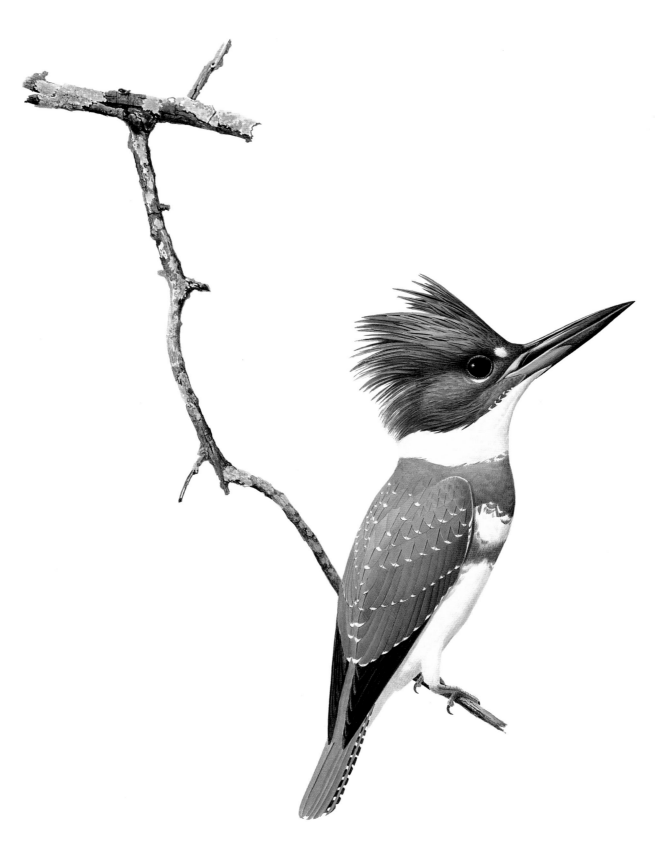

PAINTED BUNTING

FOX SPARROW

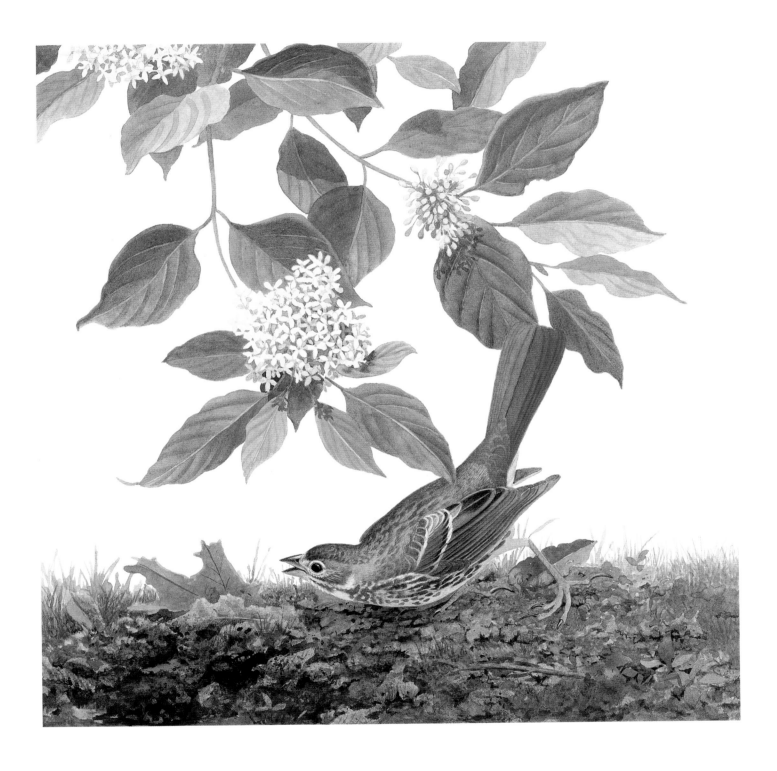

BIBLIOGRAPHY

Archer, Stanley. "Bird Painting and Tradition: The Gentlings' Achievement." *Bulletin of the Texas Ornithological Society* 19, nos. 1 & 2 (1986).

Arthur, Stanley Clisby. *Audubon: An Intimate Life of the American Woodsman.* New Orleans: Harmonson, 1937.

Audubon, John James. *The Original Water-color Paintings for the Birds of America.* 2 vols. Intro. by Marshal B. Davidson. New York: American Heritage, 1966.

————. *My Style of Drawing Birds.* Intro. by Michael Zinman. Ardsley, New York: Overland, 1979.

Audubon, Maria R., ed. *Audubon and His Journals.* 2 vols. New York: Dover, 1986.

Bennett, Patrick. *Talking to Texas Writers, Twelve Interviews.* College Station: Texas A&M University Press, 1980.

Blow, Steve. "Flights of Fancy, The Curious and Artistic World of the Brothers Gentling." *Dallas Life Magazine* (May 10, 1987).

Cantwell, Robert. *Alexander Wilson, Naturalist and Pioneer.* Philadelphia and New York: J. B. Lippincott, 1961.

Durant, Mary, and Michael Harwood. *On the Road with John James Audubon.* New York: Dodd, Mead, 1980.

Ford, Alice. *Audubon's Animals, the Quadrupeds of North America.* New York: The Studio Publications, 1951.

————. *Audubon's Butterflies, Moths, and Other Studies.* New York: Thomas V. Crowell, 1952.

————. "An Early Audubon Drawing." *Princeton University Library Chronicle* 15 (1954):169–178.

————. *John James Audubon.* Norman: University of Oklahoma Press, 1964.

————. *John James Audubon, A Biography.* New York: Abbeville Press, 1988.

————, ed. *The Bird Biographies of John James Audubon.* New York: Macmillan, 1957.

Fries, Waldemar H. *The Double Elephant Folio, The Story of Audubon's "Birds of America."* Chicago: American Library Association, 1978.

Gentling, Scott, Stuart Gentling, and John Graves. *Of Birds and Texas.* Fort Worth: Gentling Editions, 1986.

Graves, John. *Goodbye to a River.* New York: Knopf, 1960.

————. "Recollections of a Texas Bird Glimpser." In *Of Birds and Texas.* Fort Worth: Gentling Editions, 1986.

————. *A Graves Reader.* Austin: University of Texas Press, 1996.

Greene, A. C. "Focus on Texas." *Center for Texas Studies Bulletin,* no. 2 (March 1987).

Lee, Mack. "Of Birds and Texas." *Texas Library and Archives Commission* 48, no. 1 (Spring 1987).

Lowman, Al. *Printing Arts in Texas.* Austin: Jenkins, 1981.

————. "Texas' Largest—and Best—Bird Book." *Texas Books in Review* 7, no. 1 (September 1987).

Milazzo, Lee. "A Lavish Look at Birds of Texas." *Dallas Morning News* (March 22, 1987).

Oberholser, Harry C. *The Bird Life of Texas.* 2 vols. Austin: University of Texas Press, 1974.

Pate, Donna. "The Gentlings Evoking Audubon." *Ultra Magazine* 6, no. 12 (August 1987).

Reese, William S. "The Bonaparte Audubons at the Amon Carter Museum and the Friendship of John James Audubon and Charles Lucien Bonaparte." In *Prints of the American West,* ed. Ron Tyler. Fort Worth: Amon Carter Museum of Art, 1983.

Sotheby's. "Important American Paintings, Drawings and Sculpture." Catalogue, May 28, 1987. New York: Sotheby's, 1987.

Strickland, Ansel. "In the Manner of Audubon, Two Artists Publish a Masterpiece." *Southern Accents Magazine* (January/February 1987).

Tyler, Ron, ed. "Of Birds and Texas, A Review Essay." *Southwestern Historical Quarterly* 92, no. 3 (1989):464–472.

————. *Prints of the American West.* Fort Worth: Amon Carter Museum of Art, 1983.

Vogt, William, ed. *The Birds of America, John James Audubon.* New York: Macmillan, 1937.